Ferdinand Bauer

The Nature of Discovery

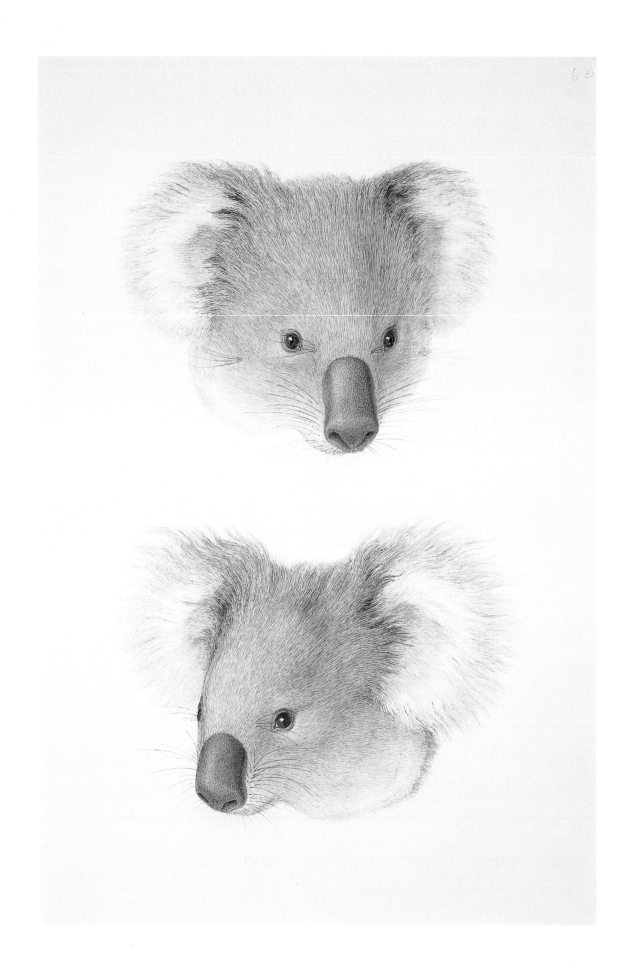

Ferdinand Bauer

The Nature of Discovery

DAVID MABBERLEY

MERRELL HOLBERTON

PUBLISHERS LONDON

and

THE NATURAL HISTORY MUSEUM, LONDON

First published in 1999 by
Merrell Holberton Publishers Ltd
42 Southwark Street, London SE1 1UN
and
The Natural History Museum, London

Distributed in the USA and Canada by Rizzoli International Publications, Inc.
through St Martin's Press, 175 Fifth Avenue, New York, New York 10010

British Library Cataloguing in Publication Data
Mabberley, David
Ferdinand Bauer : the nature of discovery
1.Bauer, Ferdinand 2.Wildlife painting – Australia
3.Painting, Modern – 19th century – Australia
I.Title II.British Museum (Natural History)
759.9'94

ISBN 1 85894 087 7

Designed by Roger Davies

Produced by Merrell Holberton Publishers
Printed and bound in Italy

Front jacket: *Native hibiscus*, detail (plate 42)
Back jacket: *Seadragon* (plate 32)
Frontispiece: Koala *Phascolarctos cinereus* (Goldfuss) (Phascolarctidae)
Watercolour by Ferdinand Bauer (Australian Zoological Drawings 8)
based on sketches made in Sydney in August 1803 of animals
probably captured at Hat Hill, south of Botany Bay, New South Wales.

Contents

Acknowledgements

I am greatly indebted to the staff of The Natural History Museum, especially Lynn Millhouse, Judith Magee, Jane Hogg and Malcolm Beasley, for help in getting access to the materials needed for writing this book. I am also grateful to the Director and staff of the Royal Botanic Gardens Sydney, notably the enthusiastic librarians, Anna Hallett and Miguel Garcia, for their support. To other Bauer scholars, Walter Lack, David Moore and Erika Pignatti-Wikus, I am indebted for hints and pointers, while Susan Boyes-Korkis (Phillips, London), Gavin Bridson, Brent Elliott, Aljos Farjon, Alan Leishman, Serena Marner, Anne Sing, Robin McCleery, David Scrase, Charlotte Tancin and Anne-Marie Townsend cheerfully answered a number of particular queries I had. Ivan Katzen, always a great host, extended much appreciated hospitality in London. As always, I am fortunate in the support of my family, Andrew, Laura and Marcus.

Introduction

The Bauer brothers, Ferdinand and Franz, have been called the greatest of all botanical painters. Franz became a man settled in comfort as artist for life at Kew Gardens, whereas Ferdinand was a travelling painter, drawing views and animals as well as plants not only in Europe but also in Africa and the Pacific. His colour-chart system, allowing him to 'paint by numbers' once he got to base, was an elaborate but efficient way of capturing the colours of animals and plants when they were fresh.

Their work, though brilliant, is not well known because little of it appeared in popular books or periodicals. Most was executed for the very rich or for official purposes. Some was intended for publications that never appeared, some for publications so expensive that they exist in minute editions issued at great expense. This is resoundingly true for the output of Ferdinand. His first work was for an unpublished florilegium in what is now the Czech Republic; then there were commissions for the Viennese — grand books, some even with individual paintings so no two copies are the same. Then came the illustrations for the most costly botanical book ever produced, *Flora graeca*, in a very limited edition. His breathtaking work on pines for Lambert, though nowhere near as extensive, is in a very rare book that was always very expensive. None of his drawings — with just a handful of exceptions — of plants and animals for the British Admiralty made during Flinders's circumnavigation of Australia and afterwards in New South Wales and on Norfolk Island was published until 1960. Those that were published in colour in his lifetime comprised his only private venture, an edition of perhaps fifty copies: although it was financially disastrous for Bauer, this is now one of the most prized of all botanical books.

Following recent exhibitions in Australia, Ferdinand's work is perhaps better known there than it is in Europe or America. Although there are British holdings in the Department of Plant Sciences, Oxford — some of which are reproduced here for the first time — and elsewhere, including the Broughton Collection in the Fitzwilliam Museum, Cambridge, The Natural History Museum houses the originals of much of Bauer's most accomplished work, as well as fine copies of the rare books in which his other illustrations were published.

Ferdinand Bauer was a bachelor and had no pupils: there is not even a portrait of him and his surviving correspondence is almost negligible. Hardly any contemporaries wrote about him and inevitably he cannot wholly 'come alive', particularly in any account of certain stages of his life. In consequence, this book, the first attempt at an assessment, based on the museum's holdings, of his whole career, shows that his legacy is indeed his art — he was "the Leonardo of natural history".

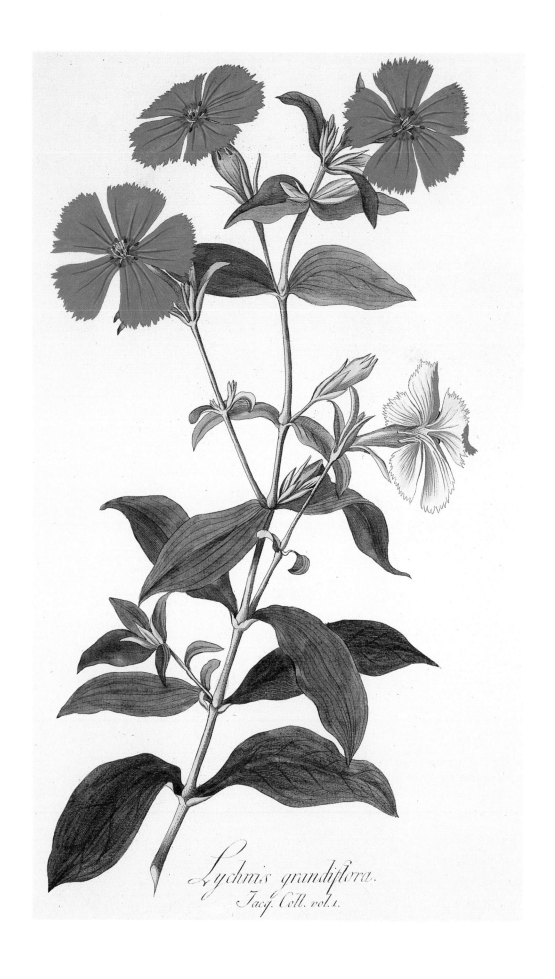

Lychnis grandiflora.
Jacq. Coll. vol. 1.

The Holy Roman Empire

Boccius and Jacquin

1 Baron Nikolaus Joseph von Jacquin (1727–1817)

NOTE: PLATES AND FIGURES

All illustrations reproduced here are from the collections of The Natural History Museum unless otherwise stated. The captions give the current common and/or scientific names followed by the relevant authority. Family names are also given in brackets. If Bauer used a different name this is given in square brackets or referred to in the caption.

Notes to the plates and figures appear on page 128.

PLATE 1 *Silene banksia* (Meerb.) Mabb.
[*Lychnis grandiflora* Jacq.] (Caryophyllaceae)
(N.J. Jacquin, *Icones plantarum rariorum* 1, t. 84 [1787?])

An ancient Chinese garden plant introduced to Europe a number of times under different names. It is one of 'The Hundred Flowers' of seventeenth-century Chinese painters, though depicted by them as early as the tenth century; its specific name commemorates Sir Joseph Banks. Drawn by Jacquin's workshop, which included Ferdinand Bauer.*

Ferdinand Bauer came from an artistic family. His father, who wrote his name Lucas Baur, was court painter to the Prince of Liechtenstein:[1] before that he had been keeper of the Prince's art gallery in Vienna. Ferdinand's mother, born Therese Hirsch, was evidently a capable art teacher, because she was to train Ferdinand and his brothers to copy their father's completed works.

The Baurs' position seemed an enviably secure one in that the Liechtenstein family, with large estates in what is now Austria, Poland and the Czech Republic, was one of the richest in the Holy Roman Empire under the Habsburgs. One of the family's summer residences was north of Vienna, at Feldsberg, now Valtice in the Czech Republic, where the Baurs lived. Under the Liechtensteins' patronage, Lucas painted church altarpieces as well as embellishing the family's various houses with elaborate flowerpieces and paintings of the game they shot whilst hunting.

Ferdinand Lucas Bauer was christened at Valtice on 22 January 1760 but, in July 1762, before Ferdinand was three years old, his father died, aged only 55. Ferdinand's mother, now a widow of 32, also lost her sixth son, her seventh and last child, that year, but did not remarry, bringing up her children to earn a living as illustrators. Other elements of their education seem to have been sacrificed, for Ferdinand, at least, never learned to write German in any polished way and shied away from writing anything at all, save a few letters, for the whole of his life: partly because of this, little is known of him and, particularly in his early years, he remains a shadow behind his drawings. His brother Josef, who was four years older, eventually succeeded his father both as court painter and keeper of the gallery in Vienna, while Franz, just two years older, was to become resident botanical artist at Kew Gardens in England.

The critical event leading to the boys' advancement was the arrival in 1763 of Dr Norbert Boccius (1729–1806), who was a native of Temesvár, now Timișoara in western Romania. He had received his medical training in Prague and Vienna and came to Valtice to be sub-prior of the convent of the order of St John of God there. Boccius taught medicine, but he was soon prior and became the personal doctor of the

2 King leek orchid *Prasophyllum regium* R.S. Rogers (Orchidaceae). Colour-coded and inked drawing by Ferdinand Bauer, based on his field sketch made at King George Sound, Western Australia in 1801–02 (Lindley Herbarium, Royal Botanic Gardens, Kew). Previously unpublished. The numbers on the sketch refer to numbers on Bauer's *Investigator* colour chart (now lost), which, in the mode of its predecessors, had some 1000 numbered colour shades. Bauer often used abbreviated words to indicate texture or sheen, too, particularly in his animal sketches.

3 Bristly donkey orchid *Diuris setacea* R. Br. (Orchidaceae). Colour-coded and inked drawing by Ferdinand Bauer, based on his field sketch made at King George Sound, Western Australia (Lindley Herbarium, Royal Botanic Gardens, Kew). Previously unpublished.

Liechtensteins. He was an amateur botanist, who built up a book herbarium, which he completed at Valtice in 1766: it is now preserved in Brno in the Czech Republic and contains over 1200 specimens, many of them of cultivated plants, embellished with butterflies and other insects.

Instruction in botany was part of a doctor's training but herbaria such as Boccius's have limited use in such teaching. He therefore utilized the talents of the widow Baur's three artistic boys in initiating a project, in which he steered them towards the scientifically accurate portrayal of plant form, rather than the merely artistically pleasing style of their father. This was to become a collection of watercolour drawings making up a florilegium of some 2750 sheets in several volumes. Besides being a work of art in its own right, it is likely that the drawings were also used to explain plant structure to Boccius's students.

Eventually Boccius presented this *Liber regni vegetabilis* to the Prince: it is now in the Sammlungen des Regierenden Fürsten von Liechtenstein in Vaduz, but so far only one plate from it has been published. The *Liber* contains illustrations made of wild plants from the Valtice area but also exotics cultivated under glass and in the open as well as copies of plates in other books. Boccius used at least five artists for his book, but the Bauer boys seem to have been employed first; their work, which is restricted to the first eight volumes, is superior to that of the others. However, their training had been so uniform that it is not possible to distinguish between

the brothers' work. The Bauer volumes each have an intricate title page, a watercolour landscape and some 200 botanical watercolour drawings with inked frames. This stereotyped format was to be followed in Ferdinand's greatest published work, *Flora graeca*, notable for its lavish title pages that include landscapes. It has been calculated that each of the Boccius watercolours took about a week to complete, a rate Ferdinand was to keep up when working on Australian plants for the British Admiralty some thirty years later.

To expedite execution of the drawings, Boccius trained the boys to use a colour code for their work, such that pencil sketches for the *Liber* are marked with numbers referring to 140 numbered shades in a colour chart. Before live material faded it was therefore possible to note the colours and later, perhaps in the winter months, recreate the colours through this 'painting by numbers' technique. It has been suggested that the Boccius colour chart is that now preserved in the Real Jardin Botánico in Madrid.[2] However, the method was in use at least as early as the time of Albrecht Dürer but it was Ferdinand Bauer who was to perfect it during his career.

Although it is not known precisely when, the boys were sent to the Akademie der Bildenden Künste in Vienna, Josef leaving from there for Rome in the employ of the Prince. It is also not certain when Ferdinand left the Akademie, where he seems to have studied with Johann Brand, professor of landscape drawing, but he entered his name for a prize there in 1785.

The other major project undertaken by Ferdinand as a young man was that initiated by Nikolaus Joseph von Jacquin, director of the botanic garden and professor of botany and chemistry at the University of Vienna. Between 1781 and 1795, Jacquin brought out his *Icones plantarum rariorum*, some of the plates of which are by Ferdinand Bauer, but it is not clear whether Bauer prepared engravings as well as watercolours. Like Boccius's *Liber*, the *Icones* covered plants growing wild in the area but also many exotics grown outside or under glass. Particularly prominent were many new species from the Cape, their cultivation then coming into fashion, including species of *Pelargonium* and *Gladiolus* and other 'bulbous' plants. While working on the project Ferdinand lived in

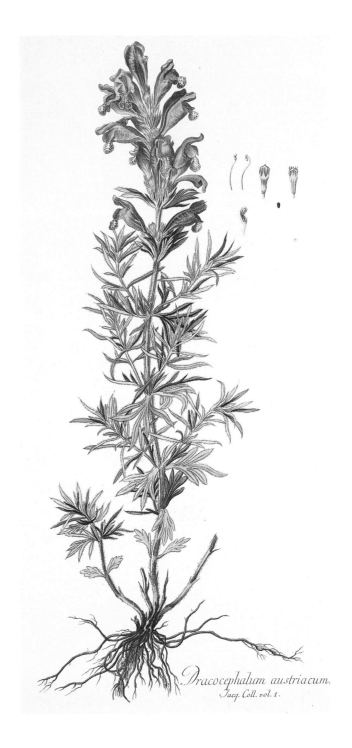

PLATE 2 *Dracocephalum austriacum* L. (Labiatae) (N.J. Jacquin, *Icones plantarum rariorum* 1, t. 112 [1787?]). A plant wild in Austria but also grown in gardens. Drawn by Jacquin's workshop which included Ferdinand Bauer.

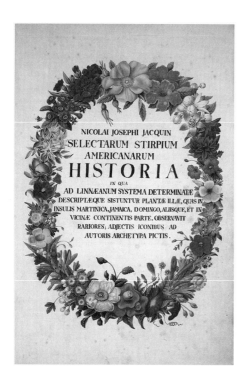

4 N.J. Jacquin, *Selectarum stirpium americanarum historia*, ed. 2 (*ca.* 1780). Unsigned title page of The Natural History Museum copy, attributed to Ferdinand and/or Franz Bauer.

were copied by hand from his own original drawings and not printed – even the title page with its text was painted. Scarcely surprisingly there are very few copies known; perhaps only eighteen were prepared,[3] one being offered for sale in London in 1997 at £95,000. The copies differ most markedly in their title pages, some of which were drawn by Josef Hofbauer (1752–1809), who also worked on the *Icones*, and Franz Bauer. Those are elaborate confections of flowers and butterflies, rather perversely including plants cultivated or growing wild in Austria! It is also highly likely that some of the frontispieces include the work of Ferdinand.

Ferdinand Bauer's technique therefore has its roots in his father's opulent flowerpieces and game paintings, Boccius's strict botanical regimen and Jacquin's scientific analytical approach: all the elements for a great natural history artist. Now insinuated into academic circles, despite his poor general education, Ferdinand Bauer could have looked forward to a comfortable sedentary life, like that his brother was to enjoy in England through the invitation of Sir Joseph Banks, who was effectively director of Kew Gardens, as a resident botanical artist in a 'scientific' institution. But another Englishman came to Vienna at the end of 1785 with the result that Ferdinand was to become one of the greatest of all travelling natural history painters.

NOTES
1 Unless otherwise stated, information here is taken from Lack with Mabberley (1998), ch. 5.
2 Pencil sketches by Bauer, apparently related to the project, are preserved in The Natural History Museum in Vienna.
3 Lack (1998).

Jacquin's house at the botanic garden. The drawing for the *Icones* was an advance on the work for Boccius because the structure of the flowers depicted is often displayed in dissections, the artist having to use a lens. Although it is not possible now to be certain which drawings are Ferdinand's, Jacquin's book contains Bauer's first plates to be printed.

Jacquin himself was a competent illustrator and had prepared his own plates of Caribbean plants for his *Selectarum stirpium americanarum historia*, published in Vienna in 1763. He later had a second edition of the *Historia* prepared, with 80 plates additional to the original 184, but this edition is a remarkable book in that the illustrations

PLATE 3 *Albuca abyssinica* Jacq. (Hyacinthaceae)
(N.J. Jacquin, *Icones plantarum rariorum* 1, t. 64, 1783). A medicinal plant native in much of tropical Africa and Arabia, grown under glass in Vienna and first figured by Jacquin. Drawn by his workshop, which included Ferdinand Bauer.

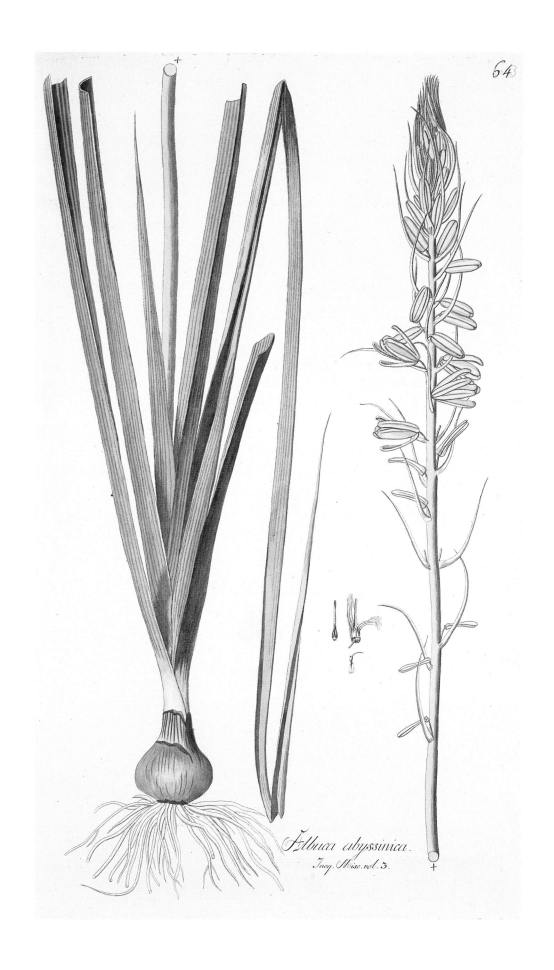

64

Albuca abyssinica.

Jacq. Misc. vol. 3.

13

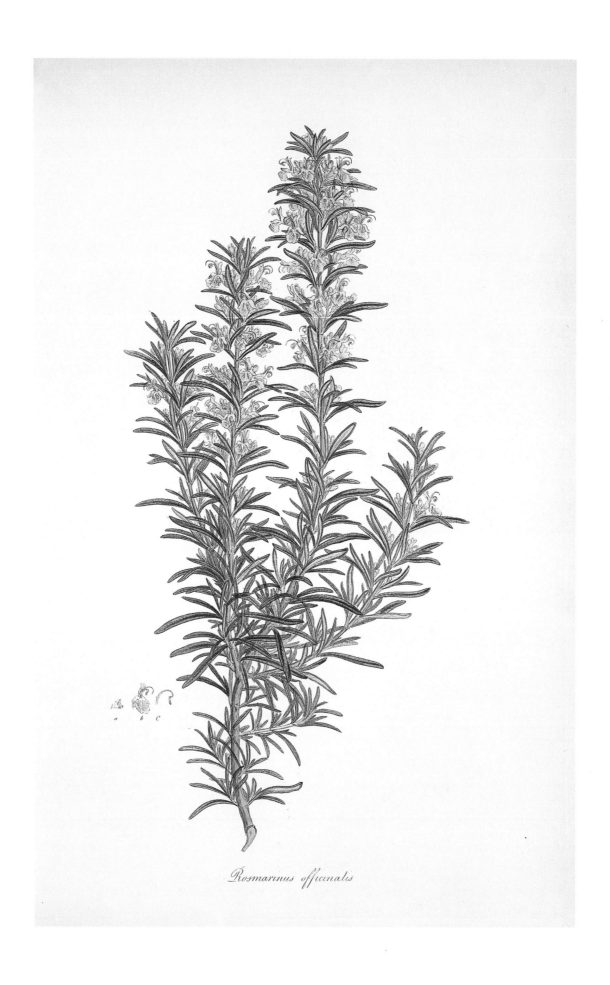

Rosmarinus officinalis

To The Ottoman Empire
John Sibthorp

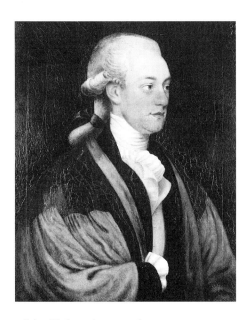

5 John Sibthorp (1758–1796)

PLATE 4 Rosemary *Rosmarinus officinalis* L. (Labiatae) Engraving by Sowerby (J.E. Smith, *Flora graeca*, 1, t. 14, 1806) from the original watercolour, now in Oxford) by Ferdinand Bauer, perhaps based on his field sketch made in Trieste in March 1786.

The Latin name comes from *ros* (dew), *marinus* (maritime), *officinalis* = medicinal.

The next few years of Bauer's life saw Mediterranean travels and employment in England: the result was to be his greatest published work, the plates for John Sibthorp's *Flora graeca*. Despite the book's fame, rather little is recorded of Bauer during this time, while a great deal more is known of his employer, Sibthorp.

John Sibthorp (1758–1796), Sherardian professor of botany at Oxford, reached Vienna towards the end of 1785 on his way to the eastern Mediterranean.[1] Trained as a medical student at Edinburgh, he came from a family of rich Lincolnshire landowners: his father, Humphrey (1712–1797), had been Sherardian professor before him. A bachelor, John lived with his family in academic splendour in Cowley House, now part of St Hilda's College, near the Physic Garden, now Botanic Garden, in Oxford, which housed the most significant herbarium collections in the country. At the age of 22, Sibthorp lost his mother, but he inherited her Instow estate in north Devon. The rents from the estate, combined with an Oxford University travelling fellowship he was awarded in 1781, ensured that this privileged young man could indulge his every ambition.

The fellowship was called the Radcliffe Travelling Fellowship; his father had lobbied for it on John's behalf while John was studying in Edinburgh. It was worth £300 a year for ten years – a huge sum of money then. The only condition of its being awarded was that the holder should spend five years travelling abroad for 'improvement'. Sibthorp was on the Continent from October 1781 until autumn 1783. In Paris he visited the Jardin du Roi and it is likely that the materials he found there, both herbarium specimens and living plants collected in the Levant on Joseph Pitton de Tournefort's pioneering expedition of 1700–01, were the inspiration for his own travels to come. In 1783 he was in Montpellier and saw, for the first time, the Mediterranean vegetation which was to obsess him – and its study eventually kill him. At the end of the year, his father vacated his chair and, in the following April, John succeeded him. His father had been a disaster both academically and administratively, giving only one lecture in his entire career. And now his son, too, was to brush aside whatever duties

6 *View from the walk of Christ Church Meadow to Magdalen College in Oxford*, pen and black ink by Ferdinand Bauer, *ca.* 1790? (Department of Prints and Drawings, Ashmolean Museum, Oxford, Prov. As No. 366). Cowley House, Sibthorp's residence, is in the background: it is now part of St. Hilda's College.

were attached to his post, for, with the new salary to add to his travelling fellowship as well as the allowance he received from his father, he abandoned Oxford to go travelling once more.

In 1784, Sibthorp was on the Continent, visiting Leiden in The Netherlands: the following year he was at Göttingen in Germany and it was there that he began to plan a Mediterranean expedition in earnest. He was soon in Vienna, where he had intended to meet his future travelling companion, John Hawkins (1761–1841), a member of the Cornish landed gentry. The meeting did not take place but in the winter of 1785–86 Sibthorp met Jacquin, who introduced him to his "principal Draughtsman", Ferdinand Bauer. It seems that Sibthorp saw not only Bauer's work for Jacquin but also Boccius's *Liber regni vegetabilis,* perhaps at Valtice, where he may have met Boccius himself. In any case, Sibthorp promptly engaged Bauer for his expedition, as an illustrator with a salary of £80 a year. Sibthorp was indeed modelling himself on Tournefort who had taken Claude Aubriet (1665–1742) as his illustrator on his journey.

It is clear from surviving letters that Sibthorp's motivation was principally to earn scientific fame: he saw that the eastern Mediterranean had many plants and animals unknown to earlier naturalists and therefore unnamed. He saw the opportunity to make new discoveries and to immortalize himself in naming them: Bauer's job was to illustrate the novelties to the glory of Sibthorp. Sibthorp wrote excitedly to Hawkins, still on his way to Vienna, "My Painter in each part of Natural history is Princeps pictorum – he joins to the Taste of the Painter, the Knowledge of a Naturalist & Animal, Plant & Fossil touched by his Hand shew the Master."

In Vienna, Sibthorp acquired from Jacquin unpublished engravings intended to illustrate an edition of the early sixth-century *Codex neapolitanus* now held in Naples and the later *Codex vindobonensis* held in Vienna, two manuscript accounts of the Greek plants described by Dioskorides (*fl. ca.* AD 65) in his writings on pharmacy. Dioskorides's work was a classic and its interpretation was then thought to be fundamental to progress. Armed with these engravings, which are now preserved in the

PLATE 5 Lady tulip *Tulipa clusiana* DC. (Liliaceae)
Engraving by Sowerby (J.E. Smith, *Flora graeca,* 4, t. 329, 1823) from the original watercolour (now in Oxford) by Ferdinand Bauer. It had not received a Latin name when Sibthorp collected it near Florence, but it is now known to be merely a weed of cultivation in southern Europe, having been introduced from its native Iran–Afghanistan region. Its Latin name comes from *tulbend,* the Turkish for turban, in which the Turks wore the flowers, and Clusius (Charles de l'Ecluse, 1526–1609), the botanist who introduced tulips to Holland in 1571.*

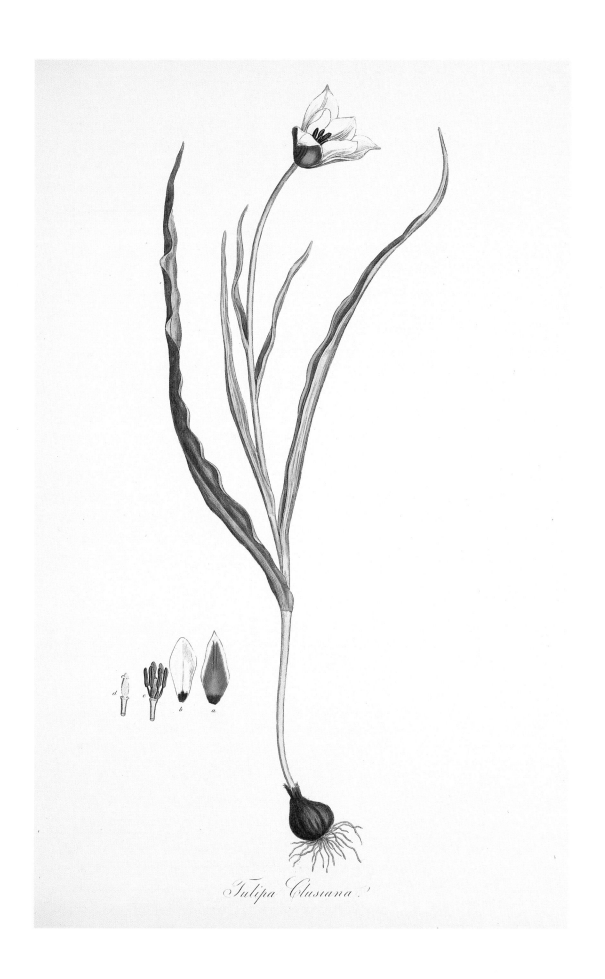

Tulipa Clusiana

17

Department of Plant Sciences in Oxford, Sibthorp was at a great advantage by comparison with earlier travellers, for the engravings could not only be shown to local people in Greece but they also bore Byzantine names. However, Tournefort's findings were now being published in Paris and so rivalry, curiously foreshadowing that between England and France over Bauer's later Australian expedition, urged Sibthorp on.

And so, on a windy, snowy day in March 1786, Bauer and Sibthorp left Vienna in Sibthorp's barouche: Bauer was not to return home until 1814. They travelled via Graz to Trieste, where Bauer drew a sprig of rosemary (*Rosmarinus officinalis*, Labiatae). From the start he used an improved version of the Boccius colour chart, with numbers up to 250, though it is now lost. Often he added localities to the drawings, though not to the zoological ones, but Sibthorp did not add them to any of the specimens they collected. From Trieste they sailed to Venice, arriving on 21 March in the home of the first university, Bologna, which Sibthorp sneeringly noted as "at present more celebrated for its Sausages than its Learning". In a few days they were in Florence, near which Bauer made a colour-coded pencil drawing of what Sibthorp thought was a new species of tulip, afterwards named *Tulipa clusiana*. Next were Pisa, Livorno, Siena and then Rome (the Romans a "degenerate Race & treacherous"), where Bauer began a series of landscapes by drawing the Colosseum: whether he saw his brother Josef is not recorded. Bauer and Sibthorp travelled south to Naples (the Neapolitans a "despicable race"), Sibthorp describing his work pattern in a letter to his father:

"Early in the morning I herborize with my Painter – the Remainder of the Day we work, he in drawing, I in describing the Plants … . I certainly on my Return shall have the first Collection of coloured Plants in Europe … I am particularly fortunate with a Draughtsman – his good Temper & honest Countenance endear Him me much … he has made more than a hundred Designs of different Plants found about Florence, Rome & Naples … I never saw Beauty & Accuracy so fully combined together."

In April they sailed to Capri, where Bauer sketched at least nine views, but the real adventure was about to begin, with their sailing in May or June 1786 for Izmir in Turkey via Messina in Sicily. Sicily gave them many plants to collect and draw, and views for Bauer to sketch: although the flora was relatively well known, many plants had not yet received Latin names and in due course were to be given them with Sibthorp material as type specimens. From Sicily they visited disease-stricken Milos, their first taste of the Ottoman Empire, and then Crete, where they botanized in the high mountains, discovering several new species. They called at other islands in the Aegean including Samos before reaching the Turkish mainland, and Izmir on 3 August.

Sketching and collecting, they probably followed the ancient caravan route to Istanbul, the road taken by Tournefort and Aubriet eighty years before: indeed they had so far scarcely deviated from the tracks of the earlier expedition. But they did climb Mount Olympus (Ulu Dagh), spending three nights on the mountain: they may even have reached the summit before pressing on to Istanbul, which was their base from September 1786 to the following March. In November they were lodged at Heybeliada in the nearby Princes' Islands (Kizil

PLATE 6 Judas tree *Cercis siliquastrum* L. (Leguminosae)
Engraving by Sowerby (J.E. Smith, *Flora graeca*, 4, t. 367, 1824), from the original watercolour (now in Oxford) by Ferdinand Bauer, perhaps based on a sketch made between Rome and Naples in April 1786. Sibthorp wrote then, "The Hedges that seemed as a Screen to the Olive Grounds & the Corn Fields were now empurpled with the Flowers of *Cercis* mixing with the yellow of Spartium spinosum [*Calicotome spinosa* (L.) Link]". The name *Cercis* comes from the Greek for weaver's shuttle, *kerkis*, an allusion to the shape of the fruit.

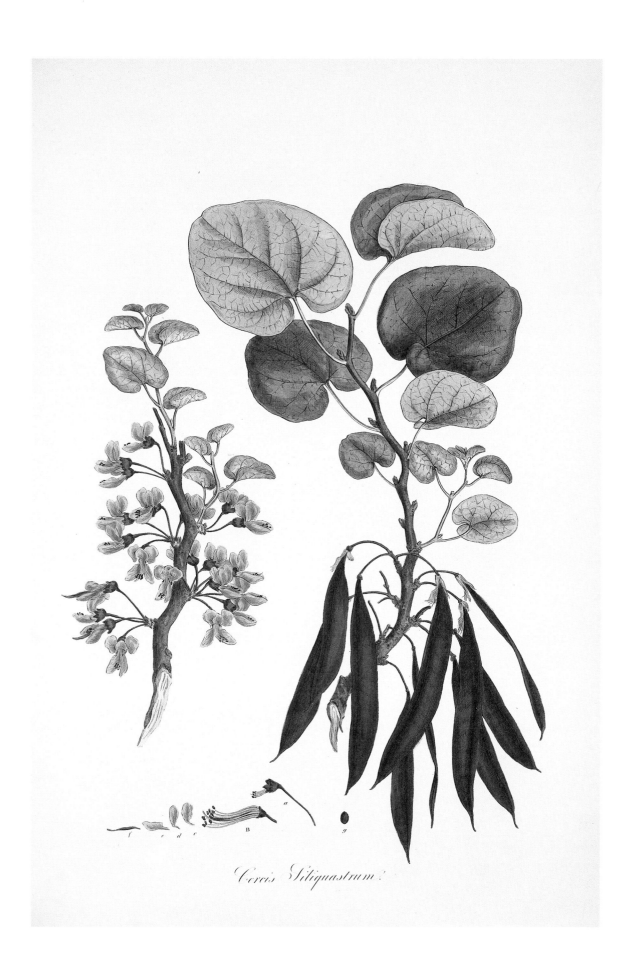

Cercis Siliquastrum.

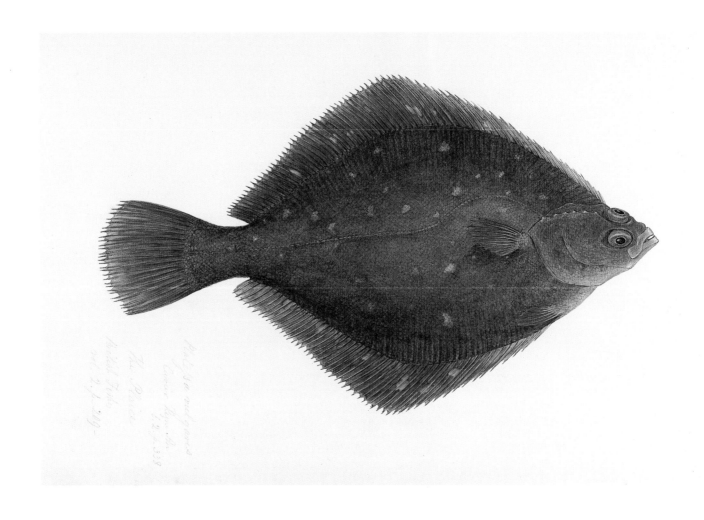

PLATE 7 Plaice *Pleuronectes platessa*

Watercolour by Ferdinand Bauer (*ca.* 1792), probably drawn from a fisherman's catch in the Princes'
Islands, or in Istanbul, Turkey, 1786–87 (MSS Sherard MSS 238 f. 80, Department of Plant Sciences,
University of Oxford). Previously unpublished. This economically important European flat fish,
frequently the 'fish' of British 'fish and chips', can reach 90 cm in length.

PLATE 8 Hoopoe *Upupa epops*

Watercolour by Ferdinand Bauer (*ca.* 1793), probably drawn from a migrating bird shot by Sibthorp
in the Princes' Islands, near Istanbul, Turkey, 1786 (MSS Sherard 240 f. 69 ["238" on drawing],
Department of Plant Sciences, University of Oxford). Previously unpublished. Bauer has drawn the
bird with its characteristic crest raised; it is native in Africa and Eurasia, the northern populations
overwintering in the tropics. Its Latin and English names recall its guttural cry of "hoop hoop".

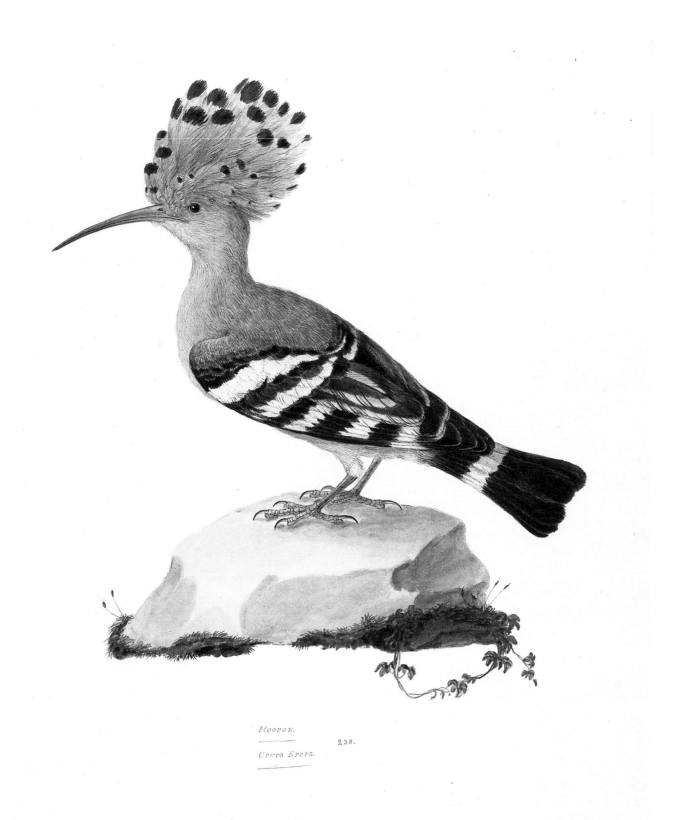

HOOPOE.

238.

UPUPA EPOPS.

Fer. Bauer. del.

7 St Anne Convent, Mount Athos, Greece. Engraving by Sowerby (J.E. Smith, *Flora graeca*, 2, i (1813) from the original watercolour (1794), now in Oxford, by Ferdinand Bauer, based on a field sketch made in August 1787.

On 13 March 1787, in a storm of "sleety snow", the *Bethlehem* left for Cyprus, which Tournefort had not visited. The *Bethlehem* narrowly avoided running aground at the Topkapi point and encountered stormy weather in the Aegean. They touched at various points, including the Dardanelles and Rhodes, and in Cyprus they based themselves at Larnaca. On an excursion to Monte Croce in April they dined under a carob and noted the bee-eaters foraging for insects in the oleanders along the streamside. One was shot and perhaps it is the one figured by Bauer in what became Sibthorp's unpublished *Fauna graeca*, now preserved in Oxford. A mule ride to Famagusta gave them a new species of *Arum*, probably *A. dioscoridis*, the subject of one of Bauer's most brilliant watercolours. Bauer dealt with mammals, too, having to sketch a live, and lively, gazelle at the palace of the Turkish governor in Nicosia: "The Turks hung over us in staring groups while we were thus employed".

The expedition reached the snow line in the Troödos Range and later, on horseback near Ktima, Sibthorp noted "*Cyclamen cypricum*", which Bauer sketched: this, the only Cyprus cyclamen flowering in spring was none other than *Cyclamen persicum*, the parent of all florist's cyclamen, long known in cultivation but until their finding it in the wild presumed to have come from Persia, hence its Latin name. Cyprus was the site of their greatest discoveries and Sibthorp listed about a third of the plant species now known to grow there.[2] They were also the first to record many of the birds and other animals found on the island.

They left for Athens on 14 May 1787, but calms and contrary winds stayed their progress, though they visited the Turkish coast — Bauer sketching a tame lynx in a village there — as well as islands such as Patmos, finally reaching Athens on 19 June. Here Bauer made many landscape sketches, perhaps using a camera obscura. Five

Adalar), where Sibthorp made a collection of fish specimens (now lost), recording more than eighty different species: he paid to get the fishermen's netted catch. It is likely that this is where many of Bauer's fish drawings, now in Oxford, were made and probably many of water birds: certainly Sibthorp recorded the migrating hoopoe there and Bauer's watercolour drawing of it may be based on a sketch he made there.

Sibthorp was still energetically botanizing and Bauer was set not merely to draw the plants but to prepare the specimens for Sibthorp's herbarium collection. By Christmas, Sibthorp could boast that he had at least 300 species which had not yet been given Linnaean names and that Bauer had made sketches of over 500; already he was talking of not merely publishing his findings but of making a monumental *Flora graeca*. In January, Hawkins caught up with Sibthorp and they planned the rest of the expedition, now joined by Captain Ninian Imrie, whose main interest was geology.

PLATE 9 *Arum dioscoridis* Sm. (Araceae)
Engraving by Sowerby (J.E. Smith, *Flora graeca*, 10, t. 947, 1840), from the original watercolour by
Ferdinand Bauer, probably based on a sketch made between Larnaca and Famagusta, Cyprus,
17 April 1787. An east Mediterranean species smelling of carrion and dung. The name comes from
aron, its Greek name, and Dioskorides, the ancient Greek botanist-physician and writer.

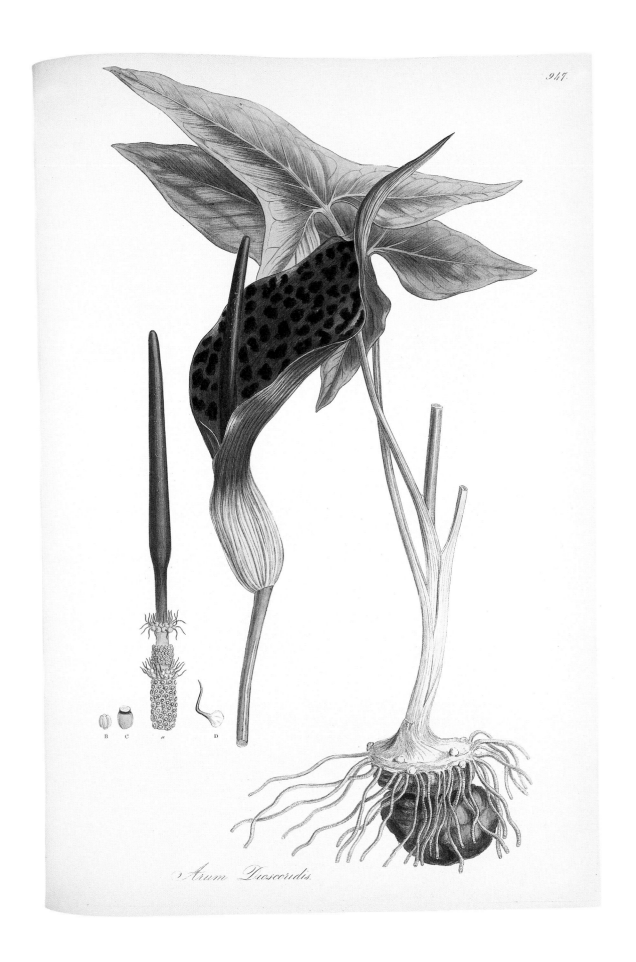

Arum Dioscoridis.

B C a D

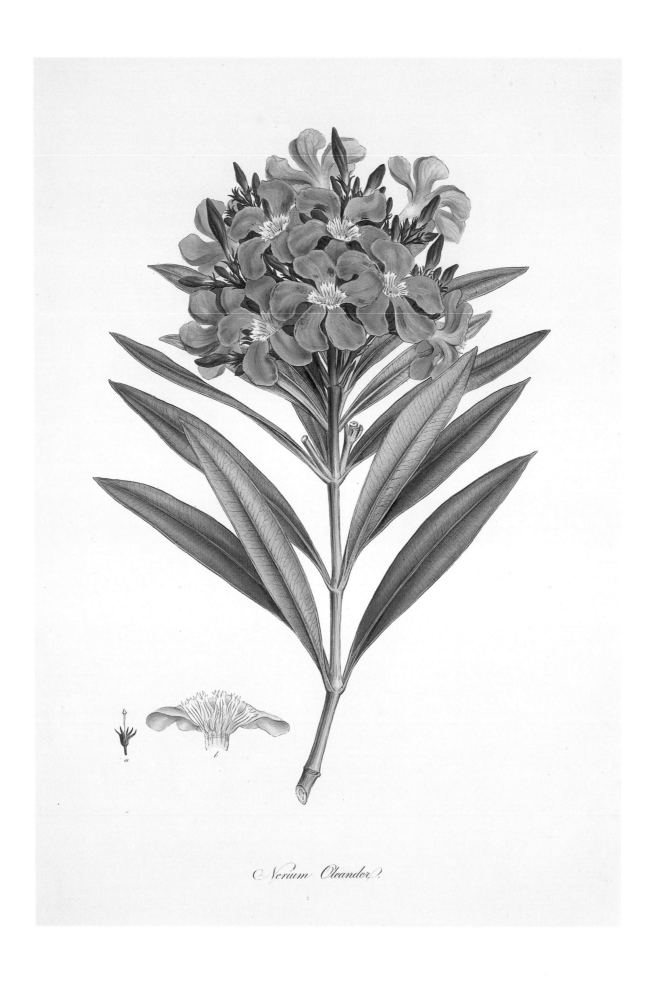

Nerium Oleander.

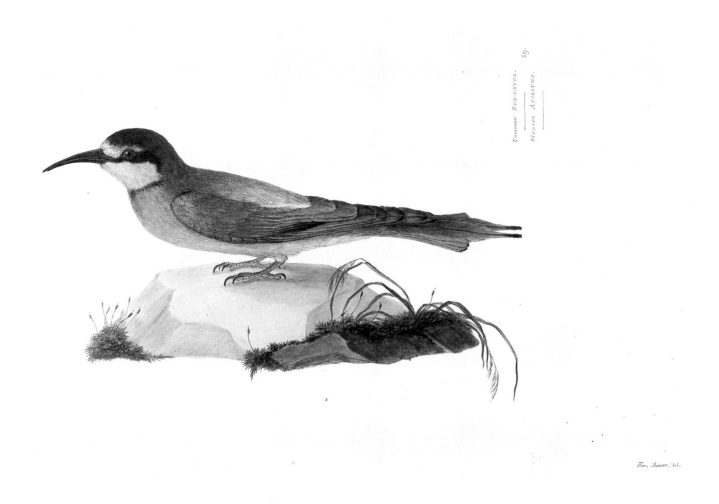

PLATE 10 Bee-eater *Merops apiaster*
Watercolour by Ferdinand Bauer (*ca.* 1793), probably based on a sketch made in Cyprus in April 1787. (MSS Sherard 240 f. 18 ["59" on drawing], Department of Plant Sciences, University of Oxford). Previously unpublished. Bee-eaters overwinter in west and south-east Africa and migrate up to 16,000 km to their summer quarters; their principal food in Europe is bumblebees and so many thousands of them are shot each year by bee-keepers.

PLATE 11 Oleander *Nerium oleander* L. (Apocynaceae)
Engraving by Sowerby (J.E. Smith, *Flora graeca*, 3, t. 248, 1819) from the original watercolour (now in Oxford) by Ferdinand Bauer, perhaps based on a sketch made in Cyprus in April 1787.

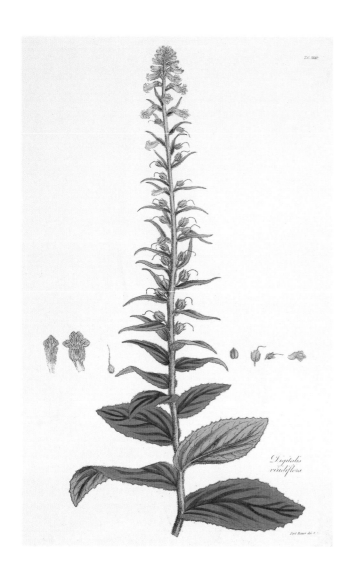

days later they left for Mount Parnassus and the party was probably the first European one in modern times to reach the summit. On 15 July they went to Marathon: on the way, on the Pentéli, the site of Athens's quarries, Sibthorp noted the peeling bark of *Arbutus andrachne*, perhaps the one Bauer also sketched.

By the end of the month they were sailing up the Greek coast, reaching Halkida on 1 August, and ascending Mount Delphis on 3 August. They reached the Athos peninsula a week later and visited several monasteries, including St Anne. Among Bauer's finds was a new foxglove, *Digitalis viridiflora*, and it is likely that a drawing he prepared for John Lindley several decades later (plate 12) was based on a sketch he made of it there. From Athos they went on to Thessaloniki and from there sailed for the isthmus of Corinth, ascended Parnassus once more, and reached Patras. On 24 September, Bauer and Sibthorp sailed on the *Pomona* for Bristol, finally arriving in England on 5 December.

NOTES

1 Unless otherwise stated material is from Lack with Mabberley (1998) ch. 4 and 7.

2 See Meikle (1977), pp. 8–9.

PLATE 12 *Digitalis viridiflora* Lindl. (Scrophulariaceae)
Engraving by Ferdinand Bauer (J. Lindley, *Digitalium monographia*, t. 18, 1821), based on his own watercolour (*ca.* 1819) now in the Royal Horticultural Society, and perhaps derived from a field sketch made on Mount Athos, Greece, in August 1787. Lindley's description is based entirely on Bauer's drawing, which is therefore the holotype.

PLATE 13 *Cyclamen persicum* Mill. (*C. latifolium* Sm., Primulaceae)
Engraving by Sowerby (J.E. Smith, *Flora graeca*, 2, 185, 1816), from the original watercolour (now in Oxford) by Ferdinand Bauer, probably based on a sketch made near Ktima, Cyprus in May 1787. The name *Cyclamen* comes from the Greek *kyklos*, circular, referring to the spiralling of the flowerstalks in fruit in some wild Greek species; *persicum* refers to Persia, mistakenly thought to be the original home of the plant.

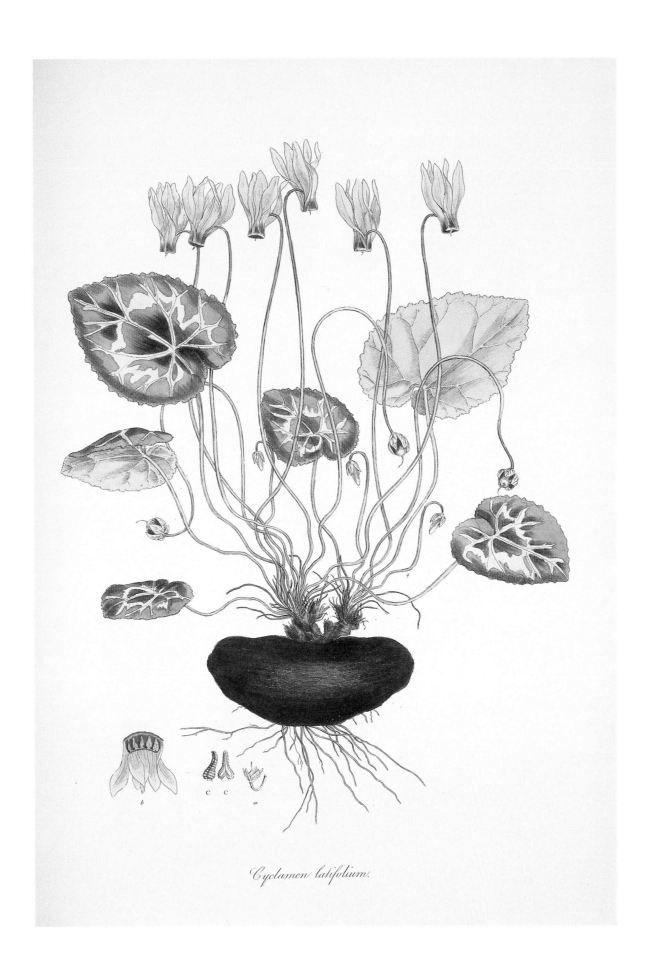

Cyclamen latifolium.

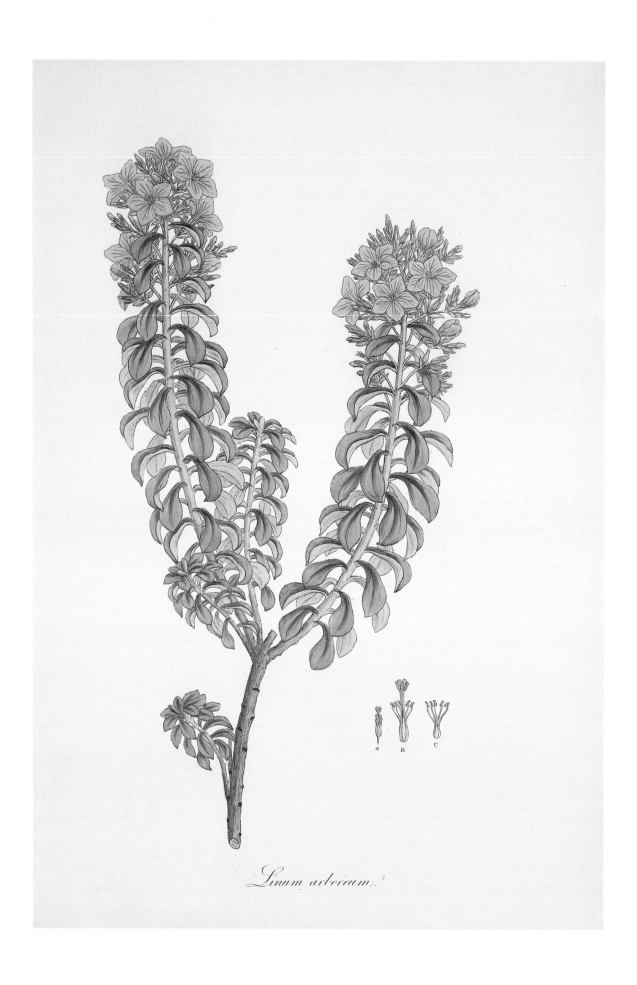

Linum arboreum

Oxford

Flora graeca and Fauna graeca

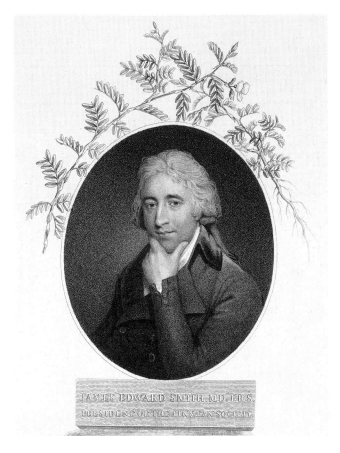

8 James Edward Smith (1759–1828) wreathed with the eponymous Australian plant, *Smithia sensitiva* Aiton (Leguminosae), a name later used by his enemies to poke fun at him.

PLATE 14 *Linum arboreum* L. (Linaceae) Engraving by Sowerby (J.E. Smith, *Flora graeca*, 4, t. 305, 1823), based on watercolour (now in Oxford) by Ferdinand Bauer. A shrubby flax native on limestone rocks in the southern Aegean and south-west Turkey, introduced into cultivation in England from Crete by Sibthorp.

Loaded with his sketches of animals and plants, Bauer was settled to work in Oxford.[1] The President of the Royal Society, Sir Joseph Banks (1743–1820) and the President of the Linnean Society, James Edward Smith (1759–1828) visited Sibthorp: the success of his expedition meant that even Alexander von Humboldt came to see him. No doubt they all examined Bauer's drawings, as well as the specimens Sibthorp had brought back.

But Sibthorp's first priorities were attending to the management of his estates and writing a local Flora for his county – *Flora oxoniensis*, which was published in 1794 and dedicated to Banks. He was soon planning a second expedition to the Mediterranean, however. Although that did not begin until 1794, he failed to start sorting his manuscripts and specimens in readiness for writing the text for his *Flora graeca*.

As with Tournefort in Paris before him, though, Sibthorp had seeds from the expedition sown and attempted to establish "a Plantation sacred to Greece" in the Physic Garden. This provided living material for Bauer to augment and improve his sketches before painting in watercolour. Some plants went to Kew and these included *Linum arboreum*, likely to have been that collected by Bauer and Sibthorp in Crete.[2]

Bauer was therefore set to work to prepare watercolours from not only his field sketches, but also living and preserved material. He transferred the outlines from the sketch, perhaps using a light box, and then coloured the drawing according to the colour chart via the code numbers. Sometimes a layer of gum arabic was added to give a shiny effect. He started with the plants, to become *Flora graeca*, and moved on to the animals, *Fauna graeca*, before working on title pages for the *Flora*.

Within six months, Bauer completed 102 folio-sized watercolours for *Flora graeca*: a year later over 300 had been finished. On 11 June 1792, Hawkins wrote that Bauer had finished the plants and was about to begin the fish. He had made 966 botanical portraits at a rate of 18 a month, though the later ones were only partly coloured. By January 1794, the animals, almost a further 300 drawings, were finished. The plant drawings were perhaps the best ever made and remain among the finest

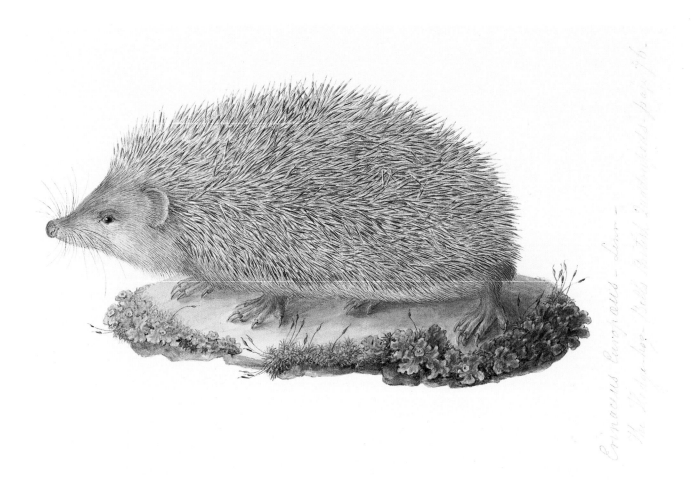

PLATE 15 Hedgehog *Erinaceus europaeus*
Watercolour by Ferdinand Bauer (*ca.* 1793), based on field sketch made 1786–87 on John Sibthorp's
first expedition to the Mediterranean (MSS Sherard 238 f. 6, Department of Plant Sciences,
University of Oxford). Previously unpublished. Found from Morocco to Britain and east to
Manchuria, the hedgehog is, save for a few species of tenrec, the only insectivore capable of
dormancy in adverse conditions.

PLATE 16 Middle spotted woodpecker *Dendrocopus medius*
Watercolour by Ferdinand Bauer (*ca.* 1793), based on a field sketch made 1786–87 on John Sibthorp's
first expedition to the Mediterranean (MSS Sherard 240, f. 67 ["230" on drawing], Department of
Plant Sciences, University of Oxford). Previously unpublished. Bauer's drawing does not show the
white wing-markings generally characteristic of this bird.

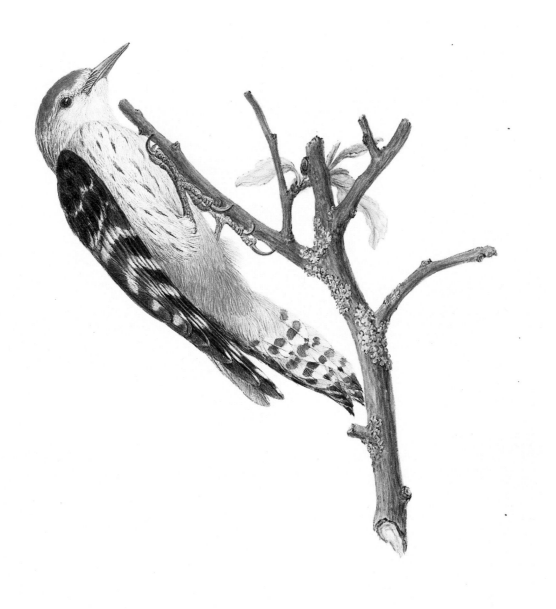

MIDDLE SPOTTED WOODPECKER.

230.

PICUS MEDIUS.

Fer: Bauer. Del.

examples of botanical art. The animals are less satisfactory, but the birds, usually drawn from shot specimens, have been given somewhat lifelike stances and some waterbirds were even portrayed swimming. For their eyes Bauer used the gum arabic and he highlighted them, though not in the position usually used today – the highest part where light strikes the eye – but nearer the front. Occasionally there were more serious lapses, suggesting the original material he worked from was mutilated, an example being a fish (MSS Sherard 239 f. 39) where a fin is omitted.

The plan for the whole work was in Sibthorp's mind and he was to set it out in his will (see below), which was fortunate, because his dilatoriness before his second expedition and its disastrous consequences were such that he was to write none of it himself. He intended the title pages for the *Flora* to reflect the Linnaean system covered in each volume, the first, for example, with the classes at the beginning, Monandria, Diandria and Triandria – plants with flowers with, respectively, one, two or three stamens.

But all was not well with Sibthorp's artist. Excluded by his poor grasp of English and his meagre general education, Bauer had soon found himself isolated in Oxford. With work on Sibthorp's first expedition materials almost completed, he might well have been happy that Sir Joseph Banks was anxious to recruit him as artist for an expedition to the West Indies. Sibthorp was paying him just £80 a year, while Banks was paying Ferdinand's brother Franz, as the highly respected resident botanical artist at Kew, instructing the royal family in botanical art, £300 a year for life. Sibthorp, on the other hand, seems always to have treated Ferdinand as a servant: disagreements between them, apparently largely over money, became magnified into disputes, such that

the lofty Sibthorp became more and more supercilious, with disastrous consequences for both of them. Relations between them broke down completely when it was proposed that Bauer should accompany Sibthorp and Hawkins on a second expedition to the eastern Mediterranean. Bauer, fearing his talents were declining as one eye was beginning to fail, wanted a higher stipend for the best years of his life. He spoke to the more sympathetic Hawkins, who raised the matter in a letter to Sibthorp, even suggesting that Bauer could complete his work in Hawkins's house in London, rather than in Oxford. This brought a ferocious response from Sibthorp, who replied:

"I am highly satisfied with his Drawings & sensible of their Beauties, but like a prudent Man with a beautiful Mistress I must not suffer myself to be intoxicated with the Beauty, & run thro lengths which Prudence cannot approve. More than I pay Him at present neither can I afford nor am I willing to give."

The harshness of the response must be seen in the context of the attitude of Sibthorp's family, who considered it an extravagance that Sibthorp employ an illustrator at all.

Hawkins and Bauer discussed Bauer's publishing the expedition bird drawings at Bauer's own expense, Bauer himself to engrave the plates. As there were no novelties in them, Sibthorp would have seemed not to have been interested in doing this himself, but he opposed even this move and the drawings remain largely unpublished: all those in this book appear in print here for the first time. Whilst working on the *Fauna* for Sibthorp, Bauer wrote his only known letter from his Oxford years, to Hawkins, ending, "I must big parden if I shall Esgus

PLATE 17 Great bustard *Otis tarda*

Watercolour by Ferdinand Bauer (*ca.* 1793), based on a field sketch made 1786–87 on John Sibthorp's first expedition to the Mediterranean (MSS Sherard 240 f. 77 ["267" on drawing], Department of Plant Sciences, University of Oxford). Previously unpublished. Found in the Mediterranean region and parts of north, central and eastern Europe, the great bustard is the world's heaviest flying bird: males can weigh up to 14 kg in weight and have a wingspan of 240 cm.

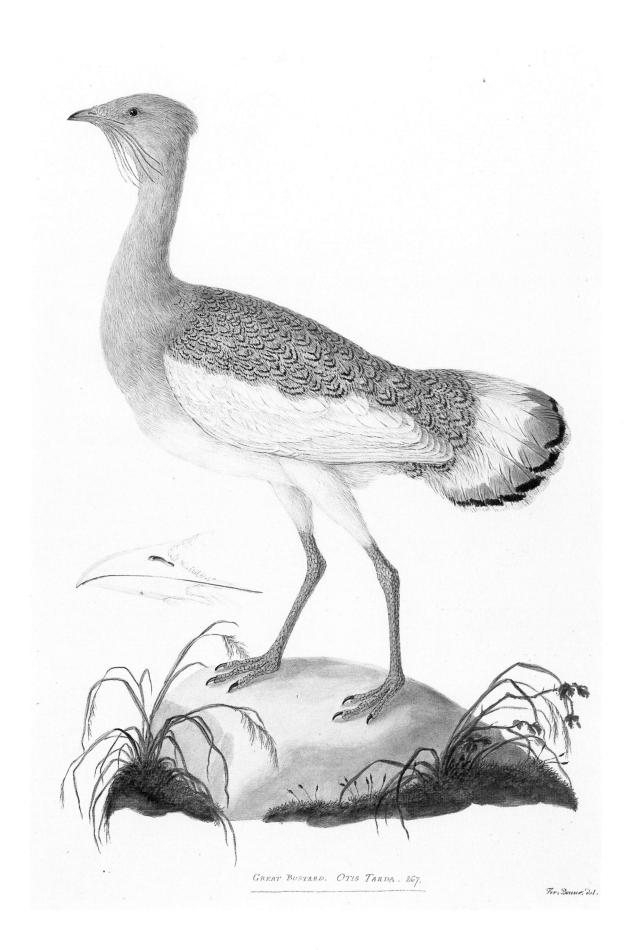

GREAT BUSTARD. OTIS TARDA. 267.

Fer: Beuck. del.

myself to accompeny Dr Sibthorp". Bauer's work stopped after the seventh title page for *Flora graeca*; the remaining three were probably all executed by William Westall, perhaps from views drawn by Imrie and not Bauer.[3] Bauer himself seems not to have completed his other landscape studies until after he left Sibthorp's employment in 1794: they were worked up for Hawkins much later (p. 100).

Nevertheless, Hawkins and Sibthorp did go back to the Mediterranean, Sibthorp leaving London in March 1794, though he was seriously ill. His condition deteriorated on the expedition when he probably contracted malaria[4] and, as a result of what appears from his letters to have been pigheadedness and overconfidence, this medically trained but headstrong man died in Bath in February 1796, not long after his return the previous autumn. His will stipulated that the rents from his estate at Stanton Harcourt near Oxford were to be used to produce the *Flora graeca*, which was to be of ten volumes, each of 100 plates, to be accompanied by a small octavo *Prodromus*. After this, £200 a year was to be used as a salary for a Professor of Rural Economy and the rest put at the Professor's disposal, while all the specimens and drawings were bequeathed to the University.

Hawkins was one of the executors of Sibthorp's will and his energies were to bring the projected publications to completion, though not until 1840, a few months before he himself died. Despite Sibthorp's earlier obstruction of Bauer's publishing animal drawings, there was no mention in the will of the *Fauna graeca*, and, except for a few annotations, only the birds received enough attention to result in any publication.[5] The bird drawings were examined by John Gould (1804–1881) when he visited Oxford in 1846 or 1847 and are now arranged according to his *Birds of Europe* (1832–37).

The executors' job was to publish Bauer's botanical drawings with accompanying text. Hawkins and the other executor, the solicitor Thomas Platt (died 1842), however, did not meet until some two years after Sibthorp's death to deal with it. Platt was to handle legal and money matters, Hawkins the production of the work. But Sibthorp had left scarcely any useable material for the books and so the executors had to find not merely an editor of his papers but someone in effect to write the books. In 1799, they settled on James Edward Smith, President of the Linnean Society, who was used to taking on gigantic but well-paid tasks such as this. Smith was to have £75 a year for *Flora graeca* from 1799 until his death in 1828: he actually received £1250. He was also to make over £2000 (approximately £200,000 today)[6] with the 3348 botanical entries he contributed to Abraham Rees's *Cyclopaedia* (1802–20) between 1807 and its completion.

All the *Flora graeca* materials were transferred to Smith's house in Norwich. For engraving and colouring the plates, Hawkins in 1799 turned to Bauer,[7] then based at "Paas Engraver [*i.e.* the German Cornelius (Charles) Paas (*ca.* 1741–1806) with Andrew Paas, engravers to the King, 1788–1790] No 53 opposite the new Turnstile Holburn [High Holborn]" in London. With a thousand copper plates to be engraved and fifty prints from each to be coloured, even with Hawkins proposing an edition of just fifty copies, the project was an enormous undertaking to contemplate. Bauer would need assistance and he had none.

By November that year, there was another factor: Sir Joseph Banks, still anxious to engage Bauer, this time for a projected expedition to Australia. Despite this, Hawkins commissioned Bauer to prepare specimen engravings for the *Flora*, also proposing, at the sugges-

PLATE 18 Purple heron *Ardea purpurea*
Watercolour by Ferdinand Bauer (*ca.* 1793), based on a field sketch made 1786–87 on John Sibthorp's first expedition to the Mediterranean (MSS Sherard 240 f. 79 ["274" on drawing], Department of Plant Sciences, University of Oxford). Previously unpublished. Found in southern Eurasia and in Africa, the purple heron is remarkable for its toes which are much longer than those of other similar-sized herons: they enable it to walk easily on floating vegetation.

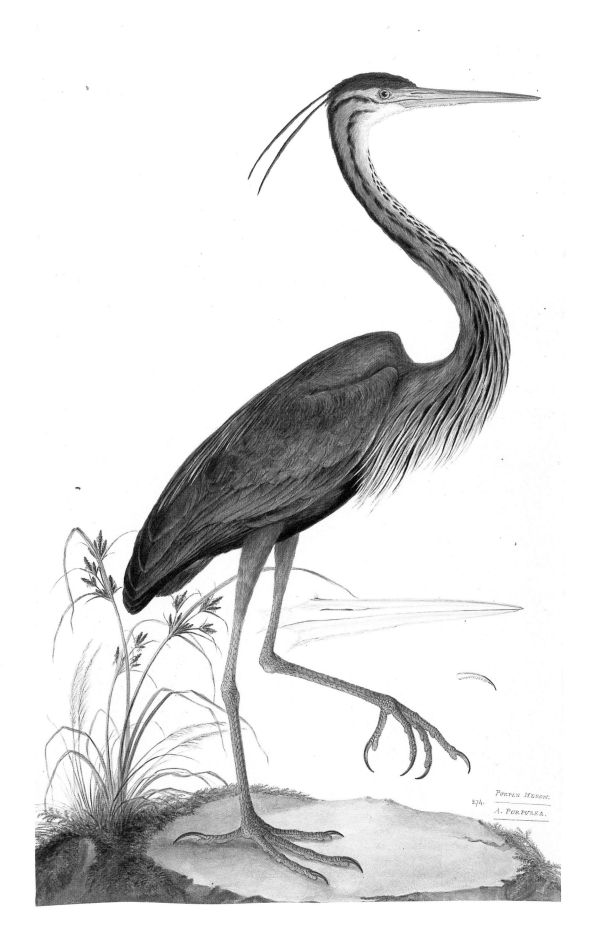

PURPLE HERON.
274.
A. PURPUREA.

35

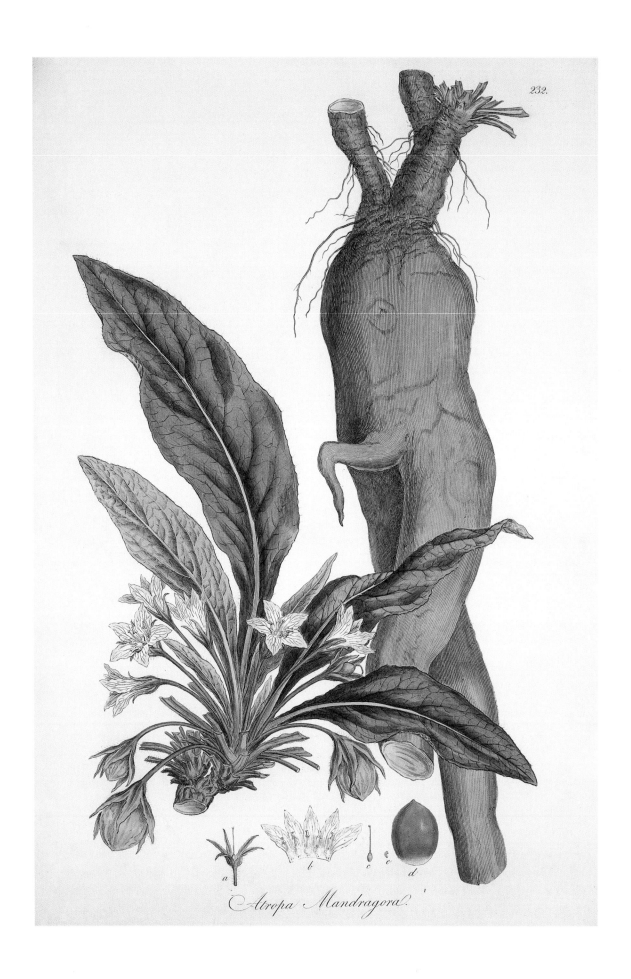

Atropa Mandragora.

tion of Banks, a second engraver to deal with the simpler subjects, but the candidate died in February 1800. Meantime, Bauer was accepting other commissions (see pp. 43–54) and Hawkins wrote to Smith later that month: "I believe if he cannot execute the Flora Graeca in the way he likes & on the terms he has proposed he will absolutely decline it … he will certainly not execute it with any other artist and will not bind himself to any time."

Although Bauer was paid seven guineas for his trial engraving, the work, perhaps not surprisingly, went to Smith's long-time collaborator, James Sowerby (1757–1822), who effectively had a firm of illustrators in his family, a business that could complete this gigantic project. Bauer had no more to do with the book.

Smith began the unillustrated *Prodromus* and, in February 1805, a prospectus for *Flora graeca* was printed, half-volumes being offered at twelve guineas each – a reflection of the huge production costs, despite the generous subsidy, of what Sibthorp had stipulated in his will. The first half-volume appeared in November. Each watercolour[8] was sent from Norwich to Sowerby in London, where it was copied, probably using a light box, Sowerby charging more for those which Bauer had not finished; the plate was engraved and a proof with Bauer's watercolour sent to Smith for corrections. Then the Latin name was added and about thirty copies of the engraving coloured for distribution in royal folio half-volumes, the proceeds from the sale of one part being used to subsidize the production costs of the next. Whilst working on the project, Smith was busy turning out many other publications, in some of which he cited Bauer's unpublished illustrations, as in his account of *Vitis* (grapes) for Rees's *Cyclopedia*.

OVERLEAF

PLATE 19 *Hypericum calycinum* L. (Guttiferae) Engraving by Sowerby (J.E. Smith, *Flora graeca*, 8, t. 771, 1835) from the watercolour (now in Oxford) by Ferdinand Bauer, based on a field sketch made on Mount Olympus in 1786. Native in south-east Bulgaria and Turkey, the plant was introduced from Istanbul in the seventeenth century and is now one of the most widely cultivated of 'ground-cover' ornamentals.

PLATE 20 Chaste tree *Vitex agnus-castus* L. (Labiatae) Engraving by Sowerby (J.E. Smith, *Flora graeca*, 7, t. 609, 1831) from the watercolour (now in Oxford) by Ferdinand Bauer, based on a field sketch made in Crete in 1786. The shrub is common in southern Europe: its twigs are used in basketry (at the site of Troy, Sibthorp noted their use in bee-skeps*) and its fruits as a pepper substitute.†

PLATE 21 Mandrake *Mandragora officinarum* L. (Solanaceae) Engraving [*Atropa mandragora*] by Sowerby (J.E. Smith, *Flora graeca*, 3, t. 232, 1819), from the watercolour (now in Oxford) by Ferdinand Bauer. A long-revered medicinal plant from southern Europe with a tuberous root which has a fancied resemblance to the human form, allegedly screaming when pulled out of the ground and deafening humans, so dogs were said to be used to do this. The plate suggests that Bauer's sense of humour may have been rather earthy. Mandrake was used as an anaesthetic before the introduction of ether (1846).*

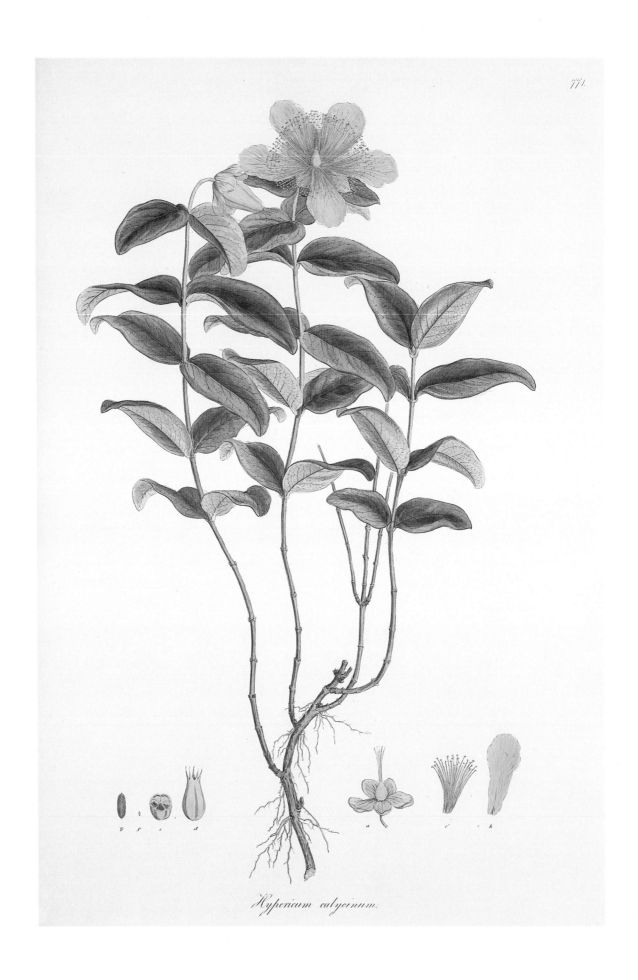

Hypericum calycinum.

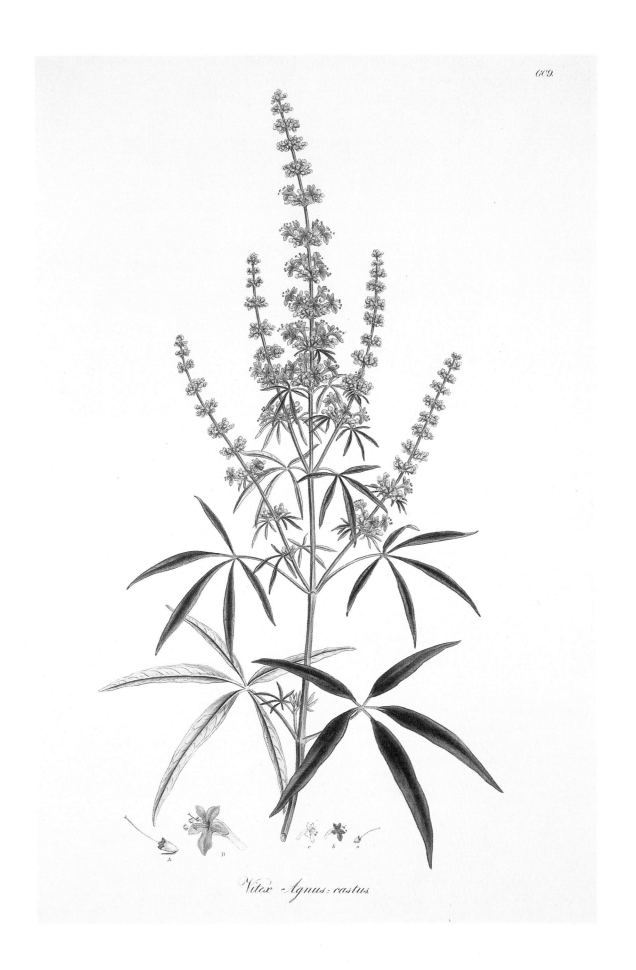

Vitex Agnus-castus.

By 1840, when the book was completed, nearly 29,000 coloured plates had been made and each copy of the book had cost about £620 to produce: the asking price was merely £254, the shortfall being paid from the rents of Sibthorp's estate.

The issue of the first part of volume 5 in January 1825 led to a celebrated court case, brought by the Trustees of the British Museum under the Copyright Act. To lose the case would have meant Sibthorp's executors would have had to deposit copies of the book in eleven libraries in the British Isles, which would have cost some £3000 just to prepare the fascicles that were already published.[9] At the rate of progress they were then making, the next fascicle could not have been issued until about 1836. In the end the Museum lost the case, the judgment holding that the fascicle was "a part of a work, to which there were twenty-six subscribers, and of which only thirty copies were printed – published at intervals of several years, at an expense exceeding the sum to be obtained by the price of the copies, and which expense was defrayed by a testamentary donation, was holden not to be a book demandable by the British Museum."

In 1825, the first 500 of the original watercolours were returned to Oxford, where they are now preserved in the Department of Plant Sciences with the rest, which followed in instalments, as well as the field sketches, the *Fauna graeca* and some of Bauer's landscape paintings. In 1828 Smith died and the work was briefly taken over by Robert Brown (1773–1858) of the Banksian Department, i.e. Department of Botany, of the British Museum. To him, such an intellectually unoriginal undertaking based on what was by then considered an archaic classificatory system, the Linnaean one championed by Smith, was extremely distasteful. Brown was internationally recognized as the scientist who had replaced it with a natural system of classification favoured on the Continent, so he was relieved to pass it on after just one fascicle. The book was completed by John Lindley (1799–1865), then Secretary of the Horticultural Society, who seems to have overcome his qualms – in any case, he certainly needed the money.

The project was wound up at the end of December 1840,[10] fourteen years after Bauer had died and almost forty-five after Sibthorp's death. The book was a great rarity, only for the rich, so it was scarcely 'published' in the modern sense. A second printing was prepared by Bohn, London, who, in 1847, offered copies of the whole book for £63. These copies are almost indistinguishable from the originals: but only about forty were issued. Many library copies of the book, though, comprise mixtures of fascicles or plates from both impressions. They very rarely appear on the market, though a copy was sold in 1962 for £3500 and, in the 1990s, one went at auction for £321,500.[11]

NOTES
1 Unless otherwise stated material drawn from Lack with Mabberley (1998) ch. 9.
2 Lack with Mabberley, p. 179.
3 Lack with Mabberley, p. 211.
4 Lack with Mabberley, pp. 149, 152.
5 Sclater (1904).
6 Mabberley (1983).
7 Lack with Mabberley, pp. 189–190.
8 Lack with Mabberley, pp. 209–211.
9 Lack with Mabberley, p. 215.
10 Lack with Mabberley, p. 226.
11 Swann (1997).

PLATE 22 Blessed thistle *Centaurea benedicta* (L.) L. (Compositae)
Engraving by Sowerby (J.E. Smith, *Flora graeca*, 10, t. 906, 1840), from the watercolour by Ferdinand Bauer, based on a field sketch made in Athens, June–July 1787. Formerly this Mediterranean thistle was used in the treatment of gout and as a tonic; its fruits yield a useful oil.*

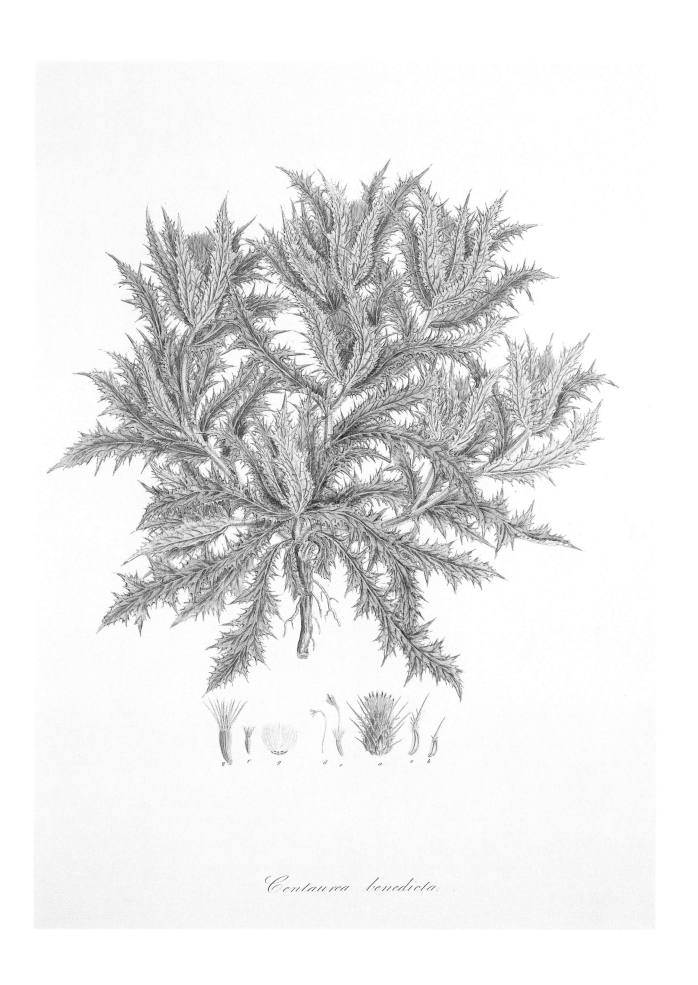

Centaurea benedicta

Tab. XXXV.

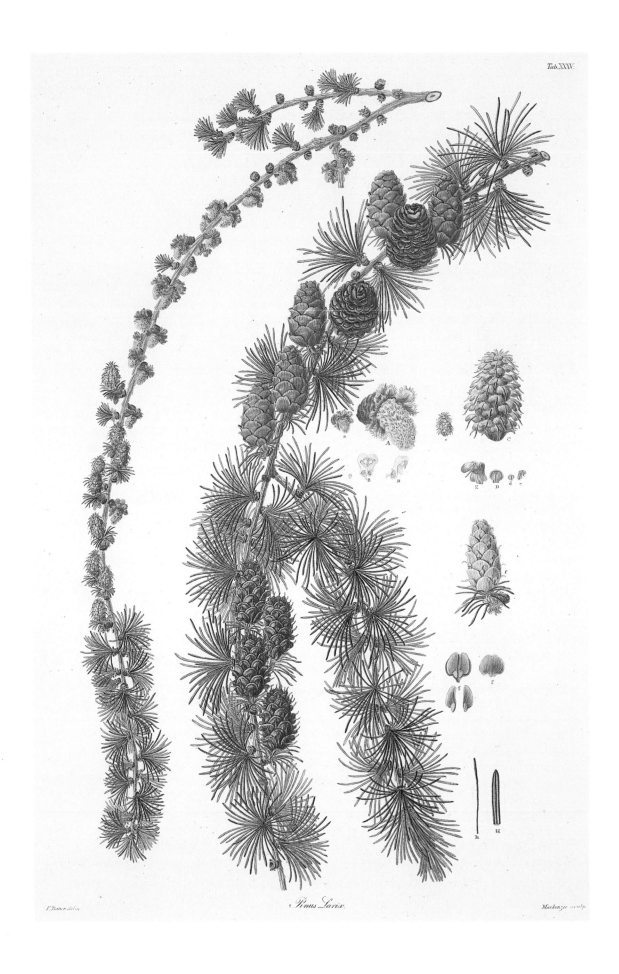

Pinus Larix.

F. Bauer delin.

Mackenzie sculp.

London
Aylmer Bourke Lambert

9 Aylmer Bourke Lambert (1761–1842)

PLATE 23 Larch *Larix decidua* Mill.
[*Pinus larix*] (Pinaceae)
Engraving by Daniel Mackenzie (A.B. Lambert, *A description of the genus Pinus*, 1, t. 35, 1803), from an original drawing by Ferdinand Bauer. Native in the Alps and Carpathians, its timber is still much used for fencing, shingles, gates and poles.

The next few years of Ferdinand Bauer's life are almost completely unrecorded: much more is known of his employers and the beautiful drawings he made. It is not known when he left Oxford to settle in London or whether he ever returned to the university city. His future was certainly in London and his contacts with Banks critical to his ensuing career.

However, he may have hoped that his private work in Oxford would bring in some money: whilst there, he had prepared a number of drawings of local scenes, but none was published. They are reminiscent of the style favoured by the Delegates of the University Press at Oxford for their almanacks, which are calendars attached to an illustration of local significance. The almanacks published from 1797 to 1814, save that of 1810, were engraved by James Basire (1769–1822): whether Bauer's drawings were ever considered is not recorded. In 1795 Edward Dayes (1763–1804) was paid for six drawings for future almanacks.[1] That for 1797 is of Magdalen Tower and Bridge, of which a pencil version with Bauerian spelling, "Magdalen Colledg, July 1794", perhaps by Bauer, is preserved with Dayes's original in the Bodleian Library at Oxford. Many of those from 1799 onwards were drawn by J.M.W. Turner (1775– 851).

Five finished Oxford views by Bauer are preserved in the Ashmolean Museum at Oxford, one of them on paper watermarked 1804.[2] They are very similar in style to the Levant views worked up, probably in London, for Hawkins at about the same time.

The successful commissions Bauer was undertaking were in London too and the most significant were for Aylmer Bourke Lambert, (1761–1842). A consideration of the life of Lambert is central to understanding the work Bauer was to do until 1801, particularly as we have so little documented of Bauer's own life. Lambert[3] was a rich collector: he was a Fellow of the Society of Antiquaries as well as of both the Royal and Linnean Societies. Before he was old enough to go away to school he had a room in his father's house, Boyton, in Wiltshire, set up as a museum. He spent much of his school holidays in Dorset with his stepmother's father, Henry Seymer, a naturalist with collections of insects, shells and fossils; Seymer was also a keen horticulturist.

While studying at Oxford, Lambert met Sibthorp. Lambert's mother was the Hon. Bridget Bourke, heir of the eighth Viscount Mayo, and at her death in 1773, Lambert inherited sugar estates in Jamaica as well as land in Ireland: on his father's death in 1802 he was to inherit Boyton House, where he extended the plantations and grew many exotic plants under glass, even experimenting with the germination of seeds taken from his herbarium specimens. Before taking over Boyton, Lambert and his wife lived in London at 26 Lower Grosvenor Street and also maintained a house in Salisbury in Wiltshire. In the country he collected plants to be illustrated by Sowerby for Smith's successful venture, *English botany*.

With ample funding, Lambert built up a botanical library and a herbarium then considered to be of international importance: after 1820 David Don (1799–1841) was librarian and curator. Among Lambert's many acquisitions were Greek plants from Hawkins, collected on Sibthorp's expeditions, and plants from Jacquin in Vienna. He was responsible for bringing to notice the most important hazel nut grown today, the filbert 'Kentish Cob', originally known as 'Lambert's Filbert'.[4] Boyton was "a curious old gabled house with delightfully irregular garden", as George Bentham (1800–1884)[5] wrote of it in 1830. Lambert, "as nervous and fidgety and laughing as much as ever", as Bentham put it, entertained, rather in the mode of Sir Joseph Banks, visiting naturalists who were allowed free access to his collections.

But the estates began to fail and, in 1836, Don, who had also been librarian to the Linnean Society since 1822 and living in its premises in London, was dismissed: he became Professor of Botany at King's College London. Lambert's wife died and his own health declined. Nonetheless, when he then retired to Kew, he held a kind of scientific salon at 10 Cumberland Place, now 300 Kew Road,[6] like that of Banks, if rather faded by comparison. Increasingly eccentric and chaotic in all his dealings, Lambert died at Kew in 1842, the American botanist Asa Gray referring to him as "the queerest old mortal I ever set eyes on". Lambert's cactus collection was presented to Kew in 1841[7] but Boyton had been entailed and, for his creditors, who got 15 shillings in the pound, the executors sold the London house and contents; his library and herbarium of perhaps 50,000 sheets were split into lots and sold at auction.[8]

It is possible that it was Lambert who commissioned Bauer to prepare illustrations of his living plants, because the plant drawings[9] attributed to Bauer in the Broughton Collection in the Fitzwilliam Museum, Cambridge, seem to have been bought up as job lots. Although all but one are now bound together as *Botanical Drawings/Ferdinand Bauer*, they have inked frames of two distinct kinds, suggesting a diverging and reconverging history since they were painted. Moreover, atypical of Bauer's work, several of the specimens are depicted growing in earth, suggesting that they were rare plants in cultivation and could not be sacrificed. Several of the drawings are of South African species and include one until recently attributed to Robert.

Bauer's greatest work for Lambert, though was for his book on conifers, *A description of the genus Pinus* (1803–24), which went into a number of editions, some of them with rather esoteric additions, these being

PLATE 24 Weymouth or white pine *Pinus strobus* L. (Pinaceae)
Named after the first Lord Weymouth, who planted it extensively at Longleat, Wiltshire,
shortly after its introduction to England, hence the French name, 'Pin du Lord';
native in eastern North America.
Engraving by Warner (A.B. Lambert, *A description of the genus Pinus*, 1, t. 22 , 1803), from an original drawing by Ferdinand Bauer of material grown at Kew, with details from herbarium specimens. The Provincial Tree of Ontario and the State Tree of both Maine and Michigan, formerly very important as a timber tree: its unavailability to the British in the American War of Independence meant that masts in the their fighting ships were of poorer quality than those of the colonists.*

Pinus Strobus.

45

10 *Exostema caribaeum* (Jacq.) Schultes [*Cinchona caribaea*] (Rubiaceae), Jesuits' bark; original drawing by Ferdinand Bauer from herbarium material sent to Lambert by Henry de Ponthieu from the West Indies in 1796.* Previously unpublished.

ing on this project as early as 1795, drawing material in Banks's herbarium.

While Bauer was working on *Pinus*, his illustrations for another Lambert commission appeared in print. Lambert was interested in many groups of plants and, like Banks, was particularly concerned about those of potential economic value for the good of Great Britain. He had prepared an account of a medicinally important group of plants, those yielding cinchona bark, the source of quinine used in the treatment of malaria, and Bauer illustrated it.

The trees in the genus *Cinchona* are native to South America, particularly the Andes. Quinine, extracted from the bark, is an alkaloid that suppresses malarial trophozoites and was of fundamental importance in maintaining a healthy European population in the colonies. Its qualities were known to the early Spanish conquerors of South America: successful establishment of cinchona plantations was to be a key factor in the efficient running of what was to become the British Empire, notably in India and south-east Asia. Even today quinine has not been entirely replaced by synthetics and still finds a market in the production of tonic water, while other alkaloids found in the bark are being examined because quinine-resistant strains of malaria are now known.

Lambert's *A description of the genus Cinchona* (1797),[10] dedicated to Banks, is illustrated with thirteen plates, engraved in mezzotint with etched outlines by J. Barlow, eight of them from originals by Bauer. They were drawn from herbarium material in the main, four from that in Lambert's own collection, four from that in Banks's. Bauer's original drawings, that is those for plates 4, 5 and 7–12, are preserved in The Natural History Museum. Lambert included work attributed to others and acknowledged his debt to the Banksian collection. He

concerned with quite unrelated novelties from his own herbarium. At the time, the genus *Pinus* was taken to include not merely the pines but also, among others, the larches (*Larix*), cedars (*Cedrus*), spruces (*Picea*) and firs (*Abies*), species of all of which were covered. The finished book was to be superbly illustrated, all but eight plates – four of those by Franz Bauer and one by G.D. Ehret (1708–1770), the others by Sowerby and John Lindley – being supplied by Ferdinand, who may have been work-

PLATE 25 *Lambertia formosa* Sm. (Proteaceae)

The mountain devil of eastern Australia. Ferdinand Bauer's own copy of the engraving by Daniel Mackenzie (*Transactions of the Linnean Society*, 4, t. 20, 1798), from Bauer's original drawing, now in the Linnean Society of London, redrawn (and "corrected from wild Specimens") from one by Sydney Parkinson (?1745–71) made at Botany Bay, New South Wales, Australia, on Cook's first voyage, and probably coloured by Bauer himself.

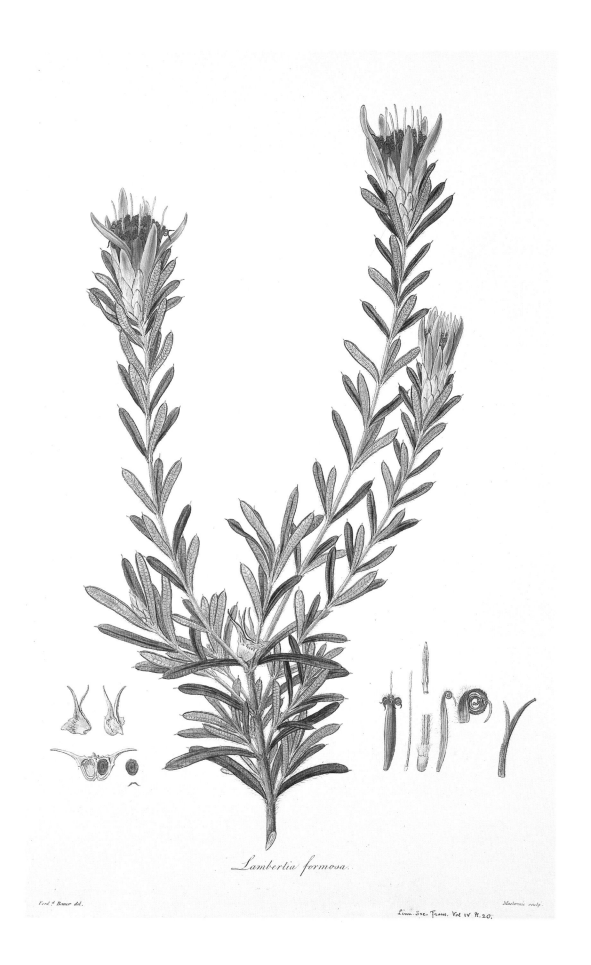

Lambertia formosa.

Ferd. Bauer del.

Linn. Soc. Trans. Vol IV A. 20.

Mackenzie sculp.

11 Hyaena poison *Hyaenanche globosa* (Gaertn.) Lamb. (Euphorbiaceae). Original drawings by Ferdinand Bauer for A.B. Lambert, *A description of the genus Cinchona*, t. 10 (1797), based on (left) a living female plant growing under glass at Walton House, Walton-on-Thames, Surrey, in 1795, and (right) a male specimen collected in South Africa by Francis Masson and sent* to Lambert in 1796–97. Previously unpublished. The mountains near Rhynsdorp, South Africa, are known as the Gift (*i.e.* poison) Bergen because this bush is so common there.

dealt with eleven species then considered to belong in *Cinchona*, though now all but two are placed in other genera.[11] Also included by Lambert, as was his habit, was an account of a new genus of quite unrelated plants, "Hyænanche: or, Hyæna poison" (Euphorbiaceae), its fruits ground up as a poison for hyaenas and other vermin in South Africa where it is native. The illustration is one of the plates engraved from a Bauer drawing, based in part on a living plant drawn in 1795 at Walton House, the home of Charles Bennet, Fourth Earl of Tankerville, at Walton-on-Thames, Surrey. The book was to be followed by Lambert's *An illustration of the genus Cinchona* (1821), with yet more extraneous additions.

Shortly after the appearance in 1797 of Bauer's first published work for Lambert, James Edward Smith gave the Australian honey-flower or mountain devil a Latin name, *Lambertia formosa*, honouring Lambert, one of Smith's vice-presidents at the Linnean Society. It was perhaps appropriate, then, that Bauer's illustration, redrawn from Sydney Parkinson's original made under Banks's supervision on Captain Cook's first voyage to the Pacific, should be used in the paper, which appeared in the *Transactions of the Linnean Society* in 1798: the original watercolour survives in the Society's archives.[12]

But it was Lambert's *A description of the genus Pinus*, like *Cinchona*, dedicated to Banks, which was to make Bauer, and Lambert, famous and to attract the memorable comment from Goethe, "It is a real joy to look at these plates, for Nature is revealed, Art concealed".[13] The book appeared in two folio volumes, the first in 1803 (57 × 45 cm, in an edition of 200), with forty-four coloured plates and three uncoloured, uncoloured copies offered at 10 guineas being available in September of that year. Coloured ones were offered later at 40 guineas: of these, twenty-five sets were coloured by William Hooker (1779–1832), a pupil of Franz Bauer. A supplement, perhaps by George Jackson (*ca.* 1780–1811), Lambert's assistant, with a description of Lambert's herbarium, was issued 1806–07. Jackson wrote most of the Latin descriptions in the first volume: Smith corrected them and generally helped Lambert with his great work. The second volume did not appear until 1824: it was larger (61 × 47 cm) and had eleven coloured plates and the text was all written by Don.

A second edition of sixty-eight plates (two uncoloured) was issued in 1828, a third in octavo in 1832, with all but one of the seventy-four plates coloured. A third volume with twenty-nine coloured unnumbered

PLATE 26 Norway spruce *Picea abies* (L.) Karsten [*Pinus abies*] (Pinaceae)
Engraving by Banks's engraver, Daniel Mackenzie (A.B. Lambert, *A description of the genus Pinus*, 1, t. 25, 1803), from the original drawing by Ferdinand Bauer of material from Painshill, Surrey. Norway spruce, native in north and central Europe, is the familiar 'Christmas tree' in Britain; its timber (white deal) was formerly much used for telegraph poles, and, because of its resonance, cellos and violins.*

Tab. XXV.

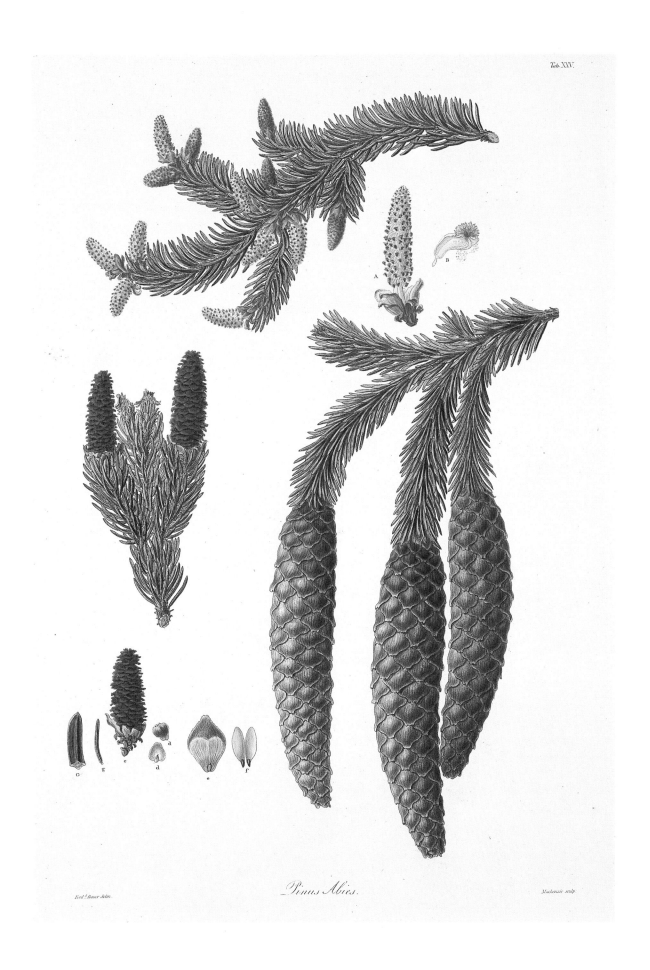

Pinus Abies.

Ferd.l Bauer delin.

Mackenzie sculp.

12 Jack pine *Pinus banksiana* Lamb. (left). Native in eastern North America, the Territorial Tree of the Northwest Territories, now used for paper pulp – original drawing by Ferdinand Bauer from material grown at Painshill, Surrey. Tamarack *Larix laricina* (Duroi) K. Koch [*P. microcarpa*] (Pinaceae) (right). Native in North America – original drawing by Ferdinand Bauer from material grown at Whitton Place near Twickenham, Middlesex, where George Campbell, sixth Duke of Argyll, had a collection of North American trees to rival Painshill. Previously unpublished.

plates was published in 1828 and in 1837–42 an edition of 103 plates (two uncoloured) comprised all three volumes; H.G. Bohn's copy offered at £90 in 1887 is that in The Natural History Museum. In 1842 James Bohn issued yet another edition, with letterpress in an octavo volume with ninety-two plates making up a second folio volume.[14] Despite the bibliographer's nightmare of copies apparently made up to order and therefore many departing from the above, Bauer's drawings have excited the most discriminating of art critics:

"The plates produce their effect of stimulus and of slight intoxication by means of their incessant repetition of minute differences and variation in structure and in ornament … What is marvellous in the *Genus*

Pinus is the play of the pine needles, wherein one soon comes to understand how it was that the Chinese *literati* evolved a whole school of artists who took for their subject nothing of more substance than the movement of bamboos. It is, also, the incredible variety of tasselling in the branches; the diversity of the pine cones; even the salubrity and pungency of the pinewoods with their therapeutic properties, as in the calm, clean air of the mountains in a hundred different lands, with the noise of the wind among the pine needles, but returning, always, to this incredible skill in their delineation where every individual needle leads its own independent life and has been given the importance of, it could be said in slight exaggeration, a sword blade by one of the great sword masters of the Far Orient."[15]

For Lambert, though, it was no financial success. He was to write to Smith in November 1803:

"I shall have only 175 copies to sell which I shall clear by eight hundred pounds, to repay me fourteen hundred pound; then I have the Drawings and the Copper plates, which I reckon at two hundred pound, so that I shall be about four hundred pounds Minus … Sir J. Banks told Dr. Whyne in my presence it was the finest work ever published …"[16]

Bauer drew some conifers from material grown at Kew, but many specimens were from other large gardens of the day, notably Painshill, near Cobham in Surrey, a famous landscape garden set out by Charles Hamilton (1704–1786). Hamilton assembled a fine collection of North American trees: in 1781 Linnaeus's son visited the garden with Banks and Daniel Solander, finding it the best collection of conifers he had ever seen.[17]

Both Banks and Smith helped Lambert select the illustrations to be engraved for the book. On 3 January

PLATE 27 *Pinus banksiana* Lamb. (Pinaceae)
Engraving by Warner (A.B. Lambert, *A description of the genus Pinus*, 1, t. 3. 1803) from the original
drawing by Ferdinand Bauer. The specific name commemorates Sir Joseph Banks.

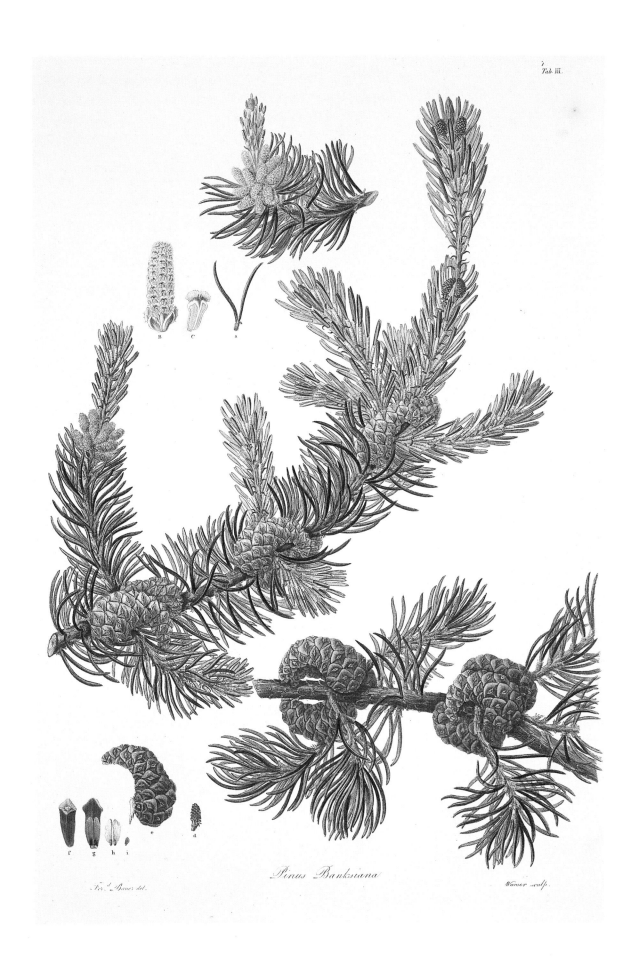

Tab. III.

Pinus Banksiana

Ferd. Bauer del.

Warner sculp.

1798 Lambert could tell Smith that he had shown Banks the "Drawings of the *Pini* which he seemed very much to approve of & has been kind enough to undertake the direction of the Engravings".[18] By 2 March 1801, he could write to Smith,

"I should have sent you plates of all the Pines ... but am waiting till Warner [the engraver] has finished the last two plates which he has now got ... I long to shew you the plate of the *Pinus sylvestris* ... I paid Warner twelve Guineas for the engraving of it. Nothing I believe can be much better finished. Sir J. was much pleased with it ..."

Bauer kept his original drawings and, at his death, his brother Franz inherited them. On bankrupted Franz's death in 1841 they were sold at the auction of his effects, which, as lot 157, included twenty sets of Ferdinand's drawings, and were bought by Robert Brown for 18 shillings: they are now preserved in The Natural History Museum. Even a missing illustration – referred to by Lambert, who wrote, "For want of sufficient materials, I have not been able to complete the drawing of [*Prumnopitys taxifolia,* a conifer from New Zealand], the figure of which is therefore necessarily omitted"[19] – has recently come to light in Australia.

Besides re-drawing the Sydney Parkinson *Lambertia,* an illustration then in Banks's hands, Bauer had also been working directly for Banks. He engraved *Erica banksia* from Franz's original to be published in Franz's *Delineations of exotick plants cultivated in the royal garden at Kew* (1803, t. 29). In 1790, Margaret Meen had started a similar venture with her *Exotic plants from the royal garden at Kew,* a folio work stopped after just two issues of four plates each.[20] Under Banks's auspices, the new book was being brought out by William Townsend Aiton (1766–1849),

head gardener at Kew, and was intended to appear in annual instalments, each of ten plates. The first part was published in 1796 but, with the third in 1803, it ceased, partly because it sold at a loss and perhaps because the principal engraver, Daniel Mackenzie died.[21] Thus the book, which is a broadsheet volume, comprises merely thirty plates, all of them figuring heathers from the Cape. Banks had written the dedication to Queen Charlotte (though the text is attributed to Aiton in the book) and probably the preface[22] of *Delineations.* And it was Banks who was now to precipitate Ferdinand into the adventure for which he is justly most famous – as natural history painter on Matthew Flinders's circumnavigation of Australia.

NOTES

1 Petter (1974), pp. 80 *et seqq.*
2 Lack with Mabberley (1998), p. 108.
3 Miller (1970); Henrey (1975), II, pp. 34–36; Stafleu & Cowan (1979), pp. 736–37.
4 Roach (1985), p. 232.
5 Jackson (1906), p. 70.
6 Renkema & Ardagh (1930).
7 Desmond (1995), p. 157.
8 Miller (1970).
9 Scrase (1983, tt. 4–7; 1997: 96, t. 45).
10 Henrey (1975), II, p. 33.
11 Andersson (1998).
12 Mabberley & Moore (1999).
13 Sitwell & Blunt (1990), p. 37.
14 Symes (1988).
15 Sitwell & Blunt (1990), p. 19.
16 Renkema & Ardagh (1930).
17 Symes (1988).
18 Renkema & Ardagh (1930).
19 Mabberly & Moore (1999).
20 Henrey (1975), II, p. 33.
21 Desmond (1995), pp. 110–11.
22 Henrey (1975), II, pp. 253–54.

PLATE 28 *Erica banksia* Andr. (Ericaceae)
Engraving (Franz Bauer, *Delineations of exotick plants,* t. 29, 1803) by Ferdinand Bauer from an original drawing by Franz Bauer, made of a plant grown at Kew, introduced to England in 1787 by Francis Masson, Kew's first paid collector. From the third part of Sir Everard Home's copy: only 50 copies of this part were produced.*

Frane. Bauer del.

Erica Banksii.

Ferd. Bauer sculp.

53

Fer? Bauer. del:

Australia

Matthew Flinders and Robert Brown

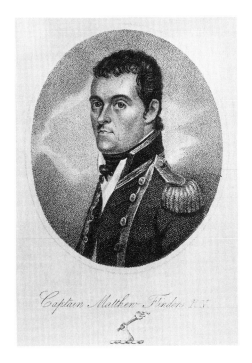

13 Matthew Flinders (1774–1814)

PLATE 29 Winged wattle *Acacia alata* R. Br.
(Leguminosae)
Watercolour by Ferdinand Bauer (Australian Botanical
Drawings 38). Previously unpublished. Herbarium
specimens were collected at Observatory Hill, Princess
Royal Harbour (*i.e.* Albany), December 1801; seeds col-
lected by Peter Good germinated at Kew, where the
resultant plants flowered in 1806.*

Having failed to secure Ferdinand Bauer's ser-
vices for an expedition to the West Indies, Sir
Joseph Banks was to have him employed by the
British Admiralty to travel to the Pacific. On 15 May 1798,
Banks wrote to the Colonial Office about "Terra
Australis".

"It is impossible to conceive that such a body of land
as all Europe does not produce vast rivers capable of
being navigated into the heart of the interior; or if
properly investigated, that such a country, situated in a
most fruitful climate, should not produce some native
raw material of importance to a manufacturing coun-
try such as England is." [1]

Banks had sailed with Captain Cook on his first Pacific
voyage of 1768–71 and had collected on the newly dis-
covered eastern coastal fringe of "New Holland" in
1770. It was Banks who was to promote the settlement
of New South Wales, as Cook had named it, his pro-
motion leading to the establishment of a penal colony
at Sydney Cove in 1788. In a few years Banks was press-
ing for an expedition into the interior, an expedition
with Mungo Park as naturalist and with a small ship with
a moveable rudder permitting river navigation under the
command of his countryman, Lieutenant Matthew
Flinders, then already in New South Wales.

By 1800, Flinders was back in England, suggesting to
Banks that there should be a major survey of New
Holland, an idea already in Banks's mind. The combin-
ing of the survey and Banks's wish for a collecting expe-
dition led to the circumnavigation of Australia in the
Investigator, with Flinders as commander. No doubt the
British government's support for this ultimately had a
military motive. The rivalry between France and Britain
was such that many "voyages of exploration" were in fact
covers for strategic positioning. Before Cook's first
voyage, the French had sent an expedition to the Pacific
and there were to be more after his subsequent two
voyages between 1772 and 1780. With the rise to power
of Napoleon Bonaparte after the French Revolution,
tension was acute in a Britain bracing itself for invasion
by 'Boney'.

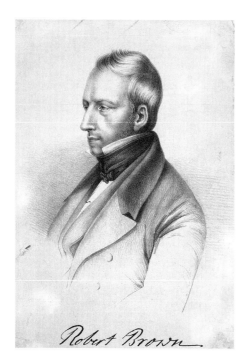

14 Robert Brown (1773–1858)

Extraordinarily, the "voyages of exploration" were treated as if they were purely scientific ventures, the opposing powers granting one another passports for expedition vessels. In April 1800, the British Admiralty learnt that a French expedition of twenty-two scientists including four botanists, four zoologists, three gardeners and two artists under Nicolas-Thomas Baudin (1754–1803) was to collect, among other things, the "vegetable productions" of New Holland. Napoleon had in fact ordered Baudin to find out whether there were British settlements in Tasmania (Van Diemen's Land) and to survey Bass Strait, which Bass had discovered with Flinders, and the south-west and north coasts of New Holland. In October, the French set sail for the Pacific and, playing on anti-French sentiment and the ancient rivalry, Banks got what he wanted: an exploring expedition with Flinders as commander was approved by his friend Earl Spencer, First Lord of the Admiralty.

Banks set about selecting the scientific team, one very modest indeed by comparison with that of the French. In inviting the Scottish botanist, Robert Brown (1773–1858), then an army surgeon, who had visited Banks's herbarium when on leave in England, but was now back in occupied Ireland, Banks wrote:

"Sir, a ship is this day ordered to be fitted out, for the purpose of exploring the natural history (and many other things) of New Holland, & it is resolved that a naturalist & a Botanic Painter shall be sent in her … the voyage will I conclude last 3 years at least."

Banks first settled on William Alexander (1761–1816), draughtsman on Sir George Staunton's diplomatic mission to China (1792), as expedition artist but Alexander eventually declined because of his wife's health. Banks then turned to Bauer, now out of the *Flora graeca* project, and offered him £300, later increased to 300 guineas a year. With a good salary at last, Bauer was able to make arrangements for some of it to be used to help some of his relations still in Austria.[2] He was to be under the orders of the naturalist, Robert Brown, himself actually also a replacement – for Mungo Park, who had declined because of a love affair. Bauer was natural history painter; as landscape artist, the roles separated this time, Banks chose William Westall (1781–1850), yet another second choice after Westall's sister's fiancé, William Daniell (1769–1837), had also declined because of a woman.

Flinders was to survey the southern and northern coasts of Australia and to determine whether it was a group of islands or one vast continent. Like Cook's *Endeavour*, his expedition ship had been built at Whitby. Originally a collier, the *Fram*, she was bought by the navy in 1798, re-named *Xenophon* and pierced with gun ports which weakened the hull. Now re-named *Investigator*, she was fitted, at Sheerness, with a 'Garden Room' for living plants, according to orders made in January 1801. Flinders, as if with a premonition, had the recoppered hull strengthened because he was very concerned about the vessel's seaworthiness.

Bauer and Brown had cabins on the quarterdeck with the commander and warrant officers, as did Westall and the "mineralist", John Allen. Allen, Brown's geological assistant, was "a practical miner" recruited through Banks's family connections in Derbyshire, and had a cabin as did the astronomer, who was responsible, like Westall, directly to Flinders. Brown's other assistant, a

gardener called Peter Good, and Brown's, Westall's and Bauer's servants "to keep their Cabins clean, brush their Cloaths" were with the rest of the crew below decks. According to *The Times* of 27 June 1801:

"The Investigator (late Xenophon), ordered to Botany Bay on a voyage of discovery, is expected to sail from Portsmouth the first fair wind. She is admirably fitted out for the intended service, and is manned with picked men, who are distinguished by a glazed hat decorated with a globe, and the name of the ship in letters of gold."

The ship had food, including livestock, for a year and a half, presents for the Aborigines, a library and a working collection of dried plants made on earlier voyages.

But there were delays. The French withheld a passport and Bauer, with Brown and Westall, did not reach Portsmouth by coach to meet their servants and board the vessel until 14 June. There were yet more delays and so Bauer and Brown collected plants in Hampshire and on the nearby Isle of Wight. At last on 18 July 1801, Brown could write in his diary, "At 11 got under way".

Ominously, after five days at sea, the leaky *Investigator* was shipping water, but on the last day of the month, the crew sighted the Azores and Flinders caught a small turtle. Bauer drew it, using his colour chart, which, if like Boccius's, must have had up to 1000 shades on it, to encode its coloration, and Robert Brown measured its rectal temperature as 84° F. Next day a rowing trip of five and a half hours brought Bauer and Brown to Bujio, the southern Deserta, for just three-quarters of an hour ashore before six hours' rowing back. Four days later they were anchored off Madeira, but even there Bauer and the rest of Brown's party had only uncomfortable excursions on the island, one night being "much disturbed by fleas and bugs". Most of their collections and sketches were lost when their boat back to the *Investigator* was swamped, though at least some sketches by Bauer, including one of a bramble, survive today in Vienna.[3]

During the voyage south to the Cape, where the ship was to be revictualled, Bauer prepared drawings not only of the birds shot but also the lice they carried, while Brown examined the ship's herbarium collection. At the Equator, Brown noted that they "cross'd the line with the usual ceremonies", while Peter Good wrote in his diary, "the usual ceremony of shaving was performed and some very laughable incidents occurred". Bauer was a good sailor: he could write to his brother Franz from the Cape, "I found that from the time I first set foot on the ship till this moment I have not felt the slightest touch of any sea sickness".[4]

The *Investigator* anchored at Simonstown in the Cape. Bauer with Brown, Good and Allen set foot on the African mainland on 17 October and "collected a great variety of fine plants some insects and minerals … returned on board about 6 p.m. loaded", as Good put in his diary. Bauer wrote from ship to his brother Franz at Kew Gardens:

"I have hopes that we will stay here for some time because the ship requires extensive repairs and I am sorry to say that throughout the entire voyage so far we seldom had a dry cabin because water was coming in everywhere through the sides of the upper-middle deck despite the fact that during this time we were not exposed to any great storm."[5]

Over the next few days, Bauer did not go on land and must have been occupied with drawing the botanical haul being brought on board. He wrote to Franz, "The mountains, however, which are for the most part large sand hills are covered with the most beautiful blooms, of these I wish I could send you in England all the orchid types which I have seen so far". On 24 October[6] he accompanied Brown's party to Cape Town, Good writing in his diary, "Each carried provisions and a large tin box for specimens etc. – we missed our way and it rained considerably". They were taken in at Tokay where they spent the night. Next day, as Good continued:

"Set out early in the morning & passed Constantia … We then ascended a range of mountains called Stein Berg adjoining Table Mountain and passed ridge after ridge till about 5 PM we got very near the summit of the Table – but it now came on a thick fogg and rain –

Orchideæ. Ophrydeæ (fixa)

Bartholina pectinata Lindl.

Ferd. Bauer del. Gebhart in (40)

15 Spider orchid *Bartholina burmanniana* (L.) Ker (Orchidaceae) Lithograph [*B. pectinata*] by Gebhart (S. Endlicher, *Iconographia generum plantarum*, t. 40, 1838), from an original pencil drawing by Bauer, probably based on material he collected between Cape Town and Muizenberg, South Africa, 28 October 1801.

Bauer did not join the second successful ascent to the summit of Table Mountain that Brown and Good made on 27 October but wended his own way back to the *Investigator*. Unfortunately he arrived too late to go on board and had to spend the night in a tent on the wharf. On Table Mountain, Brown recorded thirty orchid species; among the plants Bauer drew was a spider orchid, *Bartholina burmanniana*, that he himself collected between Cape Town and Muizenberg on 28 October. Although he made seventy-nine plant sketches at the Cape,[7] this was to be his only African plant drawing ever published, and, even then, it was long after Bauer's death, by the Austrian botanist Stephan Endlicher (fig. 15).

Bauer wrote to his brother Franz on 3 November, the day before the ship left for Australia:

"It has been decided to depart for King Georges Sound, New Holland. I must admit, however, that I am not happy to be leaving this area so soon because of the great number of beautiful things which could be found here if one had more time to look for them. Our journey over the foot of Table Mountain to Capetown was rather arduous but I am glad I undertook it because we saw much that was beautiful in the way of botany above all the Orchides, Proteas and much else …"[8]

we had not long to consider our situation till we fell in with a small path — we followed and soon arrived at the opening of the mountain down to Cape Town — here we consulted whether to remain all night and examine the mountain in the morning and save ourselves the trouble of again ascending it but we had little provisions and it continued to rain we all descended and arrived in the Town about 9. We enquired for the English Coffea [*sic*] house where they behaved to us with much civility & procured us lodgings where we were well accommodated at a reasonable price."

They made 140 miles a day to Amsterdam Island and then 158 miles a day to Australia, Brown noting on 6 December the first sighting of the continent, Cape Leeuwin, south of today's Margaret River wine-growing area in the south-west of Western Australia.

There had never been such a concerted effort at scientific collecting and recording of the plants of Australia. The expedition had arrived in the floristically richest part of the whole continent, the south-west botanical province of present-day Western Australia, with a huge,

PLATE 30 *Cosmelia rubra* R. Br. (Epacridaceae/Ericaceae)
Watercolour by Ferdinand Bauer (Australian Botanical Drawings 93). Previously unpublished.
Collected at King George Sound, Western Australia, December 1801. Restricted to south-west
Australia, it is the only species in its genus.

rich flora of perhaps 8000 species with perhaps 20% of them still undescribed today:[9] when they arrived fewer than four hundred species from the whole continent had been described. Although a few dozens had been illustrated, Bauer had much original work before him. The *Investigator* sailed on to King George Sound, near present-day Albany, where Flinders anchored between 11 and 12 p.m. on 8 December 1801. The very next day, Bauer, Brown and Good were among those to go on land and, as Peter Good wrote in his diary:

"Collected many specimens and Some Seeds — we were much at a loss for water this days excursion this being a sandy rocky barren headland aptly enough named by [Captain George] Vancouver [in 1791] Bald Head — we returned to the Beach to a place separated from where we had landed by a mass of Bare Granite rock very steep — it being dark the Gentlemen did not choose to cross to the Boat which came for us ... they thought it hazardous & remained on the shore all night by a good fire Many of the officers & men had eat of the flesh of seals caught in morning & most of them were sick from it."[10]

Brown and Good made many excursions on land, but Bauer seems to have been largely confined to the ship, drawing the plants as they were brought on board. In their three weeks there, they met the local people who refused their presents, but, when Flinders ordered the marines to be exercised in their presence, he wrote, "When they saw these beautiful red-and-white men, with their bright muskets, drawn up in a line, they absolutely screamed with delight".

The naturalists amassed some five hundred species of plants but it was arduous work, for a seven-day week was the navy's rule at that time. On Christmas Eve they were collecting in the burning sun and Bauer succumbed to sunstroke, Brown recording, "Mr Bauer quite exhausted and seem'd unable to proceed", Good recorded more fully:

"Mr Bawer [*sic*] was so much overcome with fatigue and want of water that he could not proceed ... Mr

Bawer having rested awhile we again proceeded intending at any rate to search some water if possible of which we were so much in want — but he was frequently obliged to sit down — we could find no water till about midnight we arrived on the Beach & soon came to known spring which was drank with delight — we then proceeded to the Tents where we slept sound till morning."[11]

Flinders was to write later:

"Amongst the plants collected by Mr Brown and his associates, was a small one of a novel kind, which we commonly called the pitcher plant. Around the root leaves are several little vases lined with spiny hairs, and these were generally found to contain a sweetish water, and also a number of dead ants. It cannot be asserted that the ants were attracted by the water, and prevented by the spiny hairs from making their escape; but it seemed not improbable, that this is a contrivance to obtain the means necessary either to the nourishment or preservation of the plant."

This was the carnivorous *Cephalotus follicularis*, which was discovered in flower by Bauer with Westall on New Year's Day 1802. The "little vases" indeed secrete enzymes that break down protein but contain living larvae of a gadfly resistant to the secretion. On 2 January, Good brought fresh material to the ship: his living collection amounted to nearly seventy species.

The *Investigator* sailed east to Lucky Bay, the Archipelago of the Recherche and the "perpendicular cliffs of whitish stratified stone" of the Great Australian Bight. Fish were caught from the moving ship with Flinders noting:

"With the shells, sea weeds, and corals, they furnished amusement and occupation to the naturalist and the draughtsman, and a pretty kind of hippocampus [seahorse], which was not scarce, was greatly admired."

In the Archipelago of the Recherche, on Mondrain Island, Flinders discovered the Black-footed rock-wallaby,

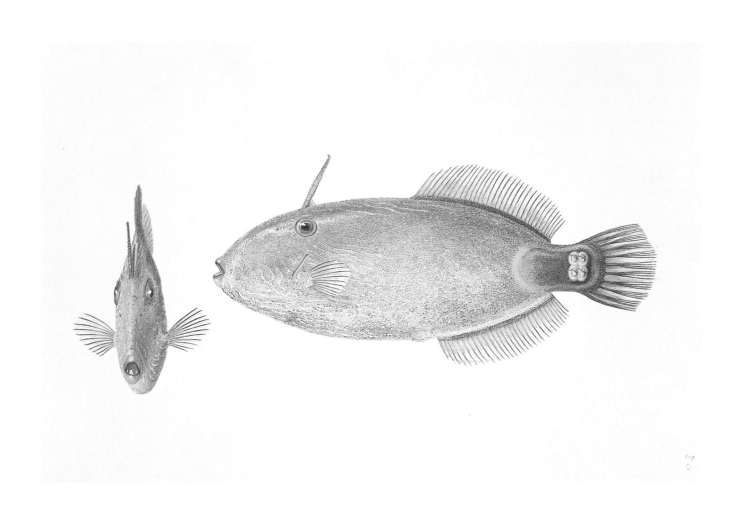

PLATE 31 Brown's leatherjacket *Acanthaluteres brownii* (Richardson)
caught in Princess Royal Harbour (*i.e.* Albany), Western Australia, 16 December 1801.
Watercolour by Ferdinand Bauer (Zoological Drawings 34), from which the species was described,
so that his drawing is the type 'specimen' of the species name. The fish is found only in southern
Australian waters east to Kangaroo Island, South Australia.

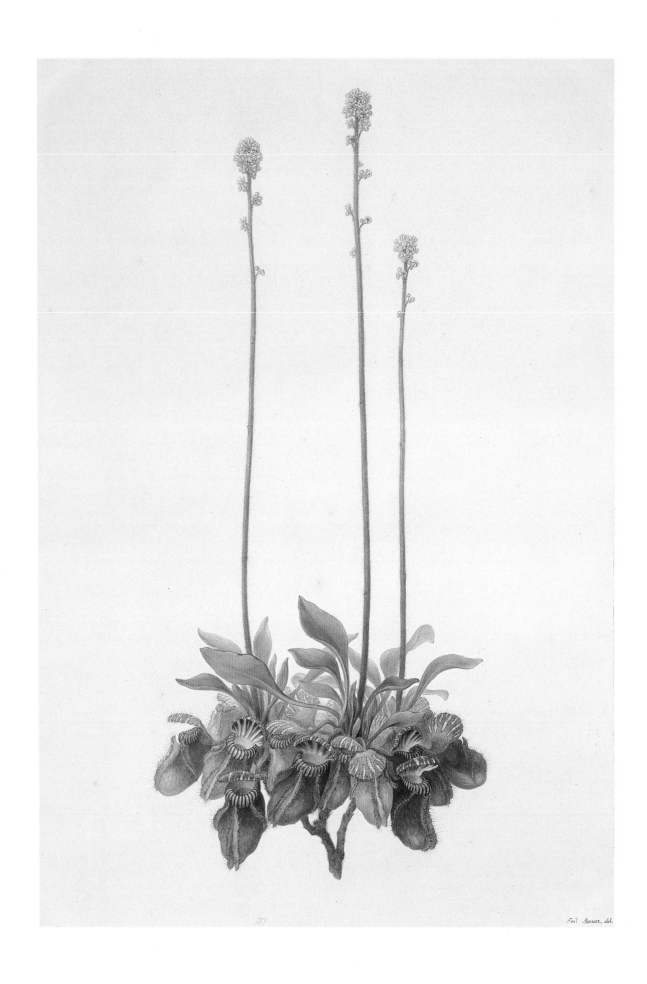

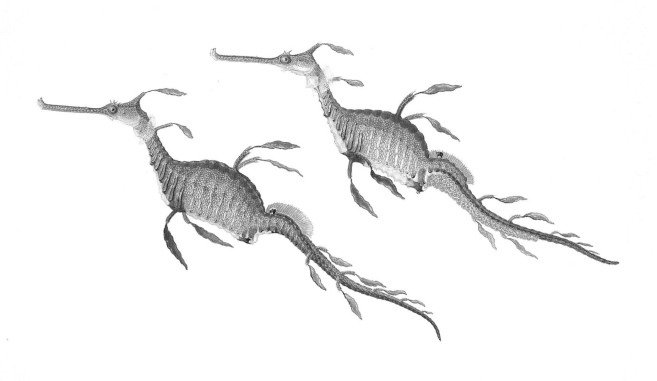

PLATE 32 Seadragon *Phyllopteryx taeniolatus* (Lacepède)
caught at King George Sound in December 1801.
Watercolour by Ferdinand Bauer (Zoological Drawings 48). First collected by Sir Joseph Banks on
Cook's first voyage, this seadragon is found in southern Australian waters north to Newcastle, New
South Wales.

PLATE 33 Western Australian pitcher-plant *Cephalotus follicularis* Labill. (Cephalotaceae)
Watercolour by Ferdinand Bauer presented to the Admiralty in 1806 (Australian Botanical Drawings
41A).* This carnivorous plant was discovered at King George Sound, Western Australia, by
Ferdinand Bauer and William Westall on New Year's Day 1802. It is restricted to peat swamps near
Albany west to near Augusta, Western Australia. The pitchers act as pitfall traps for prey: the
flowers are borne so far above them that pollinators are unlikely to fall victim too.

16 Southern pygmy leatherjacket *Brachaluteres jacksonianus* (Quoy & Gaimard) (Monacanthidae). Pencil drawing of fish's head by Ferdinand Bauer (Australian Zoological Drawings 31) perhaps made from a specimen caught at Petrel Bay, St Francis Island, Nuyts Archipelago, South Australia, 4 February 1802. Previously unpublished. Another Bauer drawing of this fish was the sole basis for *Aleuterius baueri* ('Bauer's leatherjacket'), a species not now considered distinct but described in 1846, when the drawing was in the hands of Robert Brown. The fish is common in the coastal waters of southern Australia.

Petrogale lateralis hacketti, restricted to the Archipelago. Bauer drew a specimen shot on 13 January; then it was dissected, probably by Brown, and the revealed skull added to Bauer's drawing. By 29 January they were at Fowlers Bay, South Australia, where they "caught a small quadruped genus unknown", the barred bandicoot, which Bauer sketched, but the four months they were to take to reach New South Wales were the most unsuitable part of the year for botanizing. Of St Francis Island in the Nuyts Archipelago, Flinders wrote:

"The heat indeed was intense, the vegetation being mostly burnt up … such as to make walking a great fatigue: and this was augmented by frequently sinking into the bird holes [mutton birds] and falling upon the sand. The thermometer stood at 98°[F] in the shade."

Brown noted another hindrance, "a species of grass probably a Bromus with rigid pungent leaves added to our distress in crossing the island".

It was probably at Petrel Bay, where they caught a fish, which Bauer drew, his finished watercolour being the basis for the species *Brachaluteres baueri,* now known to be the Southern pygmy leatherjacket, *B. jacksonianus.*[12] Next day Flinders noted of Bauer and Brown, "The great heat deterred the naturalists from going on shore this morning, for the very little variety in the vegetable productions presented no inducement for the repetition of their fatigue". It was so hot that the flesh of kangaroos shot for food rotted after a few hours, for the temperatures rose above 125° F.

In his later writings, Flinders named all the capes and inlets further east, including Cape (*i.e.* Point) Brown, Cape Bauer, Point Westall and the Investigator Group. They were anxious to discover whether the continent was in fact separated into islands and, as Flinders wrote:

"Large rivers, deep inlets, inland seas, and passages into the Gulph of Carpentaria, were terms frequently used in our conversations … and the prospect of making an interesting discovery, seemed to have infused new life and vigour into every man in the ship."

However, on 21 February, a cutter with its crew of eight was lost and Flinders named the area Memory Cove as a tribute to the dead men. But scientific work

PLATE 34 Black-footed rock-wallaby *Petrogale lateralis hackettii* (Gould) (Macropodidae) Watercolour by Ferdinand Bauer (Australian Zoological Drawings 13) of an animal shot on Mondrain Island, Archipelago of the Recherche, Western Australia, 13 January 1802. This subspecies is restricted to the Archipelago; the species as a whole is widespread in mainland Australia.

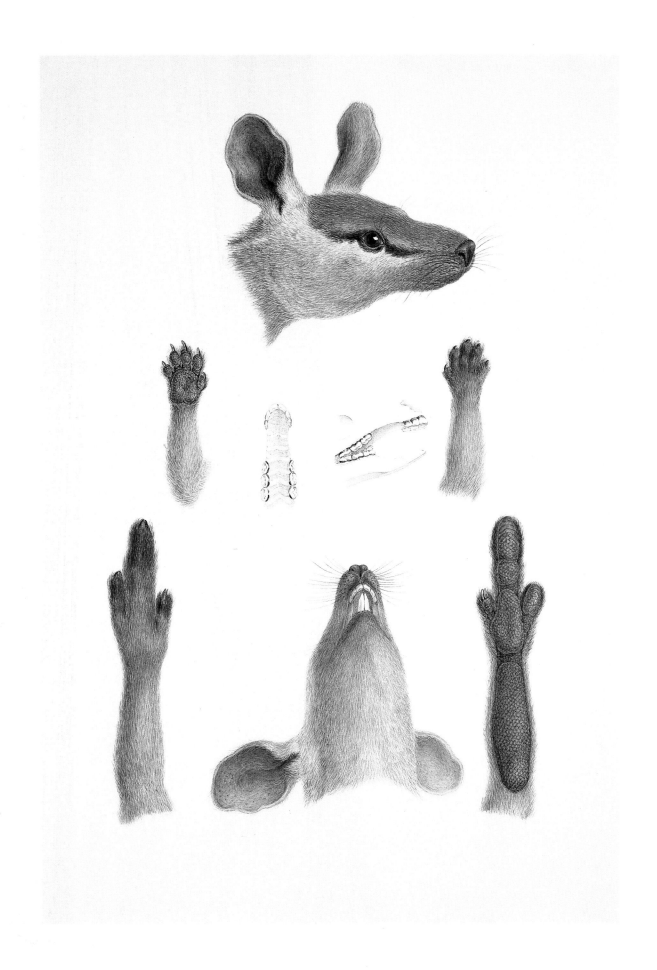

continued: a Port Lincoln parrot was shot and Bauer sketched it. After Port Lincoln, the ship entered Spencer Gulf. At its head, near present-day Port Augusta, Bauer, Brown, Westall, Good and their companions set off, wading through a mile of boggy salt-marsh for a trek of 15 miles across the coastal plain, to climb to the summit of what Flinders was later to call Mount Brown.[13] The naturalists reached the top of the mountain at dusk and had to spend the night there, while their weary servants bivouacked below.

On 21 March, the expedition discovered Kangaroo Island, south-west of present-day Adelaide, and the crew set about slaughtering the animals for food, with Flinders recording:

"I had with me a double-barrelled gun fitted with a bayonet, and the gentlemen my companions had muskets. It would be difficult to guess how many kangaroos were seen; but I killed ten, and the rest of the party made up the number to thirty-one, taken on board in the course of the day ... After this butchery, for the poor animals suffered themselves to be shot in the eyes with small shot, and in some cases to be knocked on the head with sticks ... the whole ship's company was employed this afternoon, in skinning and cleaning the kangaroos; and a delightful regale they afforded, after four months privation from almost any fresh provisions. Half a hundredweight of heads, fore quarters and tails were stewed down into a soup ... and as much steaks given, moreover, to both officers and men, as they could consume by day and night."

Fortunately, the kangaroo, among the least agile species known, is now preserved in Flinders Chase, a reserve, though the Kangaroo Island emu (*Dromaius baudinianus*) there then is now extinct. Not only did the animals suffer: the vegetation was altered, for Peter Good diligently planted seeds of exotic crops including oranges and lemons, melons, lettuce and spinach.

On 8 April 1802, the *Investigator* met *Le Géographe* of the French expedition and Flinders's discoveries on this coast came to an end at what Flinders named Encounter Bay, just south of present-day Adelaide. On 23 April, the *Investigator* crew landed on King Island (north-west of Tasmania), which Flinders had discovered in 1799, though the French missed it. Three days later the *Investigator* was grounded on a shoal in Port Phillip near present-day Melbourne. The "gentlemen", the first botanists in what is now Victoria, made several collecting excursions. Bauer found an Aboriginal club he was to keep for the rest of his life and, with Good and Allen, botanized on the Mornington Peninsula in the vicinity of present-day Sorrento, now Melbourne's most fashionable beach resort. On 30 April, a Rainbow lorikeet was shot there and Bauer sketched it.

There were no inland seas or channels linking the south coast with the Gulf of Carpentaria and Flinders pressed on to Port Jackson (Sydney Harbour) before the winter storms could begin and his supplies run out. The *Investigator* anchored in Sydney Cove (near today's Circular Quay) just after 3 p.m. on 9 May 1802.

They were to be based in Sydney for well over two months: the second part of the French expedition, on *Le Naturaliste,* was already moored in the harbour. The fourteen-year-old penal settlement now had about 6000 inhabitants: Peter Good recorded his impressions of the town:

"It has a fine appearance. It is seated at the end of a Snug Cove on a piece of ground which Slop[e]s in three directions, the centre Slop[e]s to the Sea & each Side slop[e]s to the Centre with a gentle declivity to the Sea at the same time. Each house has a considerable space of Garden ground so that the Town spreads over a great space — there is nothing grand or magnificent in the construction of any of the Buildings of the Town yet there is a degree of neatness & regularity which has a fine effect. Several of the principal houses are built with Brik and white washed others with wood painted, they are all covered with wood cut in the form of Tiles which very much resembles Slate."[14]

There was now an opportunity to write letters back to England, Flinders reporting, "It is fortunate for science that two men of such assiduity and abilities as

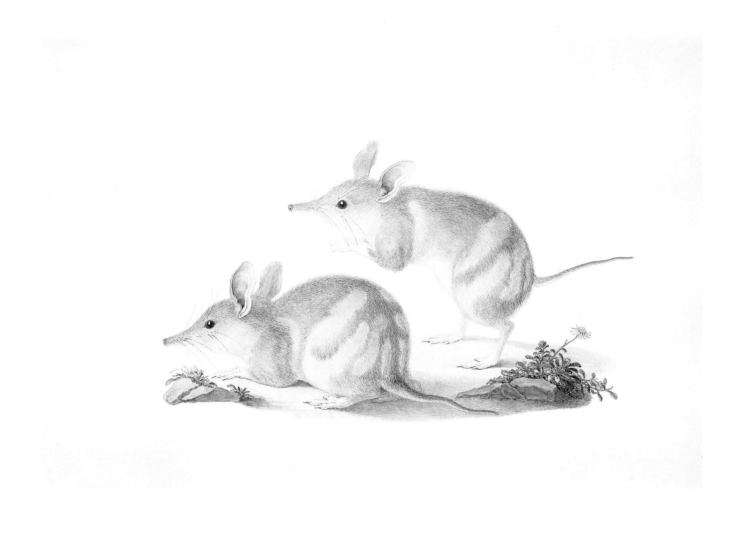

PLATE 35 Western barred bandicoot *Perameles bougainville* (Quoy & Gaimard)
Watercolour by Ferdinand Bauer (Australian Zoological Drawings 3), based on field sketches of an
animal shot at Fowlers Bay, South Australia, 28–29 January 1802. Formerly found over much of the
southern Australian mainland, it is now restricted to just two islands in Sharks Bay,
Western Australia.

17 *Rubus parvifolius* L. Lithograph by C. Neunlist
(S. Endlicher, *Atakta botanica*, t. 35, 1835) redrawn
as *Rubus zahlbrucknerianus* Endl., from a field
sketch by Ferdinand Bauer, possibly made in the
Sydney area, May–June 1802.

Mr Brown and Mr Bauer have been selected: their appli-
cation is beyond what I have been accustomed to see".

Brown could report to Banks that of the 750 species
of plant he had collected, about 300 were new to sci-
ence and that Bauer "has indeed been indefatigable & has
bestowed infinite pains in the dissections of the parts
of fructification of the Plants". And Bauer wrote to his
brother Franz:

"Although the season for plants in bloom had almost
passed in New Holland, I nevertheless made 350
sketches of plants besides 100 sketches of the animal
kingdom during this time. We should have considered
ourselves fortunate to have completed this part of the
journey which in several places, especially between the
islands, is very dangerous As far as I am con-
cerned, although we are exposed to great heat and
great fatigue in the course of our land excursions, I
am nevertheless in good health and spirits. ..."[15]

Excursions were made in the Sydney area, one, at least,
with Jean Baptiste Leschenault de la Tour (1773–1826) of
the French expedition. Bauer with Brown, Good and
Westall walked west to Parramatta on 17 June, from
there north to North Rocks with Banks's resident col-
lector, George Caley (1770–1829), and later with him on
to Castle Hill. They travelled to the Hawkesbury River
at Green Hills on 20 June and went up river to Richmond
Hill by boat. They reached to just above the junction with
the Grose River and went down the Hawkesbury as far
as Portland Head and back, returning to Sydney via
Green Hills and Parramatta on 25 June.

The living plants were transferred to the governor's
garden and a prefabricated greenhouse set up on the
deck of the *Investigator*. Flinders's plan to circumnavigate
the continent clockwise was now reversed. On 21 July
the *Investigator*, with the *Lady Nelson*, the vessel with a
moveable keel for river survey work, left Sydney Cove
to travel north.

NOTES
1 Mabberley (1985), ch. 6, modified according to Vallance (1990) and
Watts *et al.* (1997), unless otherwise indicated.
2 Lhotzky (1843).
3 Mabberley & Moore (1999).
4 Norst (1989), p. 100.
5 Norst (1989), p. 10.
6 Rourke (1974).
7 Mabberley & Moore (1999).
8 Norst (1989), p. 101.
9 Burbidge *et al.* (1997).
10 Edwards (1981), p. 46.
11 Edwards (1981), p. 51.
12 Watts *et al.* (1997), p. 60.
13 Grandison (1990).
14 Edwards (1981), pp. 78–79.
15 Norst (1989), p. 102.

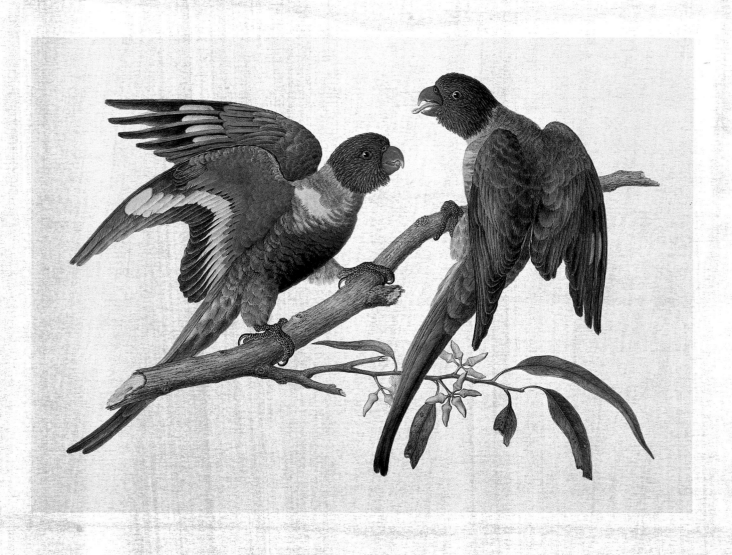

PLATE 36 Rainbow lorikeet *Trichoglossus haematodus moluccanus* (Gmelin)
shot at Port Phillip, 30 April 1802.
Watercolour by Ferdinand Bauer (Australian Zoological Drawings 26). This is a common bird of
woodland and forests, but now also parks and gardens, in the coastal regions of eastern and south-
eastern Australia.

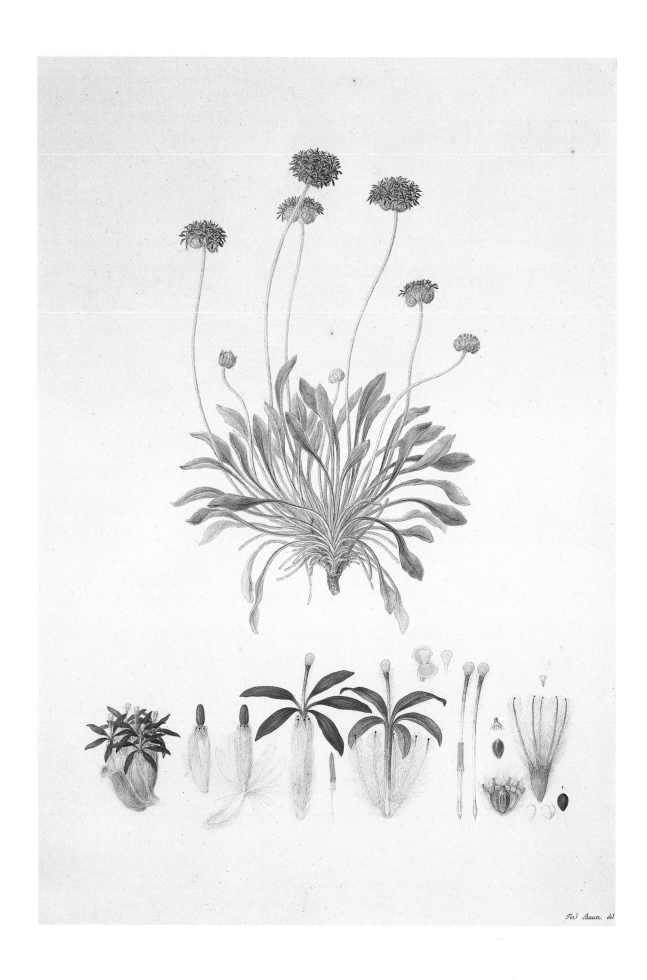

Fer. Bauer. del.

To Timor and Back

18 Sesame *Sesamum orientale* L. (Pedaliaceae). Lithograph [*S. indicum*] by Gebhart (S. Endlicher, *Iconographia generum plantarum,* t. 70, 1839), based on a field drawing made by Ferdinand Bauer at Kupang, Timor, Indonesia, April 1803. Sesame is the source of the ninth most important of the world's vegetable oils.*

PLATE 37 Pincushion *Brunonia australis* Sm. ex R. Br. (Goodeniaceae)
Watercolour by Ferdinand Bauer (Australian Botanical Drawings 91), from a field sketch made at Port Clinton, Queensland, 22 August 1802. The generic name commemorates Robert Brown.

The *Investigator* first anchored on 29 July 1802 at Sandy Cape, the northernmost tip of Fraser Island,[1] Queensland, discovered by Captain Cook in 1770. This is now part of the Great Sandy National Park, occupying the northern half of the island. There were lots of new plants to collect and draw but on 1 August the ship left for Port Curtis, which Flinders discovered. Here the party had a skirmish with the unarmed Aborigines, Brown noting, "they seem'd to have much the advantage of us in point of bravery & also in conduct". Among the live plants collected was one with flaming red flowers, a tree Brown was to name *Grevillea banksii*. Bauer drew not only that and many other plants but also a bandicoot; Brown recorded forty-nine flowering plant species there before they left on 8 August.

Next day they were at Curtis Island in Keppel Bay, another of Cook's discoveries, near present-day Rockhampton, but there was little new for the naturalists, though they discovered the Blue-winged kookaburra, *Dacelo leachii*, there. Next was Port Clinton where they saw Hoop pines, *Araucaria cunninghamii*, and collected the Pincushion plant, later to be named *Brunonia australis* after Brown. At Strong Tide Passage, they climbed the tallest hill in sight, now Mount Westall, and at Shoalwater Bay, now a military training base, Brown rather prudishly noted of the local Aborigines, "they enquired by very obvious signs whether we had women aboard". Sailing to Broad Sound and Thirsty Sound, the *Investigator* picked her way up the coast but the chain of reefs and inlets was too much for them to survey and they missed the great coastal rivers.

In Broad Sound they worked on West Hill Island, both Bauer and Brown being stung by different plants, besides encountering numerous ants and a snake. But they also found a "tree of moderate size … both in flower and with ripe capsules", the Crow's ash, which Brown was later to name *Flindersia australis* after his captain. While Flinders and Brown went upstream in the *Lady Nelson* and then a cutter, Bauer and Good botanized in the hills near the coast, where they spent the night near a source of fresh water.[2]

On 27 September, they headed for Torres Strait and first anchored off the Northumberland Islands where

they botanized. But, as Brown recorded, "In the forenoon some of the people who were employ'd in the gully washing cloaths thoughtlessly set fire to the grass which they found it impossible to extinguish – the fire spread very rapidly & in almost every direction dislodging the washers … soon after the waterers." It was still burning four days later. Brown continued the description of the journey on the Barrier Reef: "Octr 6–15 – among the reefs in vain attempting a passage sometimes in very dangerous situations chiefly arising from the depth & foul ground of our anchorages & the rapidity of the tide in many places." Flinders's prose was more lyrical:

"The water being very clear round the edges, a new creation, as it was to us, but imitative of the old, was there presented to our view. We had wheat sheaves, mushrooms, stags' horns, cabbage leaves and a variety of other forms, glowing under water with vivid tints of every shade betwixt green, purple, brown and white; equalling in beauty and excelling in grandeur the most favourite parterre of the curious florist."

Sponges, sea cucumbers and giant clams abounded, the medical man, Brown, noting of the clams, "The animal substance alone 3 lb 2 oz – they were served out to the messes of the ships company but were almost universally dislik'd & in some produced nausea & vomiting".

When they reached the Cumberland Islands, Flinders decided to send the slow and damaged *Lady Nelson* back to Port Jackson. The *Investigator*'s leakiness increased with the rising swell, but on 21 October she passed into Torres Strait through Pandora's Entrance, anchoring off the Murray Islands. Bauer accompanied Flinders and Brown, collecting on Zuizin Island ("Half way Island" of Brown's manuscripts), and the ship was through the Strait in a record three days. They collected on what Flinders

was to call Goods Island and, once inside the Gulf of Carpentaria, they were the first Europeans to follow the Dutch routes of 150 years before. But the Dutch chart was considered little better than "a representation of Fairyland", such that Flinders began to think in terms of a huge inland sea extending south from the Gulf. For the naturalists it was virgin territory and, as it is still very inaccessible, much of Bauer's and Brown's work has yet to be surpassed. Bauer was to write to his brother Franz in London: "We had high hopes of the Gulf of Carpentaria but found that the whole side facing east [i.e. west] is very low-lying country with very shallow water for a long distance so that our ship could not come close … On our way past the Murray Islands we had a strong wind which caused a lot of water to enter the ship …"[3]

In the South Wellesley Islands, Flinders was to name Allen Island after Brown's geological assistant. Here, though, he was becoming increasingly concerned about the state of his ship. From the anchorage in what was to be called Investigator Road, Brown could make a list of some 190 flowering plants and Bauer shot a bustard (*Ardeotis australis*), but the carpenters reported to Flinders, "The ship having before made 10 inches of water per hour in a common fresh breeze … in a strong gale with much sea, the Ship would hardly escape floundering … from eight to twelve months there will scarcely be a sound timber in her."

Flinders had to get the *Investigator* back to Port Jackson but, rather than try to retrace his route, he decided on completing the circumnavigation, though, once out of the Gulf, terminating the surveying and collecting work. The crew left the name of the ship and the date carved on a tree, which was to survive until 1887: its trunk is now in the Queensland Museum. They visited other of the Wellesley Islands and the Sir Edward Pellew Group

PLATE 38 Crow's ash *Flindersia australis* R. Br. (Rutaceae)
Watercolour by Ferdinand Bauer (Australian Botanical Drawings 23) based on materials collected at
Broad Sound, Queensland, 18 September 1802. Brown had originally intended the name *Flindersia* for
a Grass-tree (Xanthorrhoeaceae), but settled on this tree to commemorate Matthew Flinders. It
provides one of the most valuable of Australia's timbers.

105. *Flindersia australis* (*Oxleya xanthoxyla*)

Fer.ᵈ Bauer. del.

in the south of the Gulf; Brown's party botanized in what is now the Malagayangu District of Arnhem Land opposite Groote Eylandt, as well as on that island itself. Encounters with the Aborigines were often hostile, skirmishes leading to fatalities, with Brown even dissecting the body of one Aborigine killed on Morgan Island and having his head preserved in alcohol.[4]

The crew eagerly collected turtles, as they had on Bountiful Island in the Wellesleys, and also fruits (*Syzygium* spp.) allied to rose-apples, but they were becoming sickly with diarrhoea and fever. On Bountiful Island, Good recorded:

"Found the *Cycas circinali*s [actually *C. media* R. Br.] in great perfection & the fruit being both pleasant to the taste and sight I eat some as also Mr Brown & Bawer. On coming on board Mr Bawer and I were taken with a violent reaching with sickness which continued with short intervals the greater part of the night it had an unpleasant effect on Mr Brown – but several other people in the Ship eat a little & most did so were affected in like manner though not so violent."[5]

By contrast, the Aborigines, for whom cycad seeds are an important food-source, carefully soak and cook them before grinding them into flour: eating untreated seeds usually promotes vomiting in humans, but in cattle leads to degenerative neuromuscular disease.[6]

In the north-west of the Gulf, in The English Company's Islands, the expedition encountered Malay traders familiar with the coast and the Aborigines. But by now even Flinders was suffering from scurvy and so, on 7 March, they left Wessel Islands to make for New South Wales. Brown had collected about a thousand plant species since leaving Port Jackson, half of them since passing through Torres Strait. Bauer's industry was commensurate: he had made some five hundred sketches of plants and about ninety of animals. But the winds were against the ship and she was forced to make for Timor. Within sight of shore, Brown was writing to Banks of their findings: "The Zoology we have not done much nor do I think that much was to be done; of Quadrupeds we have only met with the Kanguroo, the Dog [dingo] & Didelphis of Shaw [bandicoot] … Mineralogy continues as barren as ever." On their arrival at Kupang, the Dutch Governor sent on board fruit, a pig and a goat for the crew and, next day, as Brown recorded, he gave Brown and Bauer

"permission to Botanize etc in the neighbourhood & offer'd me a european guide – he informd me also that I might safely go as far as 20 miles in any direction into the country … in the forenoon I sauntered about in the neighbourhood of the town, the Cocoa nuts & bananas of wch there was everywhere abundance produc'd to me who had never seen cocoanuts before a new & fine effect – most of the plants too which I observ'd about the town were quite new to me & very few N Holland ones … I returnd early on board being engag'd to dine with the Governor at 2 O'Clock … Our dinner was not splendid but to us who had been living on salt beef & putrid water was excellent – many of the best fruits as Pin[eappl]es Mangos etc were not now in season. … At Timor we remain'd til the 7th in which time our excursions were limited to the neighbourhood of the town – we were however pretty successful observing nearly 300 species of plants few of which are perhaps new [–] several were common to New Holland."

PLATE 39 *Cochlospermum gillivraei* Benth. (Cochlospermaceae)
Watercolour by Ferdinand Bauer (Australian Botanical drawings 4), based on a field sketch, now in Vienna, made on Goods Island, Torres Strait, 2 November 1802. Flinders wrote of it as a "species of silk-cotton plant … the fibres in the pod are strong, and have a fine gloss, and might perhaps be advantageously employed in manufacture". The species name commemorates John McGillivray (1821–1863), a zoologist who collected the type specimen of this tree on Lizard Island.

Good made fifty-seven collections of seed, including sesame, *Sesamum orientale*, growing in "brown soil" and later to be received safely at Kew.[7] Collecting at such a rate was matched by Bauer's industry in producing sixty-one drawings during that week,[8] an impossible task had he not been using his colour chart to record the plants' colours. He wrote to his brother Franz at Kew:

"Cap. Flinders decided to go to Timor thinking that if the ship could be repaired a little she could certainly last longer on the sea and if he could get provisions in Timor for another cruise, he would like to finish the north and west coast of New Holland before going to Port Jackson. … I have, since we left Port Jackson, made sketches of 500 species of plant but only 90 of animals, mostly birds. I have not completed anything and will not be able to do so either. The paper which I took with me on this cruise has gone mouldy because of the dampness and warmth of the cabin and is covered with spots of mould and can no longer be painted on or used for any kind of painting."[9]

Despite their warm welcome and their industry there, it is likely that it was at Kupang that members of the crew contracted dysentery. Baudin had lost twelve men from the illness there in 1801 and their monument was already decaying. On 8 April, Flinders's dash to New South Wales began. Thunderstorms and heavy rain, the leaking ship and the ailing crew, their condition perhaps exacerbated by the fruit Flinders had taken on board to combat scurvy, spurred him on.

They made for Cape Leeuwin, but pressed on to Goose Island Bay in the Archipelago of the Recherche which they had visited in January 1802, anchoring on 17 May 1803. Flinders wanted fresh meat — geese (they found only twelve) — lamp-oil (seals) and salt. A sailor died of dysentery and Good succombed to it: Flinders's own scorbutic sores were impairing his movements, though Brown was still able to collect plants and Bauer certainly sketched some of them there. The deteriorating condition of the crew forced Flinders on, "and I carried all possible sail, day and night, making such observations only as could be done without causing delay". The quartermaster died on 2 June, a week before their arrival in Sydney Cove, where the battered *Investigator* dropped anchor about midday on 9 June.

NOTES
1 Mabberley (1985), ch. 6, modified according to Vallance (1990), unless otherwise indicated.
2 Edwards (1981), p. 92.
3 Norst (1989), p. 4.
4 Edwards (1981), p. 112.
5 Edwards (1981), p. 104.
6 Mabberley (1998), p. 203.
7 Edwards (1981), pp. 194, 206.
8 Mabberley & Moore (1999).
9 Norst (1989), p. 104.

PLATE 40 *Brachychiton paradoxus* Schott & Endl. (Sterculiaceae/Malvaceae)
Watercolour by Ferdinand Bauer (Australian Botanical Drawings 13), based on a field sketch made at North Island, Sir Edward Pellew Group, Gulf of Carpentaria, Northern Territory, December 1802. This is a 'bottle tree' with a swollen trunk.

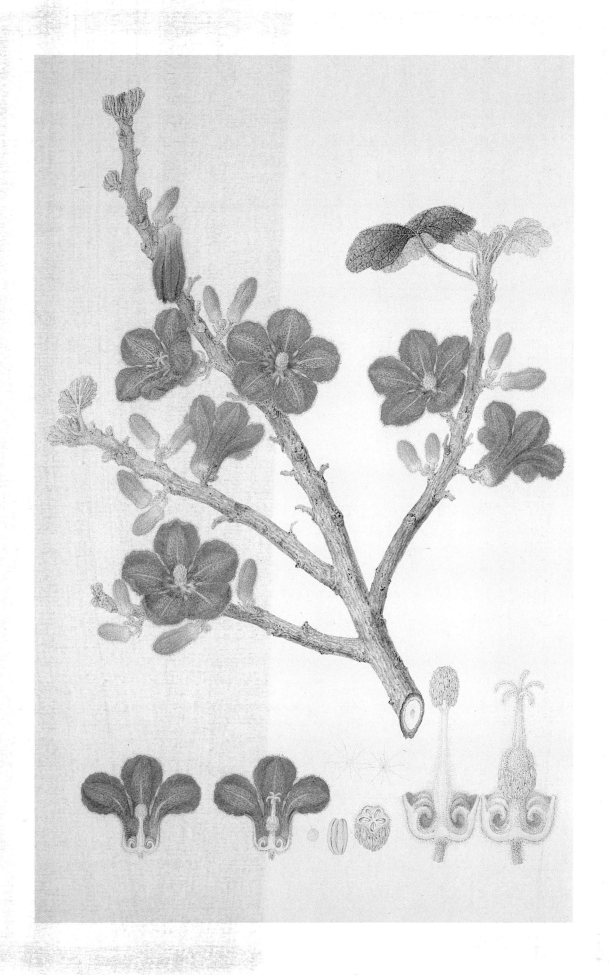

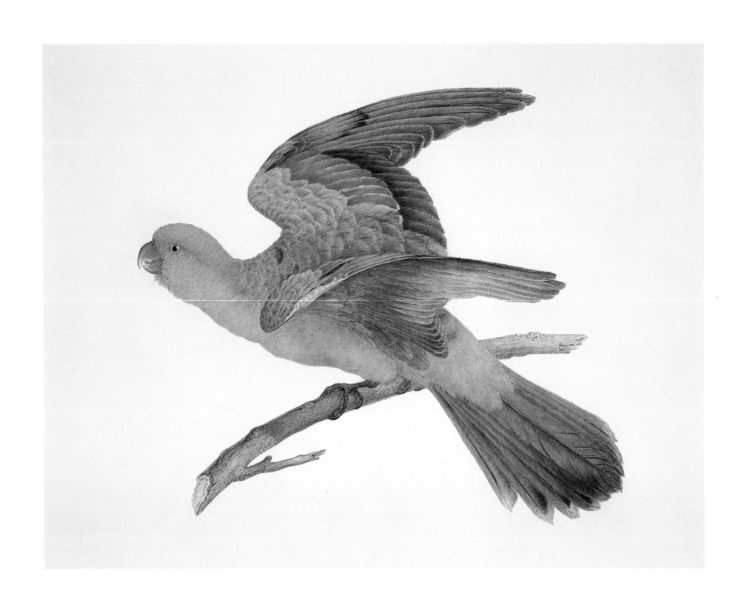

PLATE 41 Red-winged parrot *Asprosmictus erythropterus* (Gmelin). Watercolour by Ferdinand Bauer (Australian Zoological Drawings 24), based on a field sketch made of a bird probably shot by Brown's servant, John Porter, at North Island, Sir Edward Pellew Group, Gulf of Carpentaria, Northern Territory, 18 December 1802.

PLATE 42 Native hibiscus *Alyogyne hakeifolia* (Giord.) Alef. (Malvaceae) Watercolour by Ferdinand Bauer (Australian Botanical Drawings 12), based on a sketch made at Middle Island, Archipelago of the Recherche, 18 May 1803. This hibiscus was in cultivation in England by 1846.

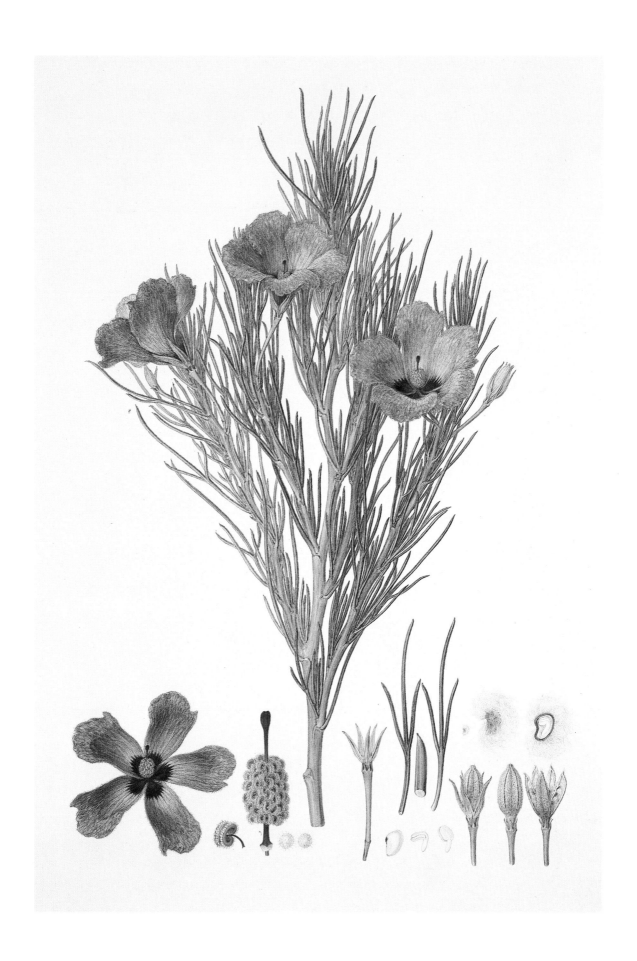

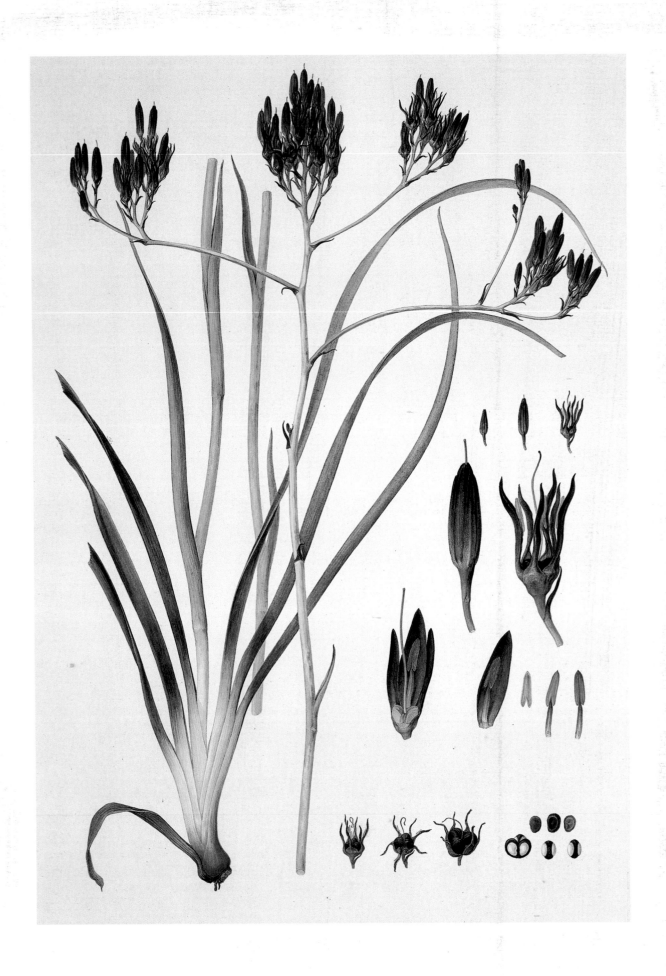

New South Wales and Norfolk Island

19 *Streblorrhiza speciosa* Endl. (Leguminosae). Unissued lithograph by M. Fahrmbacher, based on a field sketch by Ferdinand Bauer made on Philip Island, off Norfolk Island, 30 October 1804.* Previously unpublished. The name refers to the embryonic root bent double over the cotyledons in the seed: *streblos* (Gk twisted), *rhizon* (Gk root). Discovered by Bauer and last collected in the wild in 1830, it persisted in cultivation under glass in Europe until the 1840s at least, but is now believed to be extinct. In Bauer's time the island was called Pig Island as there were 5000 pigs there as early as 1796: the whole island was devastated by them.

PLATE 43 *Haemodorum planifolium* R. Br.
(Haemodoraceae)
Watercolour by Ferdinand Bauer (Australian Botanical Drawings 207), based on a field sketch probably of material collected between Sydney and South Head in October–November 1803. Previously unpublished.*

Three days after the arrival in Sydney Cove,[1] Peter Good died of dysentery and he was buried the next day. Bauer and Brown had survived the voyage remarkably well, but the *Investigator* was in a deplorable state. Flinders discussed her condition with the Governor and they agreed she had to be replaced if the survey was to be finished. She was condemned on 14 June and moored in the harbour as a store-ship with one member of the crew left as watchman. Flinders was to have the *Porpoise*, originally a Spanish prize, the *Infanta Amelia*, which had been sent to Australia in 1800. If she was not suitable, he was to return to Britain to fetch a new ship.

When the *Porpoise* returned to Sydney after an aborted voyage to Tasmania, she was deemed unsuitable but she needed repairs in England. Flinders was therefore to travel in her, but Bauer and Brown petitioned him to allow them to stay in New South Wales until he returned with a new vessel. Governor King duly instructed Flinders:

"That the request of Mr. Robt. Brown, naturalist and Mr. Ferdinand Bauer, Painter of Natural History to remain here, should be complied with to follow their respective pursuits, until it is determined whether another ship will be appointed to finish what remains of the service you had to perform. You will also discharge the above gentlemen with their two servants to remain in the Colony until instructions are received from My Lords Commissioners of the Admiralty."[2]

Flinders arranged for them to stay together in a house, leaving them with eighteen months' supplies. The *Investigator's* greenhouse was set up on the deck of the *Porpoise* and Brown's top set of dried plant specimens taken aboard. Flinders was charged with Brown's letter to Banks in which he wrote of Bauer as "indefatigable & that[,] considering his minute accuracy[,] the number of drawings he has made is astonishing". Bauer had sketched one thousand plants and two hundred animals; however, none of his drawings was later worked up into a 'finished' illustration.

The *Porpoise* sailed on 10 August 1803, leaving Bauer and

PLATE 44 Platypus *Ornithorhynchus anatinus* (Shaw) (Ornithorhynchidae)
Watercolour by Ferdinand Bauer (Australian Zoological Drawings 14) based on sketches made in
Port Jackson. Restricted to eastern Australia, the platypus was at first taken to be a hoax (a mole
with a duck's beak) but Governor King sent one preserved in alcohol to Banks in 1800.*

PLATE 45 Koala *Phascolarctos cinereus* (Goldfuss) (Phascolarctidae)
Watercolour by Ferdinand Bauer (Australian Zoological Drawings 6) based on sketches made in
Sydney in August 1803 of animals probably captured at Hat Hill, south of Botany Bay,
New South Wales.

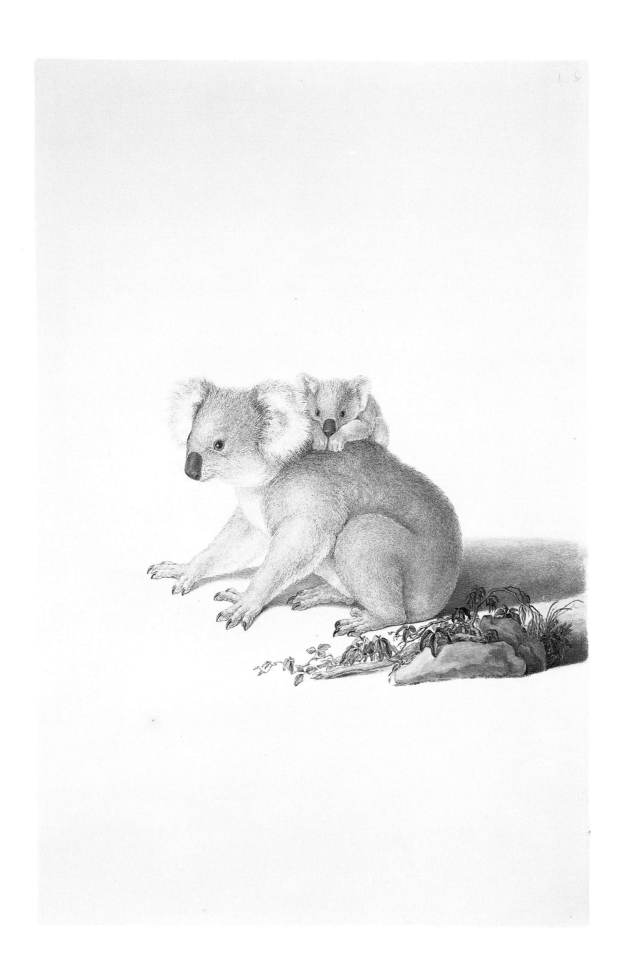

Brown collecting and drawing in the Sydney spring, Bauer making an excursion of his own to the Hawkesbury in September. While Bauer was away, Flinders returned to Sydney in an open boat with the devastating news that the *Porpoise* had been wrecked on the Barrier Reef and that all the living and preserved plants had been lost. Fortunately, Bauer had sent none of his sketches on her, no doubt hoping to finish some of them during the wait for Flinders's return from England, as he had written to Banks: "Our stay in New South Wales would add much to the collections and if not new subjects could be procurt I would be able to finish some from them wath I have already made and must bej done in England."[3]

Bauer's and Brown's shared domestic arrangements did not last long and Bauer took a house alone on one of the leased properties in Farm Cove, now the site of the Royal Botanic Gardens.[4] He drew and collected plants in the immediate area, including those on Bennalong Point, the site of today's Opera House, and the area occupied by the suburb of Woolloomooloo, as well as further afield in the Sydney basin. He and Brown were to make their own collecting trips, Bauer apparently no longer considering himself under Brown's orders. Brown sailed to Tasmania in November 1803, intending to stay away about ten weeks but did not return until August 1804. Brown wrote to Banks from Tasmania in March 1804, "Pray remember me kindly to Mr. Bauer tell him I often wish for him here but at the same time could not help envying him his situation in Port Jackson",[5] and on his return to Sydney added, "Mr. Bauer did not accompany me to Van Diemen's Land [*i.e.* Tasmania] which on the whole perhaps is not to be regretted as he would doubtless find ample employment here and during last Winter was I learn uncommonly fortunate in the detection of new species of Orchideae."

Before Brown returned to Sydney, Bauer had gone to Norfolk Island, so that during their time based in New South Wales, they had increasingly less to do with one another. Meantime, Flinders set off for England once more, in the schooner *Cumberland*, but in Mauritius he was interned by the French General de Caen, allegedly for travelling with a passport relating only to the *Investigator*: he was not to reach England again until October 1810.

In March–April 1804, Bauer was in the Hunter Valley north of Sydney, having sailed there in the *Lady Nelson* with Lt. Charles Menzies, who was appointed commandant of a new settlement: Bauer was thus with the founder of what is today Newcastle. Menzies wrote back to Governor King[6] that Bauer had made a sketch of what Menzies had named Kingstown after King (who changed it to Newcastle). This, Bauer's only known landscape of Australia, is now lost.[7] Bauer's Hunter expedition included Banks's plant collector, George Caley. Although both Bauer and Brown made separate journeys with Caley, who helped get Brown's New South Wales total up to a thousand plant species, they did work together for part of the time, especially with animals, which Bauer drew and Brown dissected.

The affinities of what are now called monotremes were then uncertain and, at Banks's request, Brown dissected both platypus and echidna. He also made long descriptions of the koala. According to David Dickenson

PLATE 46 Red cedar *Toona ciliata* M. Roem. (Meliaceae)
Watercolour by Ferdinand Bauer (Australian Botanical Drawings 22), based on a field sketch of fruiting material collected by Bauer at "Kingstown" (*i.e.* Newcastle), New South Wales, April 1804; the flowers were probably drawn from material collected there by Robert Brown the 22 October following.* Red cedar, allied to mahogany, is the most prized of all Australian timbers for furniture and indoor work such as doors. From the earliest settlement it was heavily logged and now good specimens are very rare. The first fellings in the Hunter Valley were in 1801† and Menzies's task at "Kingstown" included getting supplies regularized.

85

Mann's *The Present Picture on New South Wales* (1811, p. 49), "The Koolah, or Sloth, a singular animal of the Opossum species, having a false belly, was found by the natives, and brought into the town alive, on the 10th of August 1803". The *Sydney Gazette* of 21 August recorded

"An Animal whose species was never before found in the Colony, is in HIS EXCELLENCY'S possession. When taken it had two Pups, one of which died a few days since … the graveness of the visage, which differs little in colour from the back, would seems to indicate a more than ordinary portion of animal sagacity; and the teeth resemble those of a rabbit. The surviving Pup generally clings to the back of the mother, or is caressed with a serenity that appears peculiarly characteristic."

The first printed account of the animal dates from 1798,[8] but Bauer's drawings are the first ever made and figure the first live Koala brought to Sydney. A crude sketch was also made of it by John Lewin, a local natural history illustrator, Brown explaining to Banks:

"The Governor, I learn, sends a drawing made by Mr Lewin. Mr Bauer cannot on so short a notice finish the more accurate one he has taken. The necessity of sending my description, which is very imperfect, as the animal will not submit to be closely inspected, and I have had no opportunity of dissecting one, is in a great measure superseded by Mr Tuman having purchas'd a pair, which from their present healthy appearance, will probably reach England alive, or if not, will be preserv'd for anatomical examination …"[9]

The Governor had little hope of this: "As you will have an account of it from Mr. Brown and Mr. Bauer,

I shall not attempt a description … I much fear that their living on leaves alone will make it difficult to send them to England", though one at least learnt to eat bread soaked in milk and water, while another one became fond of tea. Bauer drew the koala alive as well as a dissected specimen.

Later, while Brown was away in Tasmania, the *Investigator* was being repaired. Bauer, having exhausted the local flora, took up the offer of Captain Eber Bunker of the *Albion* to go to Norfolk Island. He wrote to his brother Franz at Kew:

"But now the plants are beginning to be rarer and one has to go further to find something new and anyway I think New Holland is not as rich in plants as I thought. I also went several times some distance inland and to the Blue Mountains as far as my feet would let me but did not manage to go a great distance …"[10]

And to Banks:

"I am sorry to sae that I have not anything finished to send home by this opportunity, all that I have collect and don consist in sketches and matherials from which Drawings or Engravings at any time can be made … I have made a collection of sketches of allmost all the plants of New Holland which did con to my hands & I flatter myself when the Investigator Vojage should come to a happy conclusion the pense [sic] which I have taken to give satisfaction to that branch of science which was alotted to me will met with approvation … .

Having heard that the produce of Norfolk Island are so different from this of New Holland, I tuk the opportunity to go with Capt. Bunker of the ship Albion, the

PLATE 47 *Camarophyllus lilacinus* (Cleland & Cheel) E. Horak (Cantharellaceae) Watercolour by Ferdinand Bauer (Australian Botanical Drawings 233). Previously unpublished in colour. There are seven finished drawings of Australian fungi in The Natural History Museum and although there are some of Robert Brown's fungus collections at Kew, none of those relates to the drawings, which were probably made in the Sydney area for Bauer's personal collection.

20 Norfolk Island Pencil landscape by Ferdinand Bauer 1804–05 (Norfolk Island landscapes 4). The trees are Norfolk Island pines (*Araucaria heterophylla* (Salisb.) Franco) and tree ferns (*Cyathea brownii* Domin).

convoyer of this letter who in his passage to England will leave me there, which will give me time of two month stay at the Island, when the Investigator's Ship will be finished, and come to remove the settlers with whome I shall return to Port Jackson."[11]

Bunker was on his way to England with 13,000 seal skins from Bass Strait;[12] Bauer would be brought back to Sydney on the sea trial of the revived *Investigator*. He intended to be away only a short time, but the *Investigator* was not ready for months: even the first advertisement for crew had not been placed in the *Sydney Gazette* until 4 November.

Captain Cook had reported that Norfolk Island had pines useful for replacing ship's masts, and native flax (*Phormium tenax*), a fibre-plant. The island was settled in 1788, just one month after Sydney, with King as Superintendent, and it eventually became the home of the descendants of the mutineers from the *Bounty*. Although Bauer drew many plants and made the first comprehensive collection of good herbarium specimens, there is nothing beyond date of flowering and locality with them. As on the rest of the expedition, he wrote no journal, and there are no surviving letters concerned with his time there, so there is, as with so much of his life, little record of his sojourn.

Bauer, presumably with a servant, collected at least 152 different species on the main island and the adjacent Philip Island, which he visited in October 1804. He found most of the forty-seven endemic species (two of those he found are now extinct), including two new genera; specimens are now preserved in his herbarium. Many of the new species were named after him by later workers, particularly by Endlicher in Vienna, who wrote up the collection as *Prodromus florae Norfolkicae* (1833), published seven years after Bauer's death. Besides sketching forty animals and seventy-nine plants,[13] Bauer also made landscape studies of the island, the only ones to survive from his Pacific expedition.[14] It is possible that it was on Norfolk Island that he collected a specimen of the bird which bears his name, the Pacific race of the Bar-tailed godwit, *Limosa lapponica baueri*. Brown had hoped to join Bauer on Norfolk Island, travelling out in "the Investigator now cut down and repair'd", but sickness, including depression, prevented him. The ship left Sydney on 8 January 1805, bringing Bauer back on 3 March with convicts, soldiers and livestock for the colony of Port Dalrymple in Tasmania. On Bauer's return, he and Brown worked together for ten weeks and it is possible that it was then Bauer at last prepared some 'finished' drawings – of his favourite subjects, orchids, and perhaps the pitcher-plant from Western Australia as well.[15]

Whilst Flinders was languishing in Mauritius, the very cause of his aborted journey to England was being

PLATE 48 *Passiflora aurantia* Forst. f. (Passifloraceae)
Engraving by Weddell (as *Murucuja baueri*, J. Lindley, *Collectanea botanica*, t. 36, 1821), based on Bauer's unpublished drawing (then on loan to Lindley and now in the Bibliotheka Jagelloñská Kraków, Poland), itself probably based on a pencil drawing made by Ferdinand Bauer on Norfolk Island.

Ferd. Bauer. del.

Murucuja Baueri.

Waddell fc.

21 *Melicope littoralis* (Endl.) T.G. Hartley (Rutaceae). Lithograph by M. Fahrmbacher [*Evodia littoralis*, H.W. Schott, *Rutaceae*, 1834, t. 1], based on a field drawing made of material collected at Anson Bay, Norfolk Island by Ferdinand Bauer in September 1804. Discovered by Bauer, it is restricted to the island but is no longer found near the coast, though the tree is still common in the forests in the National Park on the island.*

made ready for the homeward voyage: Governor King had pressed the *Investigator* back into service after the makeshift refit so as to be able to get despatches back to Whitehall. King, who had entertained and fed the ailing French on their Baudin expedition, now prepared a 'passport' for Bauer and Brown:

"As the Hazard attending the unfortunate Warfare in which Great Britain is engaged may occasion His Britannic Majesty's Vessel Investigator to fall into your power, it is a duty I owe to the cause of science to represent to you the Circumstances in which Mr. Robert Brown, Naturalist, and Mr. Ferdinand Bauer, Painter of Natural history, are placed, and to solicit

for them and their extensive Collections that protection from you, which France, as well as other Polished Nations of Europe, have on so many occasions shown their Reslution to afford to the Scientific Voyager."

This document was prepared despite the fact that the French had interned Flinders on Mauritius, with the effect that his findings were to be pre-empted in print by the French, notably the scheming François Péron (1775–1810), who had overseen the spying activities of the Baudin expedition in Australia. He successfully eclipsed the more idealistic Baudin, King's confidant, who died in 1803 before the end of the expedition, and even published the charts and other results of the expedition without even mentioning Baudin by name.[16]

Brown protested to the Governor that the *Investigator* was unsuitable and he was still collecting plants on 5 May,[17] though he made arrangements to settle his affairs in March. A week later, Bauer did too, a notice in the *Sydney Gazette* of 31 March reading:

"ALL Persons having any Claims or demands on Mr. F. BAUERS, late of His Majesty's ship Investigator, about to depart from this Colony, are desired to present the same to Mr. [Simeon] LORD for payment; and all persons holding any Drafts or Orders drawn by Mr. Bauers on Mr. LORD, are forthwith to give in the same; as no attention will be paid to any that are not forthcoming before Mr. Bauer's Departure."

But the ship did not leave Sydney until 23 May 1805, "the crazy low cut down Investigator perhaps the most deplorable ship in the world", as Brown recorded, the *Sydney Gazette* rather more jauntily reporting:

"On Thursday sailed for England His Majesty's ship Investigator, under the command of Captain KENT. – On board the Investigator were embarked Messrs Brown and Bauers [*sic*], two of the scientific Gentlemen employed by the Board of the Admiralty to accompany Captain FLINDERS in his Voyage of Discovery. On the Investigator's being found unfit to complete the Collection of Natural History, which

they have very assiduously accomplished. The whole collection was sent on board the Investigator in her present reduced state, with every apparent reason to expect it will safely arrive in England; where it will be very acceptable to the Amateurs of Natural History."

With Menzies, who had resigned in March, and 1200 specimens collected since Flinders's departure, seeds from Tasmania and the Hunter, all the mineral and animal collections – including a live wombat – with Bauer's luggage alone comprising eleven large cases,[18] the *Investigator* sailed east across the Pacific, round Cape Horn. Too weak to face the English Channel, the rotting ship made north of Ireland, for Liverpool, where the naturalists disembarked on 13 October.[19] An eye-witness later wrote, "The extraordinary appearance of this wonderful old ship, her sides being covered with barnacles and seaweed, and her sails, masts, and rigging presenting the usual signs of a vessel that had been abandoned". The *Liverpool Chronicle* of 23 October reported:

"We understand she has brought home many specimens of the productions of New Holland both natural and artificial, the view of which has furnished particular pleasure to many of the inhabitants of this town, who … have had an opportunity of seeing them on board. The drawings, plans &c., are, however, yet kept from the public eye, being destined for the information of the Royal Society, and consequently will add to the store of general knowledge, when given to the world through their medium."[20]

Just before disembarking, Brown wrote to Banks from the ship:

"Dear Sir

After a tedious & uncomfortable passage of nearly five months, we have just been enabl'd to reach this Port … as to the Collection embark'd in the Investigator it was, after repeated representations provided for … within the Tropics the plants were carefully examin'd & those that most requir'd it were chang'd into dry paper but such has been the wet state of the ship that they must again

be suffering & that I fear considerably. I am therefore most anxious to have them remov'd on shore & I earnestly beg that they may not be again put on board the Investigator for the purpose of being brought round to Portsmouth or the River as she is not only crazy but absolutely a defenceless ship … I enclose a list of the Packing cases containing the collection as also that of Mr Bauer & I have taken the liberty of adding our luggage which is not very formidable, consists mostly of books, & contains nothing which the custom house would detain.

I shall most anxiously wait your instructions & cannot avoid again expressing my wishes that the collection may be remov'd as soon as possible from the Investigator & transported to London by land."

In the event, the *Investigator* was intended to call at Plymouth, but she fell short, having to put in at Falmouth.[21] She was laid up and, after a Navy Board inspection in 1810, she was broken up at Pembroke Dock.

NOTES
1 Mabberley (1985), ch. 7, as modified by Vallance (1990).
2 Norst (1989), p. 52.
3 Norst (1989), p. 53.
4 Watts *et al.* (1997), p. 21.
5 Norst (1989), p. 56.
6 Norst (1989), p. 56.
7 A crude tracing survives; it is reproduced in Norst (1989), p. 57.
8 Watts *et al.* (1997), p. 134.
9 Watts *et al.* (1997), p. 140.
10 Norst (1989), p. 106.
11 Norst (1989), p. 110.
12 *Sydney Gazette*, 26 October 1804 [4].
13 Mabberley & Moore (1999).
14 Moore (1998).
15 Mabberley & Moore (1999).
16 Horner in Bonnemains *et al.* (1988), ch. 1.
17 Vallance (1990).
18 Norst (1989), p. 63.
19 Mabberley & Moore (1999).
20 Mabberley (1985), ch. 8.
21 Norst (1989), p. 64.

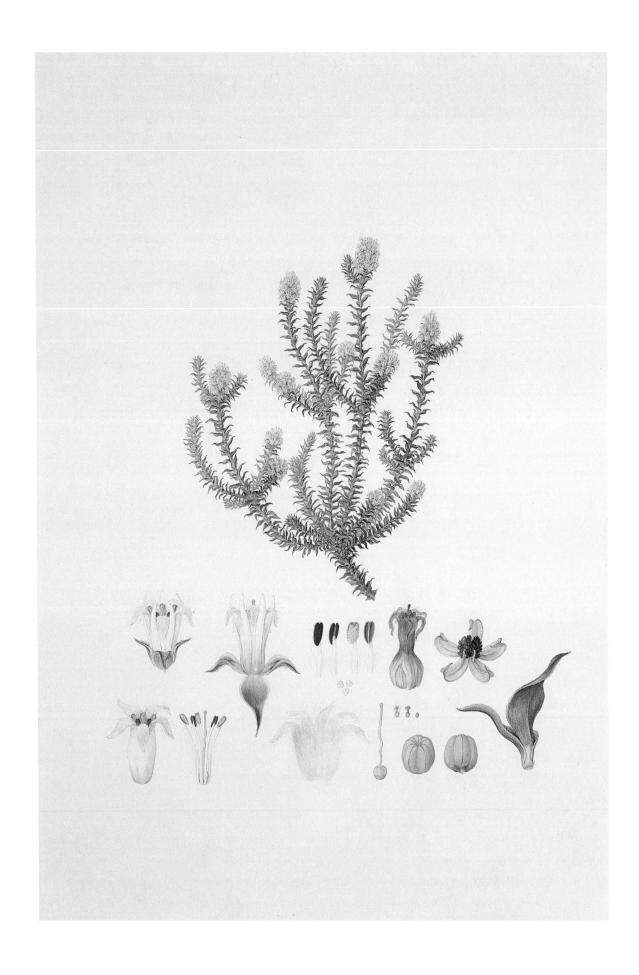

London Again

Sir Joseph Banks

22 Sir Joseph Banks (1743–1820). Medallion 1816 with *in genius and substantial learning* on reverse.

PLATE 49 *Andersonia sprengelioides* R. Br. (Epacridaceae/Ericaceae)
Watercolour by Ferdinand Bauer (Australian Botanical Drawings 95), May 1806, based on a specimen growing in Kew Gardens, raised from seed collected by Peter Good at King George Sound, Western Australia in December 1801 – January 1802.* Previously unpublished. *Andersonia* commemorates Alexander Anderson (?1748–1811), William Anderson (1750–1778) and William Anderson (1766–1846), all Scottish botanists like Brown.

Bauer and Brown reported to the Admiralty in London on 5 November 1805, but they were not received.[1] They had to leave a note: "Robert Brown Botanist and Ferdinand Bauer Painter of Natural History belonging to His Majestys Ship Investigator have the honor of acquainting Mr Marsden, for the information of their Lordships of their arrival in London".[2]

Their return was completely eclipsed by celebrations for the victory at the Battle of Trafalgar, the decisive naval action of the Napoleonic Wars. The members of their original expedition had arrived back in dribs and drabs from the Cape, Canton, Port Jackson and Mauritius. New Holland was a distant country that had lost the romanticism associated with Cook and was now, paradoxically at Banks's suggestion, a despicable place, a dumping ground for convicts and a drain on the public purse. The most significant Australian expedition up to that time was almost ignored: a deep disappointment for both Bauer and Brown, whose years away had ended so uncomfortably and humiliatingly in the disintegrating *Investigator*. Nonetheless, Banks realised the significance of their achievements and did something about it, writing to the Admiralty before Bauer and Brown arrived back in London:

"The Cases of natural history sent home by our adventurers are sufficiently numerous to do credit to their diligence. They have been Employ'd to gather the Harvest from the Boundless Fields of nature & have reap'd plentifully. I am much mistaken however if some of the indefatigable Sons of Revolutionary France have now sent home more Tonnage in Collections from Small Countries than ours have done from the immense & untrodden Continent of New Holland …"

And again:

"For the people I request you look at the Precedents of the draughtsmen of Capt. Cook on his Second and Third voyage: they were, as I remember retained for some time after their arrival in the service of the

Public to Finish the Scetches they had made in the voyage & they delivered in the Pictures with which the Admiralty is now furnished: if this is agreed to, Brown may be employed in making a complete assessment of the natural history collected, and Bauer in Finishing the most interesting of the Scetches: the whole done in the time they are thus employed to be at the disposal of the office."[3]

Playing, once again, on the rivalry with France, Banks arranged that Bauer and Brown continue to work up the collections for publication under his supervision, but at the continuing expense of the Admiralty, which also paid for the collections to be brought to London.

Bauer's collection comprised his own herbarium, particularly important being the specimens from Norfolk Island, and well over 2000 field sketches of animals and plants. There were 1542 of plants and 259 animals from Australia alone, besides those of the animals and plants drawn on Norfolk Island and the plants on Madeira, at the Cape and on Timor.[4] Because many of the zoological specimens had decayed in the *Investigator* on the way home, several of Bauer's drawings were the only surviving evidence of them: some, when 'finished', were destined to become type specimens. Many of the birds drawn by Bauer had been shot by John Porter, who prepared the skins: those specimens that survive are now in The Natural History Museum collection at Tring, Hertfordshire, though the Norfolk Island ones are kept in Vienna.

But it was the botanical collection that interested Banks most and was by far the most important of the material brought back. Carl Koenig (1774–1851), the botanist, wrote to James Edward Smith, "the specimens, the descriptions & drawings, brought home from New Holland by Brown & Bauer, are by far the most excellent that ever resulted from any expedition". Under Banks's supervision, Brown was now to write the first Flora of the continent and Bauer was to work up life-size watercolours to accompany it, concentrating on the new genera and species that Brown was the first to describe. Smith, who had contributed the botany to Surgeon White's *Journal of a voyage to New Holland* (1790)

and published his own *Specimen of the botany of New Holland* (1793), was bringing out his *Exotic botany*, which Bauer and Brown feared would steal a march on their work.[5] In the event Smith, and indeed others, had a kind of tacit agreement, no doubt in deference to Banks, to leave the field open to Brown and Bauer.

The collection arrived at Soho Square, London, in November, but could not be examined "in consequence of poor Sir Joseph being confined to his bed-room by a recent and very acute attack of gout in the right arm".[6] Some of Brown's herbarium material was incorporated in Banks's herbarium, the nucleus of what is now the herbarium of the Department of Botany in The Natural History Museum, by Banks's 'librarian', Jonas Dryander. Brown kept the rest, complete with field labels, as his own and that was not incorporated in the herbarium until after his death, when duplicated material was distributed to other institutions worldwide. Brown had his manuscript descriptions – now the 'Brown slips' in The Natural History Museum, his lists of plants from particular places ('Florulae'), his diary and the journal of Peter Good. Already there for Bauer's and Brown's use were all the earlier British collections of Australian plants, save a few collected by William Dampier at the end of the seventeenth century, then, as now, preserved in Sherard's Herbarium at Oxford. There were also the manuscripts prepared by Solander ('Solander slips') on the collections made by Banks himself on Cook's first voyage, today also in the Museum. In addition there were also the unpublished engravings made from drawings prepared on Cook's voyage under Banks's supervision.

There were also living collections at Kew Gardens, under Banks's general, if unofficial, direction, and these included materials grown from seeds sent back by Peter Good and others, including some saved from the wreck of the *Porpoise*, sent or brought by Brown after Good's death. Bauer had his own herbarium and, most importantly, life-size field sketches of plants with not only the colour-chart code numbers but also locality names used on the expedition and dates when they were drawn. The numbers of the drawings correspond to numbers in a list in Bauer's hand, now preserved in The Natural History Museum, London, though the surviving field

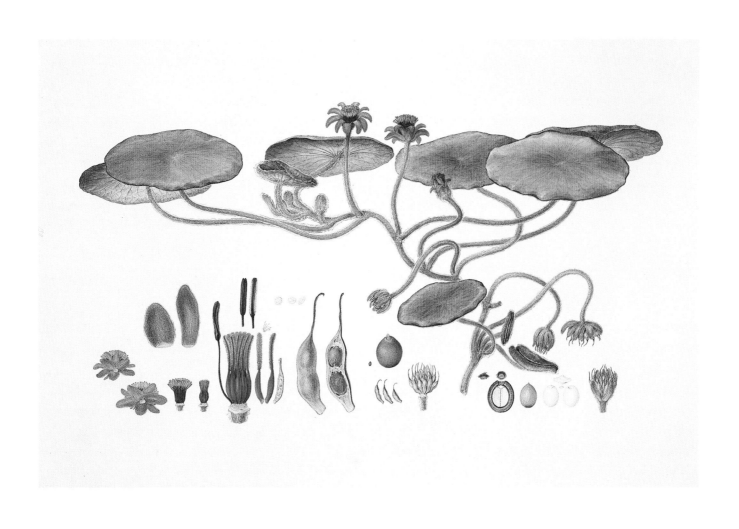

PLATE 50 Watershield *Brasenia schreberi* J.F. Gmel. (Nymphaeaceae)
Watercolour by Ferdinand Bauer (Australian Botanical Drawings 3), based on a field sketch made of
a plant growing in Yarramundi Lagoon, near Richmond, New South Wales, 9 November 1803. In
life, only the mature leaves and open wind-pollinated flowers are above the water surface.

drawings are preserved in the Natural History Museum in Vienna with what survives of his herbarium, some specimens of which at least also have the same numbers.[7]

Brown accepted the scarcely onerous position of Librarian of the Linnean Society, housed close to Banks's townhouse in Soho. In accepting the living-in post, he wrote to Smith:

"Mr Bauer whose abilities & industry you are well acquainted with has made about 1600 drawings all of which are accompanied by minute dissections. In what manner these are to be given to the public, if indeed we should ever have it in our power to publish them, it is at present impossible to say."

In the same month, Banks sent the Admiralty an example of Bauer's and Brown's work, a watercolour of the Western Australian pitcher-plant, suggesting that the botanical results might be published serially and at a profit.

Bauer seems not to have wanted to toil under the eagle eyes of the President of the Royal Society, Sir Joseph Banks, and Brown, who was to become the greatest British botanist of the century. Banks wrote to the Admiralty:

"The whole of the collections of Mr Brown are in my House, I can therefore be answerable for their safety, Mr Bauer has however during my illness removed his Scetches & has them at present in his own Custody. I must therefore request their Lordships to give particular Orders to Mr Bauer to return these Scetches to me, that they may be kept in my House, not only for the sake of secure Custody, but because it is absolutely necessary that Mr Brown, who does all his business in my Library, should have before him the Scetch of every Plant during the time it is under his Examination, lest some misunderstanding of the Structure of those minute parts, on which systematic arrangement depends, should have taken place either on his part or on that of Mr Bauer, as not infrequently happens to the most expert naturalist …"[8]

By September, the editors of the *Annals of Botany*, one of whom was Carl Koenig, could report:

"We are happy to find that Mr. Brown and Mr. Ferdinand Bauer are sedulously employed in arranging their important materials for a work which cannot fail to prove a lasting monument to both their indefatigable zeal and the talents by which they were so eminently distinguished; the former as one of the most philosophical and accurate botanists of the day, the latter as an artist whose performances (like those of his brother) unite, with a truth hitherto unseen in botanical paintings, all the neatness, grace, and effect, so much admired in the works of a Mignon and Van Huysum."

While Brown brought order to Australian botany and set the seal on the Natural System,[9] Bauer was producing 'finished' drawings for the Admiralty at the rate of about one a week. Using his field drawing with the colour-chart code numbers as a basis, there is no doubt that he added and modified his work in the light of fresh material and other specimens, so that in at least several cases, no particular plant is the one actually depicted. When working in Oxford for Sibthorp he had used the

PLATE 51 *Brasenia schreberi* J.F. Gmel. (Nymphaeaceae)
Watercolour by Franz Bauer (Kew Plants 4), probably drawn from a plant growing in Kew Gardens.
The specific name, *schreberi*, commemorates the German physician and naturalist, Johann Christian
Daniel von Schreber (1739–1810), who coined the name *Brasenia* probably after the Reverend
Christoph Brasen (1738–1774), a Moravian missionary in Greenland and Labrador.*

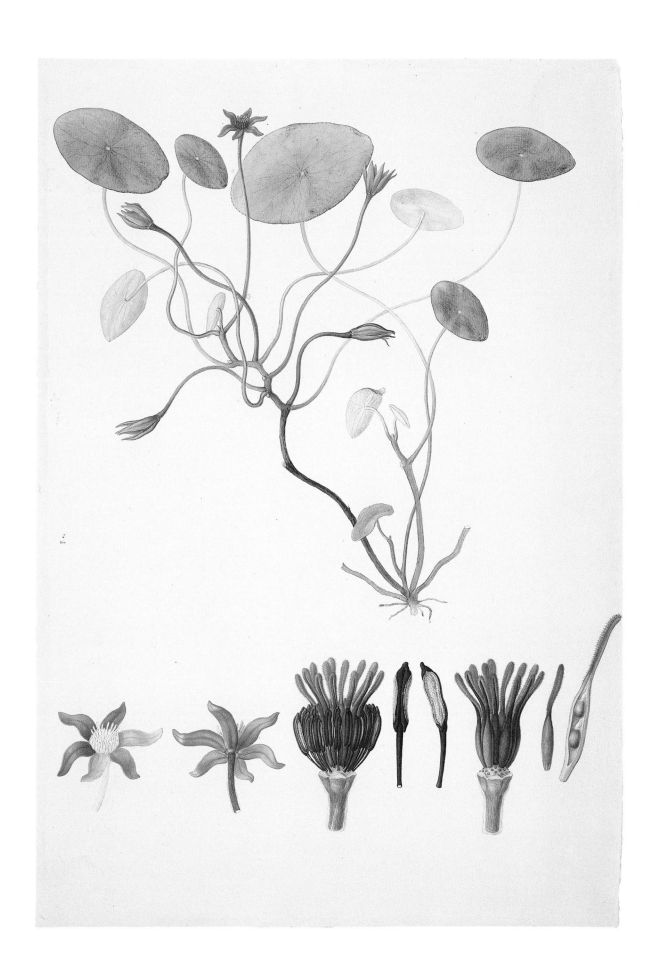

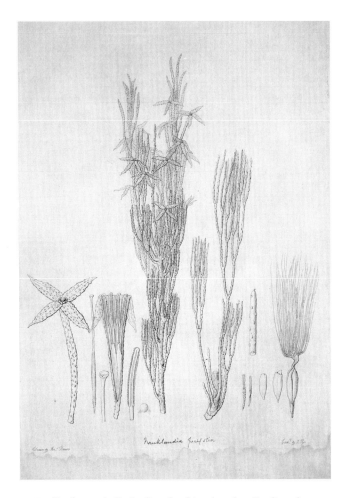

24 *Azolla pinnata* R. Br. (Azollaceae). Proof engraving by Francis Sansom (M. Flinders, *A voyage to Terra Australis*, 2, t. 10 [top], 1814) based on a Bauer drawing portraying plants perhaps collected near the Hawkesbury River, New South Wales. This water fern can double its weight in seven days, forming a cover to the water, so is useful in controlling mosquitoes; it is infested with colonies of nitrogen-fixing blue-green algae, so it is also a valuable green manure and stockfeed.* The generic name is from *azo*, Greek for dry and *olluo*, kill, recording the fact that it cannot tolerate drying out.

23 *Franklandia fucifolia* R. Br. Proof etching, based on Ferdinand Bauer's drawing, by 'I. Pye' (?John Pye, 1782–1874) (The Natural History Museum); prepared for Flinders's *A voyage to Terra Australis*, though the published image was, like the others in Flinders's book, not etched.* Previously unpublished. The drawing was also used later in Vienna as the basis for a lithograph by Gebhart, published in Stephan Endlicher's *Iconographia generum planatarum*.

living materials raised in the Botanic Garden there to improve his drawings. Plants were now being sent up from Kew to Dryander, who was assisting in the production of a new edition of William Aiton's *Hortus kewensis* (1789). By 1806 there were some ninety-five species of Australian plants growing at Kew and Bauer's drawing of *Andersonia sprengelioides*, for example, was entirely based on material raised there.[10] Bauer duly added Kew-grown specimens to his herbarium. By 1811 Bauer had produced some 203 drawings, which are the larger ones preserved in The Natural History Museum today. Their accuracy

PLATE 52 *Franklandia fucifolia* R. Br. (Proteaceae)
Watercolour by Ferdinand Bauer (Australian Botanical Drawings 128), based on a (lost) field sketch made at Albany, Western Australia in December 1801. Previously unpublished. The generic name commemorates Sir Thomas Frankland (1750–1831), algologist, punningly associated with the species name, which means "with leaves resembling the seaweed, *Fucus* [a genus of brown algae]".

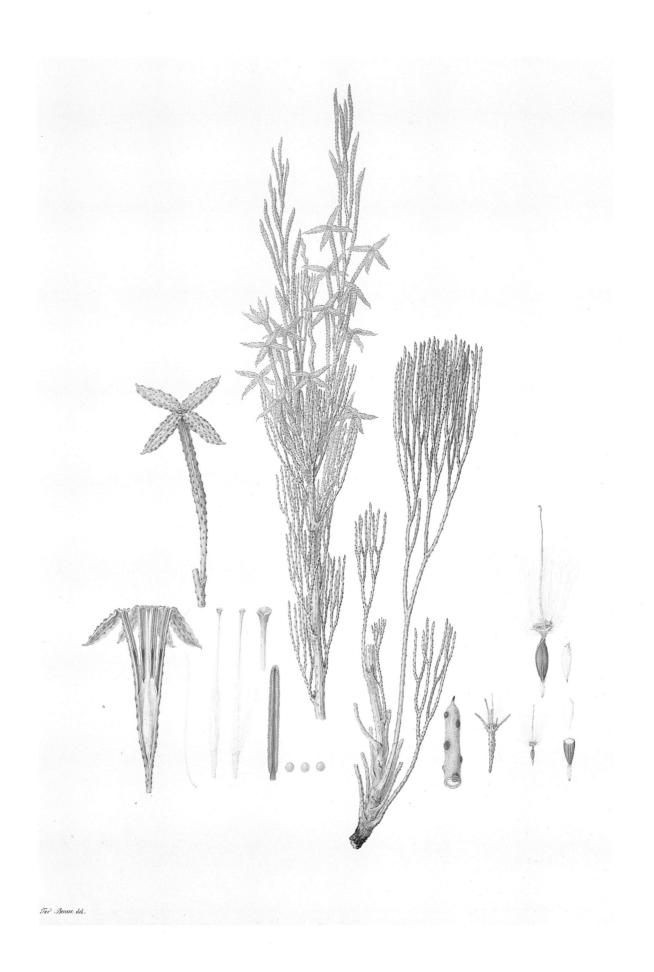

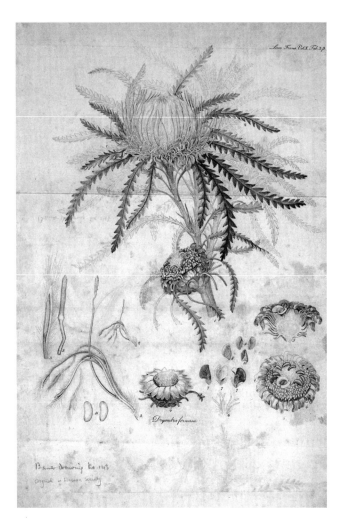

25 *Dryandra formosa* R. Br. (Proteaceae). Engraving by Sowerby
(*Transactions of the Linnean Society*, 10, t. 3, 1810), based on a watercolour
by Ferdinand Bauer, preserved in the Linnean Society of London,
probably drawn from material collected near present-day Albany,
Western Australia, December 1801 – January 1802.* *Dryandra* com-
memorates Jonas Dryander (1748–1810), Brown's predecessor as Sir
Joseph Banks's librarian.

and beauty has perhaps never been surpassed. The addi-
tion of the botanical minutiae demanded by Brown, the
interior structure of seeds and pollen, besides the gross
structure of the floral parts seem to enhance, rather than
detract from, the compositions. What is remarkable is
that despite all that had happened to him in working for
first Sibthorp and now Brown and Banks, his style did
not diverge from that of his brother Franz. It is illumi-
nating to compare the work of the two in depicting the
same species, *Brasenia schreberi*. Ferdinand's is based on a
field drawing perhaps enhanced with living and pre-
served collections at Soho Square, and Franz's was prob-
ably from a plant grown under glass at Kew: the
similarities are breathtaking.

At some time after the voyage, Bauer was working up
landscapes for John Hawkins;[11] among them is one of
Oxford, perhaps prepared with the thought of submis-
sion to the Delegates of the University Press for their
almanacks, as was the case of those made before his
Australian adventure (fig. 6, p. 16). Certain, though, was
publication of engravings made from his drawings for
the *Transactions of the Linnean Society*, overseen by Brown. Two
of his illustrations of Proteaceae appeared in Brown's
monumental monograph on that family, 'On the
Proteaceae of Jussieu', perhaps first issued as a pam-
phlet, *On the natural order of plants called Proteaceae* (1810); these
illustrations were *Knightia excelsa*, probably drawn for
Banks before the voyage of the *Investigator*, but now added
to with pollen grains and other details by Bauer, and
Dryandra formosa, based on his watercolour now preserved
at the Linnean Society of London. Also there, is his
pencil original for Smith's paper on *Brunonia* also pub-
lished in the *Transactions* (1811). In the monograph on

PLATE 53 *Chiloglottis reflexa* (Labill.) Druce *sensu lato* (Orchidaceae)
Watercolour by Ferdinand Bauer, labelled *C. diphylla* in his own hand (Australian Botanical Drawings
202B), from Bauer's personal collection, made, possibly in Sydney, from a field sketch, perhaps
drawn from material collected at Old Toongabbie, Sydney, 16 March 1805.* Previously unpublished.
The generic name comes from the Greek *cheilos*, a lip, and *glottis*, a modified form of the Greek for
tongue, referring to the flowers: these are sexually attractive to male thynnid wasps which effect
frenzied pollination (pseudocopulation) in passing from flower to flower.

Chiloglothis diphylla.
Brown prodr. 323.

Proteaceae, Brown initiated the use of pollen grains as useful taxonomic characters: Bauer added these to his later illustrations which are therefore an advance on the earlier 'finished' Admiralty drawings: this is particularly marked with respect to the *Brunonia*.

In 1810 Flinders returned home and began at last the preparations for publication of the results of the *Investigator* voyage. For the book, *A voyage to Terra Australis*, nine of Bauer's finished drawings were used as the bases for engravings to be prepared by Elizabeth Byrne, John Pye and Francis Sansom. In addition, two other plates, of *Eupomatia laurina* (from the Sydney region) and *Eucalyptus tetragona* (from Lucky Bay, Western Australia), have no finished drawings known, suggesting that Bauer prepared them, like the *Brunonia* for Smith, straight from his pencil drawings. He was paid £26 5s. od. for the work.

Flinders's book, in two volumes, was not published until 1814, the year he died, a broken man; Lambert, referring to Flinders's captor, labelled the book as "a lasting monument of disgrace to Governor de Caen".[12] The first part of Robert Brown's work came out as a singularly unattractive, poorly printed book, *Prodromus florae Novae Hollandiae et Insulae van Diemen* (1810). Despite its being rightly considered in the scientific world as the greatest leap forward of the century in classificatory principles, it was a financial disaster.

The *Prodromus*, rather like Smith's *Prodromus* for *Flora graeca*, as its name suggests, was supposed to be the forerunner of a more substantial work. Unlike Sibthorp's work, though, it was never intended that all of Bauer's drawings would be published. Banks probably had in mind something similar to William Roxburgh's *Plants of the Coast of Coromandel*, which had been coming out in parts under Banks's auspices since 1795. Just after the *Prodromus* appeared, Brown wrote to a friend:

"As to myself after finishing my Prodromus & waiting a reasonable time for the public assistance in publishing the Flora itself, I shall be under the necessity of looking round me with a view of changing & I hope bettering My situation, which at present is far from desirable. Scotland Ireland America India & even Botany Bay alternately present themselves, but I have nothing as yet like a plan, nor am I willing to think much upon the subject until I finish my 2nd volume."

But a fortnight later he added:

"I have at present very little hope of being able to accomplish [the Flora] as I could wish, or indeed in any manner for with respect to it there seems to be such a freezing indifference in a quarter where I hardly expected it."[13]

Banks seems to have declined to push for further funding: unlike *Flora graeca*, there was no endowment to cover the enormous costs of preparing the plates. The Napoleonic Wars were not a good time for large botanical plate-books in any case: there were many spectacular failures. Lacking encouragement from Banks, no more of Brown's incomplete book was to be published, though Brown worked on it until 1816 at least, many of his findings being incorporated in his other publications. When Banks abandoned the project, just as he had abandoned

PLATE 54 Trigger plant *Stylidium violaceum* R. Br. (Stylidiaceae) Coloured engraving by Ferdinand Bauer (*Illustrationes florae Novae Hollandiae*, t. 5, 1814), made in London directly from field-sketches (1536 and 1538) drawn at King George Sound, Western Australia, in December 1801 and now preserved in Vienna.* The generic name comes from the Greek *stylos*, a column, as the stamens and style are united in a single column in the flower. Trigger plants have a flexible column which is sensitive to touch, swinging round and showering visiting insects with pollen. Bauer made many drawings of these and was perhaps working towards illustrating a monographic treatment of them: Brown's manuscripts include 'Observations on Mr Bauer's Stylidia'.

Stylidium violaceum.

Brown prod. fl. nov. holl. p. 569. 19.

Ferd. Bauer.

26 Ferdinand Bauer, *Illustrationes florae Novae Hollandiae* (1813–16).
Title page of Bauer's own copy, now in The Natural History
Museum, London.

his own on Australian plants deriving from Cook's voyage – though there he had got as far as having the plates engraved – Bauer, who retained his expedition sketches and herbarium, and worked on the Admiralty drawings until at least 1 January 1812, tried to salvage some financial success from it.

Bauer continued building up his own collection of watercolours based on materials collected on the *Investigator*. As the animal drawings with watermarks show, they were not begun before 1811: but, as with his zoological drawings for Sibthorp, none of these was to be published in his lifetime. No doubt with encouragement from Brown, he started to prepare a set of botanical engravings as his own venture.[14] It is possible that he continued the series he may have begun in Sydney, and, by his death, he certainly had a collection made of both animals and plants. The venture became one of serially produced fascicles of watercolour plates intended to illustrate the more interesting new genera in Brown's *Prodromus*. The first fascicle of five of his *Illustrationes florae Novae Hollandiae* appeared late in 1813, with a title page and an unsigned Latin introduction by Brown, who may have thought sales of his own book would improve with Bauer's work to accompany it. A reviewer in the *Monthly Magazine* noted:

"No letter-press will accompany the plates but with the first number is given a general table, to which the letters, figures and marks on each plate refer. Thus, by always preserving the same characters to denote similar parts, one general table of explanation serves the whole … The drawings, we are informed in the Preface, have been, for the most part, made from the living plants in their native soil … For some of the

PLATE 55 Gymea lily *Doryanthes excelsa* Correa (Doryanthaceae)
Coloured engraving by Ferdinand Bauer (*Illustrationes florae Novae Hollandiae*, t. 13, 1816), made directly
from field sketches, now lost, probably drawn from material growing at Georges River, Sydney.
Found only in eastern New South Wales, this is a huge *Agave*-like plant now much used in 'architectural' plantings in Sydney; like those of New Zealand flax, *Phormium tenax* (Phormiaceae), its leaves
have been considered for use as fibre-sources. The generic name comes from the Greek *dory*, spear,
and *anthos*, flower, referring to the spear-like inflorescences thrust several metres into the air.

Doryanthes excelsa

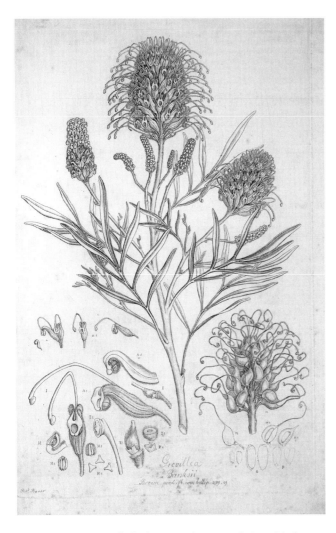

27 Red silky oak *Grevillea banksii* R. Br. (Proteaceae). Proof, before letters, of engraving by Ferdinand Bauer (*Illustrationes florae Novae Hollandiae*, t. 9, 1813–14), based on a field sketch, now lost, prepared at Keppel Bay, Queensland, August 1802. It differs markedly from the finished Admiralty drawing now in The Natural History Museum, showing that Bauer had to start all over again in preparing drawings for his own venture. The generic name commemorates the Hon. Charles Greville (1749–1809), a founder of the Horticultural Society (later the Royal Horticultural Society) and the one who recommended the gardener Peter Good for the *Investigator* voyage.

genera, not detected in this voyage, Mr Bauer is indebted to the collection of drawings made under the direction of Sir Joseph Banks, during Captain Cook's first voyage round the world; and some few will necessarily be taken from dried specimens, preserved in the herbarium of this botanist, or in that of Mr Brown."

The lack of other letterpress was in the style of Franz Bauer's short-lived *Delineations of exotick plants cultivated in the royal garden at Kew* (see p. 52) and had the advantage of the artist forging ahead without waiting for text from others. This was particularly important in any undertaking involving Brown, who was one of the most difficult of collaborators, being almost obsessively concerned not to make a mistake in print and so generally putting off further and further any publishing work done after the *Prodromus*.[15]

The plates were issued unnumbered but, in many copies, numbers have been added very neatly by hand, so as to appear, without a microscope, to be printed. Bauer sold them himself, offering coloured sets at a guinea (later a guinea and a half), plain sets at 5 shillings. In December 1813 he sold some plain sets to booksellers at 7 shillings. A second set of five, all but two unnumbered, was available by September 1814, probably issued just before Bauer left for Vienna in that August. The last was of *Brunonia*, the last genus in Brown's *Prodromus*. Where the illustrations are based on the same original drawings used for the early Admiralty ones, they differ in having greater detail, particularly in the pollen and seed structure, no doubt due to Brown's influence. Bauer not only engraved but also coloured the plates himself. They are an advance on those for *Flora graeca*[16] in that they use stippled colours rather than body, though they are not as finely engraved as Sowerby's *Flora graeca* plates.

Meantime, things had changed for Brown. From his lodgings in Great Russell Street, Bauer wrote, in English, to his brother on 20 October 1810:

"Dear Brother
It is with much grieve that I have to acquaint you, that yesterday evening Mr Brown coming from Sir Joseph

Bankses House, called and informed me that our good friend Mr Dryander is dead – he died about 7 O'Clock in the Evening –

 I remain with sincerity
 Dear Brother
 Yours Ferd Bauer"[17]

Banks promptly appointed Brown librarian in Dryander's place, but it was Bauer who had to write (again in English) to Franz on Brown's behalf about funeral arrangements for Dryander.[18]

Bauer had continued collaboration with Brown. He made a drawing of the seed of *Caulophyllum thalictroides* (Berberidaceae), which had previously been mistaken for a fruit, its embryo as the seed, from living material at Kew in 1812. It was published in 'On Some Remarkable Deviations from the Usual Structure of Seeds and Fruits', though this did not appear in the *Transactions of the Linnean Society* until Bauer was back in Austria.

According to Franz Bauer, writing to his friend, Baron Jacquin's son Joseph in September 1814, Ferdinand:

"… since his return from his Voyage to Terra Australis, was about six years employed by the Admiralty, to make finished Drawings of the most interesting Plants from that part of the World; those drawings are now deposited in the Library of the Admiralty, where nobody ever can see them again."[19]

At the Admiralty,[20] the drawings were bound in three volumes, in a sequence corresponding to the *Prodromus* and Brown's projected second volume of that unfinished work. By 1834, when they were examined by the explorer–botanist Allan Cunningham (1791–1839), one of the drawings had been lost. Cunningham wrote angrily:

"It is a known fact that for some time after the drawings were [sent] to the Admiralty, they were laid on the table of the drawing room of the then first Lord Melville [Robert Dundas, second Viscount Melville, First Lord of the Admiralty from 1812], where they were exhibited as Portfolios as most souvenirs etc. usually are – Thus exposed to inquiry in the hands of a person, utterly ignorant of Botanical Science, & therefore totally incompetent to appreciate their real worth, it is not a subject of surprize that one of the No. of these beautiful drawings should be missing. The wonder is that but one had been carried off … ."

In 1843, the Admiralty made over the drawings to the British Museum; on Robert Brown's death in 1858, Bauer's private collection of Australian drawings of animals and plants came to the Museum. In 1881 they were moved with all other natural history materials to what is now The Natural History Museum. The animal drawings went to the Department of Zoology and are now in the Zoology Library of the Museum; all the Bauer botanical drawings (234 in all) were put together, with two extraneous drawings of Australian plants by another artist, and stored in boxes, Bauer's personal drawings being referred to as 'duplicates'.

NOTES

1 Mabberley (1985), ch. 8.
2 Norst (1989), p. 68.
3 Watts *et al.* (1997), p. 22.
4 Mabberley & Moore (1999).
5 William Roscoe draft letter to J.E. Smith (Roscoe Collection letter 4513, Brown, Picton & Hornby Libaries, Liverpool).
6 Mabberley (1985), ch. 8.
7 Mabberly & Moore (1999).
8 Mabberly & Moore (1999).
9 Mabberley (1985), ch. 9.
10 Mabberly & Moore (1999).
11 Lack with Mabberley (1998), p. 114.
12 Mabberley (1985), p. 190.
13 Mabberley (1985), p. 174.
14 Mabberly & Moore (1999).
15 Mabberley (1986).
16 Mabberley (1985), p. 173.
17 Brown MSS B. 94, letter 27.
18 Brown MSS B. 94, letter 28 .
19 Norst (1989), p. 76.
20 Mabberly & Moore (1999).

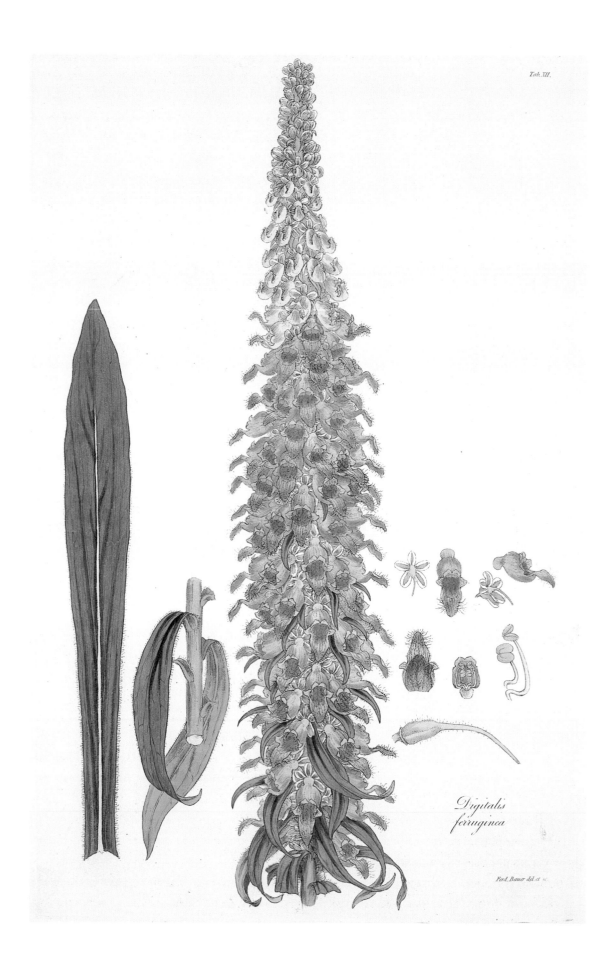

Tab.XII.

Digitalis ferruginea

Ferd. Bauer del. et sc.

Vienna Again

London Twice More?

When Bauer left for Austria in August 1814, his luggage filled fourteen large cases.[1] It is not clear what his motivation for returning to Vienna was, whether it was his family, inheritance or an invitation to carry out commissions. As *Illustrationes* was such a financial disaster, it is likely that he returned home for more lucrative work. He had already returned to painting elaborate oils of flowers whilst still in Great Russell Street and it may have been such a flowerpiece that Brown bought for £1 8s. at the sale of Franz's effects in November 1841.[2] They very occasionally appear in the art market, the most recent one offered, in London in 1999,[3] being one of passionflowers that Bauer had painted in London before his return to Vienna. It was first exhibited at the Royal Academy of Arts in 1813 and, despite its being damaged, was sold on 22 June 1999 for £30,000.

In September 1814, Franz wrote to the younger Jacquin of *Illustrationes*:

"… but though the work is highly approved off, the sell of it here is so inconsiderable that my Brother could not clear the fiveth part of his expenses; he therefore determined to leave England and packet up his whole collection of Drawings, consisting of more 2000 of plants, several hundrets of animals, Birds, fishes, snakes etc. etc. …"[4]

But Ferdinand did not completely abandon *Illustrationes*. He completed five more plates to be sold as a third fascicle, which was ready towards the end of 1816. He wrote from Vienna to Brown in London[5] on 29 November, sending coloured and plain copies: Brown was in effect Bauer's 'publisher', presenting and selling copies in London, where the bookseller White had already been sent six plain copies. Bauer had made no arrangements with the Vienna trade but had tried to interest agents in Paris; it is not known if he had any success. Nonetheless, Brown wrote to Franz the following February:

"I rejoice to hear that he is making progress with his excellent work. I intend writing very soon & the thing I have to say, which perhaps you will insert in your

PLATE 56 Rusty foxglove *Digitalis ferruginea* L. (Scrophulariaceae)
Engraving by Ferdinand Bauer (J. Lindley, *Digitalium monographia*, t. 12, 1821) from his drawing (now in the Royal Horticultural Society) (*ca.* 1819). Native in southern Europe and western Asia.

letter, is that more copies of his Nos 1 & 2 a dozen at least should be sent over, those left with me being sold & more wanted."[6]

Samuel Gray (1766–1828), in reviewing the first fascicle, had said:

"We hope that Mr Bauer will meet with due encouragement to proceed … the circumstances of the time, it must be allowed, are not very favourable to the prosecution of works of this nature, yet it would be a disgrace to the nation, if this excellent artist should not be able to proceed from want of encouragement, whilst under similar difficulties, not one only, but several expensive works are carrying on at the same time in Paris."[7]

The French works included E.P. Ventenant's *Jardin de la Malmaison* (two folio volumes, 1803–1805) under the patronage of the Empress Josephine, who had had a kind of Australian landscape with native trees and shrubs, kangaroos and other animals established at Malmaison after the return of Baudin's expedition. The *Jardin de la Malmaison* had 120 engravings by P.J. Redouté, including coloured plates of a number of plants Bauer himself had drawn on the voyage of the *Investigator* but which were never published in colour. One of these, no less than *Josephinia imperiatricis* (Pedaliaceae), named after the empress herself, was published by Stephan Endlicher in 1840, but the French illustration appeared in 1804 before Bauer had even left New South Wales.

Despite Gray's appeal to national pride, Banks did not change his mind and Bauer struggled on without patronage. From his letter of 1816 there is no question that he was working on a fourth fascicle, but the third was the last to appear, no doubt being as financially disastrous as the first two had been. The last four of the five numbered plates of the third fascicle differ from those in the first two in that three of them are devoted to just one plant, the statuesque *Doryanthes excelsa*, the Gymea lily, an important plant in Aboriginal folklore and which is as conspicuous a plant in the gardens and municipal plantings of the Sydney area as it is in the bush. The last plate has two species of Trigger-plants (Stylidiaceae), one drawn from a dried specimen in Brown's herbarium.

It is likely that fewer than fifty sets of plates of *Illustrationes* were prepared: there is no copy in either The British Library or The National Library of Scotland. The copy in The Natural History Museum is Bauer's own, complete with a list of subscribers in his own hand and a coloured example of his plate of *Lambertia formosa*. It was perhaps the copy bought by Brown for 3½ guineas at the sale of Franz Bauer's effects in 1841.[8] The unsold engravings and the fifteen copper plates, also now in The Natural History Museum, were auctioned at Ferdinand's death, as his will stipulated.[9] The engravings were bought by Endlicher and were then dispersed. A complete copy of the book was sold for £40 in 1940, another for £300 in 1965; in New York a copy went for $US 24,000 in 1982 and, in 1988, a copy with both coloured and plain sets of plates was bought for $Aus 120,000; such a copy was sold in Sydney for $Aus 125,000 in 1997. In the 1980s the copper plates now in The Natural History Museum were cleaned and chromium-plated. Thirty-five sets of plates were printed from them: a set cost £13,000.

The *Illustrationes* would seem to have been the end of Bauer's *Investigator* work, but very recently[10] it has been realised that his pencil drawing of a plant, *Rhynchoglossum obliquum* collected on Timor on 1 April 1803, was the basis

PLATE 57 *Rhynchoglossum obliquum* Bl. (Gesneriaceae)
Engraving by Franz Bauer (as *Loxotis obliqua*, Horsfield, *Plantae javanicae rarariores*, t. 24, 1838), from a drawing by Ferdinand Bauer (*ca.* 1824), based on a field drawing made on Timor, April 1803. The field drawing was also used as the basis for the intended 'Antonia', incorporated in Jacquin's *Denkmal*, Johann Knapp's monumental portrait of Baron Jacquin. The name comes from *rhynchos*, Greek for 'beak', and *glossa*, Greek for 'tongue'; *obliquum* refers to the leaf shape.

Tab. XXIV.

LOXOTIS OBLIQUA.

III

for one of the flowers in the wreath in an extravagant oil painting of Baron Jacquin by Johann Knapp, a painting now hanging in the Osterreichische Galerie, Vienna. Bauer had asked Brown to name the plant *Antonia*, after archduke Anton, a great connoisseur of botanical art. Before the name was published there was another *Antonia*, so Brown reverted to his original name for it, *Loxotis*, now a synonym of *Rhynchoglossum* (Gesneriaceae), though Bauer seems to have wanted it to be *Knappia*. No doubt Bauer wished to flatter the archduke and perhaps later Knapp, who worked for Anton. Perhaps an examination of archives in central Europe will reveal whether Bauer himself had a hand in Knapp's work, or whether Knapp helped obtain commissions for him or even had been the initiator of Bauer's returning to court circles in Vienna. It seems likely that this kind of work was more lucrative and certainly less demanding on the eyes of the painter than the fine microscopic and engraving work his more scientific commissions required. It may well be that it was this work that enabled him to live in comfort and so be able to leave a house and contents to his brothers at his death.

Bauer's *Rhynchoglossum* had been worked up into a drawing for publication in Thomas Horsfield's *Plantae javanicae rariores*, for which Brown was supposed to be writing the text. Horsfield, an American working for the East India Company, sent specimens to Brown: they had started arriving in 1814[11] and Brown made lists of them. Brown began work on describing them in 1821 and commissioned plates, the cost being subsidized by an advance of 125 guineas from the East India Company. The engraving by Franz Bauer for the *Rhynchoglossum* alone cost £3 10s. When it came to publication, however, Brown, occupied with his other research and administration, pro-

crastinated. In 1836 the organizing of the botanical descriptions was taken over by his assistant, J.J. Bennett, and the first part including the *Rhynchoglossum* appeared in July 1838.[12]

Ferdinand Bauer not only worked on his flowerpieces and botanical work for the Vienna scientists, but he also accepted two major commissions for illustrated monographic works and prepared plates for them largely from preserved material in both Vienna and London. Once again, this came about through Banks.

The first probably arose from the publication of one of Bauer's Norfolk Island drawings by Banks's friend William Cattley (1787–1835), who was a rich businessman with a large garden at Barnet in Hertfordshire. There he grew a wide range of plants both outside and under glass. He built up a collection of botanical drawings: among these many were of his new plants that he had had drawn. He now wanted these illustrations to be published but he needed an editor for what was to become his *Collectanea botanica*. He turned for advice to Banks, who suggested John Lindley, later to become secretary of the [Royal] Horticultural Society and editor of Sibthorp's *Flora graeca*, but was then a young assistant to Brown in Banks's library and herbarium. Lindley had been introduced to Soho Square by William Jackson Hooker, later to be Director of Kew and who, like Lindley, was from Norwich. Cattley took Lindley on and paid him a salary to do the work.[13] His name was to be immortalized by Lindley in the name of one of the plants he had grown and which was portrayed in the book, *Cattleya labiata*, a hothouse orchid from Brazil. Lindley had already brought out a monograph on roses in 1819 but *Collectanea*, dedicated by Lindley to Sabine, the honorary secretary of the Horticultural Society, was

PLATE 58 *Stifftia chrysantha* Mikan (Compositae)

Lithograph by Johann Knapp (J.C. Mikan, *Delectus florae et faunae brasiliensis*: t. [1] (1820) from a drawing by Ferdinand Bauer, made from herbarium material collected by Mikan near Rio de Janeiro, Brazil 1817–18.* An evergreen shrub cultivated under glass in Europe. It is remarkable that the artists felt able to ascribe colours to the plate based on a dried specimen; *chrysantha* comes from the Greek for gold-flowered.

Stifftia chrysantha

Knapp in lapid. del.

Lithogr. Kuuike exc.

113

28 John Lindley (1799–1865)

flower plate associated with a Vienna commission, the illustrations to Johann Christian Mikan's folio *Delectus florae et faunae brasiliensis*, which was issued in four parts between 1820 and 1825.[14] In it Bauer's drawings prepared from herbarium materials were to be published. The book dealt with new species of lepidoptera, birds, snakes, tortoises and a monkey, as well as plants, from Brazil, and was illustrated with hand-coloured lithographed plates. It covered some of the novelties brought back from an expedition of 1817–18 made by Mikan with Johann Emmanuel Pohl (1782–1834) – who obligingly named the genus *Antonia* (Loganiaceae) for the archduke before Brown could get round to granting Bauer's wish for his *Antonia* – and Heinrich Wilhelm Schott (1794–1865). They were sent by the Emperor to get materials for the imperial zoo and the garden at Schönbrunn, as part of the suite of Leopoldine, archduchess of Austria, who was travelling to South America to meet her husband Pedro, eldest son of the King of Portugal. She had married him by proxy, the Portuguese royal family being in exile during the French occupation of their country.

All the plants drawn for *Delectus* were thought to be species new to science, five of them representing new genera. The authors took the opportunity to honour local dignitaries, notably *Metternichia* (*M. principis!*), for Prince Metternich (1773–1859: "I governed Europe sometimes, Austria never"), who had arranged Leopoldine's marriage, as well as the expedition, and to whom the whole lavish production was dedicated. *Stifftia* was named after Dr Andreas Freiherr von Stifft (1760–1836), physician to the Hapsburg Court. According to Mikan, Bauer drew two plates from dried specimens then in Vienna from the expedition: *Stifftia chrysantha*, from a specimen collected near Rio de Janeiro by Mikan himself, for which the lithographic plate was prepared by Knapp, and *Vellozia*

being published in parts, under Cattley's patronage. The folio *Collectanea* was illustrated with forty copper engravings of drawings by Franz Bauer's pupil, William Hooker, besides the unrelated William Jackson Hooker, John Curtis, Lindley himself and others, and came out in eight parts between 1821 and 1826. Twenty-nine of the plates are represented by original drawings preserved in The Natural History Museum, which acquired them in 1897. One of the other plates is based on a Ferdinand Bauer drawing, which Lindley had on loan in 1821. This was of *Passiflora aurantia*, based on a pencil sketch made on Norfolk Island in 1804–05. The watercolour Lindley used is preserved in Kraków, Poland: it was published as *Murucuja baueri*, probably in 1821.

Bauer had painted passionflowers in the oil he sold in London, but exactly when he was invited to illustrate a monograph on passionflowers for Lindley is unclear. It is possible that it was after preparation of a passion-

PLATE 59 Foxglove *Digitalis purpurea* L. (Scrophulariaceae)
Engraving by Ferdinand Bauer (J. Lindley, *Digitalium monographia*, t. 2, 1821) from a drawing (*ca.* 1819),
now lost. Native throughout western Europe, formerly the main source of the heart drug digitalis,
the principal agent of which, digoxin, now being largely extracted from *Digitalis lanata* Ehrh. of central Europe, which is grown commercially in The Netherlands.

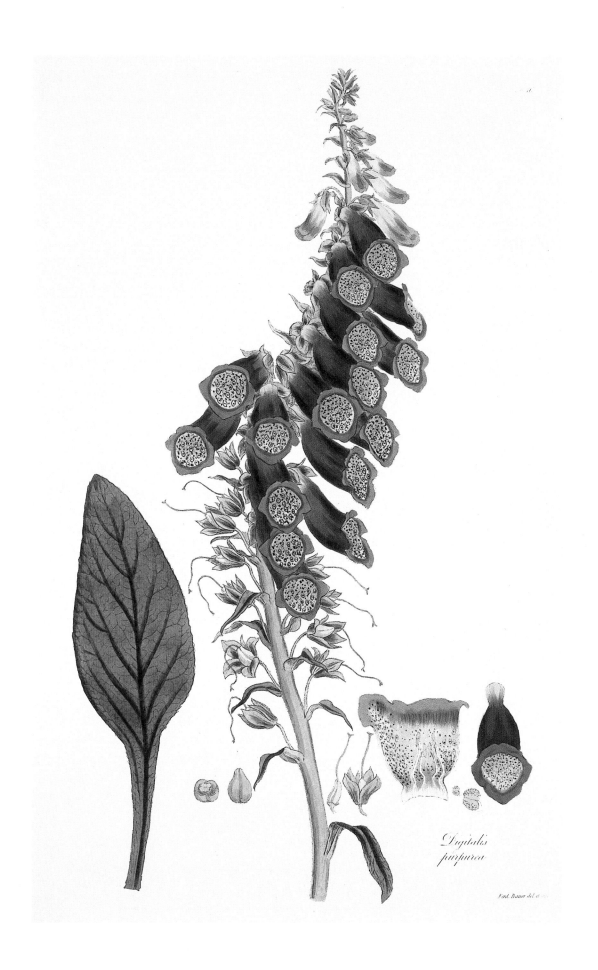

*Digitalis
purpurea*

Ferd. Bauer del. et.

candida. He also drew the floral analyses of *Conchocarpus* (i.e. *Angostura*, Rutaceae), of which the main part of the plate had been drawn by Buchberger from live material in the field. The materials from the expedition were then housed in the Brazilian Natural History Museum "in der Johannisgasse im Graf Harrachischen Hause" but have since been moved to the Natural History Museum in Vienna. Some of the other botanical plates were drawn from Brazilian material cultivated under glass in Vienna. This included the passionflower, apparently drawn by Schott, perhaps under the supervision of Bauer,[15] who certainly made his own watercolour drawings of that species. The expedition drained Mikan who, in 1826, had to give up his post as professor of natural history in the University of Prague, which is perhaps why his book ended with the fourth part – yet another aborted extravaganza in natural history publishing associated with Bauer.

While Cattley's *Collectanea* was appearing back in England, its editor, Lindley, turned to another group, the foxgloves, which had become important since the discovery in the 1780s by Dr William Withering of their efficacy in treating heart disease. Bauer's drawing of *Digitalis lutea* appeared in Cattley's *Collectanea* in 1821. Perhaps this was Lindley's inspiration for Bauer's commission: he began his monograph of *Digitalis* under Cattley's patronage. The resulting folio book has twenty-eight copper engravings, each of a single species, all but five of them issued hand-coloured; twenty-seven original drawings are preserved in the library of the Royal Horticultural Society in London with Lindley's own copy of the book and a presentation copy from Cattley to Franz Bauer. Five plates were drawn by Lindley himself, the frontispiece by Franz Bauer (the original is not at the Royal Horticultural Society), and the rest by Ferdinand, so that it seems likely that Bauer came back to England in 1819[16] to work on the project. Bauer engraved his own plates but it would appear that Lindley completed the work after Bauer left London by adding his own and writing the Latin text. Two of Bauer's plates were based on drawings he made in Greece while with Sibthorp (t. 13 – the Rusty foxglove, *D. ferruginea* (*D. aurea*), on Mount Olympus, and t. 18 – *D. viridiflora* on Mount Athos). Some were drawn from live plants at Kew, supplemented with herbarium specimens in Banks's herbarium; others were of material cultivated in nurseries in the London area, notably Lee & Kennedy in Hammersmith and Thomas Bush Bell at Brentford End, Isleworth, Middlesex, near Banks's house, Spring Grove. Several of the plants drawn were later shown to be hybrids and they include plate 19, *Digitalis rigida*, drawn from material grown at the Cambridge Botanic Garden, and plate 21, *D. lutescens*, from material seen by Bauer at the Heidelberg Botanic Garden, perhaps on the way to London from Vienna. All such hybrids in the foxgloves, most of them *D. purpurea* × *D. lutea* (= *D.* × *purpurascens*), which occurs spontaneously in the wild, are sterile.[17]

The art critic Sacheverell Sitwell has compared the foxgloves with Bauer's *Pinus* work for Lambert:

"Lindley's monograph on the *Digitalis* (1821) shows Ferdinand Bauer in just the same trauma of calm ecstasy before the foxglove. Each and every spire is drawn by him as though he were drawing Magdalen Tower or the Giralda of Seville. The marvellous stippling and mottling of each flower is rendered with patient accuracy, each mullion is drawn; and the spire of bells, when finished, could be an

PLATE 60 *Isoplexis canariensis* (L.) G. Don f. (Scrophulariaceae)
Engraving (as *Digitalis canariensis*) by Ferdinand Bauer (J. Lindley, *Digitalium monographia*, t. 27, 1821) from his drawing (now in the Royal Horticultural Society) based on living material collected by Francis Masson and dried specimens in Banks's herbarium (*ca.* 1819). A woody-stemmed foxglove of the Canary Islands, introduced early to cultivation in Britain, where it was being grown by the Duchess of Beaufort in 1698. *Isoplexis*, meaning 'equal parts' in Greek, refers to the equal lobes of the corolla compared with those in *Digitalis*.

*Digitalis
canariensis.*

Fer.t Bauer del et sculp.

29 Stephan Endlicher (1804–1849)

architect's despair but the pride and delight of the campanologist."[18]

It is likely that during Bauer's London visit of 1819, he lent Lindley his Norfolk Island passionflower drawing, or may even have completed it. This is because Lindley, who became garden-assistant secretary of the Horticultural Society under Sabine in 1822, seems to have been the initiator on behalf of the Society of the other projected monographic work to be illustrated by Bauer, on the genus *Passiflora*, passionflowers. Bauer made forty watercolours[19] and seems to have been sending them to Lindley in instalments and working on them almost to the end of his life, one of the drawings having an 1825 watermark. Some were based on living plants at Schönbrunn, but besides the Norfolk Island species (plate 48), there is another from the *Investigator* voyage, "this plant I found on the banks of the river Hawkesbury in New South Wales", probably the native passion fruit, *Passiflora herbertiana*; some sketches were also made in England, perhaps during his second return visit, in 1824. They were bound in two volumes, the dissections of the flowers being in the second, smaller, one. The original pencil drawings were acquired by Franz at his brother's death, and were bought by Robert Brown for 18 shillings

at the sale of Franz's effects in 1841,[20] and they are now in The Natural History Museum's collection, filed with Franz Bauer's drawings.

In 1859 the finances of the Horticultural Society were so dire that its premises and library had to be sold: the finished drawings of passionflowers went to auction at Sotheby's and were bought for £24 by Friedrich Wilhelm IV, King of Prussia: he presented them to the Königliche Bibliothek, later the Preussische Staatsbibliothek in Berlin. Towards the end of World War II, they, with many other treasures such as music scores by Beethoven and Schubert, were evacuated and are now in the library of the Jagellonian University in Kraków, Poland.

It is also likely that in the 1820s, in Vienna, Bauer started preparing his Norfolk Island field drawings for a projected flora of that island by Endlicher. The drawings were traced and sometimes marked with colours: some were worked up as 'finished' drawings. Robert Brown saw four of them when he visited Vienna in August 1832,[21] when he was told that the book with 117 illustrations was being brought out at the Emperor's expense. Some lithographs were prepared by M. Fahrmbacher and two sets of these survive, some of them coloured. Some of the otherwise unissued lithographs for the Norfolk Island project appear to be the two Bauer illustrations used in Heinrich Wilhelm Schott's *Rutaceae* (1834).

Some of Bauer's inked orchid drawings reached Lindley, who put them in his herbarium, of which the orchid specimens are now at Kew, where there is a handful of Bauer drawings of other Australian plants. These apparently came to Kew through the hands of George Bentham, who visited Vienna in the 1830s in connection with his monographic work.[22] By then Bauer was dead and Stephan Endlicher could produce only his *Prodromus florae Norfolkicae* (1833). Nonetheless, some of Bauer's drawings were put to good use in Endlicher's other publications, notably ten in his *Atakta botanica* (1833–35), an unfinished large-scale serial work depicting new plant species, and eighty-eight in his *Iconographia generum plantarum* (1837–41), issued serially to illustrate his *Genera plantarum* (1836–1850). They are lithographs by C. Neunlist, M. Bauer and Gebhart and were published

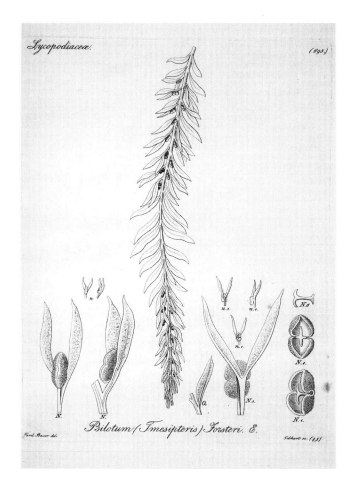

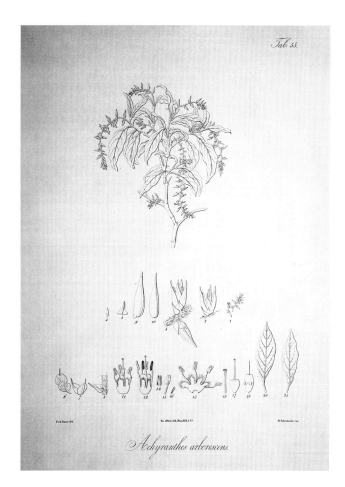

30 *Tmesipteris norfolkensis* P.S. Green (Psilotaceae). Lithograph by Gebhart [*Psilotum forsteri*, Endlicher, *Iconographia generum plantarum*, t. 85, 1839], from a field sketch made on Norfolk Island 1804–05 by Ferdinand Bauer, who discovered the species. It is restricted to Norfolk Island, where it grows as an epiphyte on the trunks of tree-ferns. The name *Tmesipteris* comes from *tmes*, Greek for 'incision', and *pteris*, Greek for 'fern', and refers to the paired sporangia.

31 *Achyranthes arborescens* R. Br. (Amaranthaceae). Unissued lithograph by M. Fahrmbacher, from a field sketch made by Ferdinand Bauer on Norfolk Island. Previously unpublished. An endangered species restricted to the island, it is a tree to 9 m tall, unlike all but one species in the family which is predominantly herbaceous including weedy plants such as pigweed (*Amaranthus* spp.). The generic name comes from Greek *achyron*, meaning 'chaffy', and *anthos*, meaning 'flower'; *arborescens* is Latin for 'forming a tree'.

uncoloured. Also in Vienna, Franz Antoine published two lithographs based on Bauer's drawings of the Norfolk Island pine in his *Die Coniferen* (1840–46). Bauer's drawing of the Norfolk Island palm, *Rhopalostylis baueri*, with others made in Queensland on the *Investigator*, were even borrowed from Vienna and London by Carl Friedrich Philipp von Martius (1794–1868) of Munich. They were redrawn for his monumental book on palms, *Historia naturalis palmarum* (1823–53).

All this industry on the Continent raised the ire of Lindley, who wrote scathingly in the *Gardeners' Chronicle*:

"With Flinders's voyage, a Botanist and a Botanical draughtsman were associated, at the public charge; and both these officers discharged their duty of collecting materials most zealously. But if we inquire for the public Botanical advantage which has been derived from that expedition, either to ourselves or to the New South Wales colonists we find that … [a] full account of the botanical discoveries made during

32 *Hydnora africana* Thunb. (Hydnoraceae). Previously unpublished. Original drawing made in London in 1824 by Ferdinand Bauer. Later published as an uncoloured engraving of 1834 by James Basire III (1796–1869) in Robert Brown, *On the female flower and fruit of Rafflesia arnoldi*, t. 6 (1844).* A beetle-pollinated parasite from South Africa restricted to *Euphorbia* spp. as hosts.

Flinders's expedition, which the public had a right to expect, has never appeared. The dried plants, or what remains of them, are to be found in the cases of the British Museum; and the beautiful plates made by Mr. Ferdinand Bauer with such care and admirable skill, after slumbering for years at the Admiralty, are now (we understand) also at the Museum. No publication of them has taken place in this country … what their merits are we chiefly know in consequence of their having been partially made public in VIENNA!"[23]

According to his biographer Jan Lhotzky (1800–*ca.* 1861), Bauer in old age still made botanical excursions in the Alps. In 1824 he certainly went back to England again, perhaps in connection with the passionflower project. It may well have been at this time that he worked up a drawing of a gesneriad he and Brown had collected on Timor in 1803 and which was published in Nathaniel Wallich's *Plantae asiaticae rariores* after Bauer's death. It is also possible that Bauer made the drawing from which his brother Franz engraved the plate of that other Timor gesneriad he had drawn, *Rhynchoglossum obliquum*, used in Knapp's portrait of Jacquin.

The brothers certainly worked together then, on parasitic plants to illustrate Brown's second great paper on the largest flowers in the world, those of the *Rafflesia* species from tropical south-east Asia. Although Ferdinand's work on the parasites was finished then, Franz continued drawing until 1831.[24] The original artwork, closely resembling the *Rhynchoglossum* in style, survives in the Franz Bauer collections in The Natural History Museum, but the plates were not to be engraved until 1834. Although Brown exhibited them at conferences on the Continent, they were not published until 1844, when they first appeared in a pamphlet by Brown, *On the female flower and fruit of Rafflesia arnoldi …*,[25] which was issued shortly afterwards in the *Transactions of the Linnean Society of London*. Brown wrote:

"The figures of Rafflesia [by Franz] and Hydnora, which so admirably illustrate, and form the more valuable part of this communication, are among the best specimens of the unrivalled talent of the two brothers Francis and Ferdinand Bauer who, as botanic painters, equally unite the minute accuracy of the naturalist with the skill of the artist."[26]

And of Ferdinand's drawings of *Hydnora africana*, Brown wrote: "They were probably the last drawings he ever made of an equally interesting and difficult botanical subject, and I consider them his best." Indeed they were so good, that they were redrawn almost a century and a half later for Job Kuijt's *The biology of parasitic flowering plants* (1969).

Despite his apparently making the bulk of his money from commissions for flowerpieces, Bauer had kept up his unparalleled skills to the very end: some of his last drawings were based on sketches he had made with Sibthorp in the Mediterranean and with Brown in the tropics decades before. In old age he lived at Schmidtgasse 155 in Hietzing, a smart district near Schönbrunn Palace; the house has been demolished and replaced by a nineteenth-century one, Gloriettegasse 12.[27] There Bauer had a library and decent furniture, specimens and even the Aboriginal club he had collected in South Australia in 1802.

In 1825 he became ill: he died of dropsy and gout on 17 or 18 March 1826, less than a week after he had written his will.[28] He received the last sacraments and was buried on 19 March according to the Catholic rite, with six masses, as requested in his will, said for his soul.[29] He left almost everything to his three brothers equally: Franz in England, Josef in Vienna and Johann in Valtice. Excluded from this benefaction were his microscope and library which went to his Hietzing neighbour, Schott, who seems to have also had some of the *Investigator* drawings, perhaps on loan for his publications. Bauer's completed drawings of the Mediterranean and Australian plants and animals[30] were for Franz, complete with the pencil views of Norfolk Island, though one remained and is still in Vienna. All the drawings Franz inherited were bought by Robert Brown at the sale of Franz's effects in 1841.

When Ferdinand Bauer died, he had 6092 florins in his London bank and 1070 florins in cash in Vienna. His house and garden were valued at 3000 florins, his original *Investigator* field drawings at just 24 florins. These, with his herbarium, which was worth 640 florins and filled "113 small parcels", skins of mammals and birds, were all bought for the k.k. Hof – Naturalen Cabinett, now the Naturhistorisches Museum Wien. Eventually all but a few hundred drawings were mounted with germane specimens in the herbarium and some were even sent on loan, as to George Bentham in England in the 1830s. With the herbarium, the drawings were evacuated from Vienna in World War II. Very unfortunately an incident in the castle in Austria where they were stored led to a fire and the destruction of a substantial part of the herbarium so that something in the order of a quarter of them, at least, were destroyed. The survivors are now being removed from the herbarium and stored in the archives of the museum in Vienna in climatically controlled conditions.

NOTES

1 Lhotzky (1843).

2 Annotated copy of Sale Catalogue at The Natural History Museum.

3 Panel 34.3 × 25 cm, signed and dated *16 Mai 1812* on reverse, with label bearing his address, *10 Great Russell Street* (sold Phillips, London, *19th-Century British and European Paintings and Watercolours*, sale no. 30,775, p. 169).

4 Norst (1989), pp. 76–77.

5 Mabberley & Moore (1999).

6 Brown MSS B. 94 letter 30.

7 Mabberley & Moore (1999).

8 Annotated copy of Sale Catalogue at The Natural History Museum.

9 Norst (1989), p. 112.

10 Mabberley & Moore (1999).

11 Mabberley (1985), p. 303.

12 Mabberley (1986).

13 Seemann (1865). Cattley fell on hard times and had to discontinue Lindley's salary at the end of 1821 and publication of *Collectanea* (see E. Hetherington, 'William Cattley – his life and times', *Proc. 14th World Orchid Conf., Glasgow 1993* (1994), pp. 18–22.

14 Stearn (1956).

15 Lack (1999).

16 Lhotzky (1843).

17 Henslow (1981).

18 Sitwell & Blunt (1990), p. 19.

19 Lack (1999).

20 Annotated copy of Sale Catalogue at The Natural History Museum.

21 Mabberley (1985), p. 312; one is published by Norst (1989), p. 89.

22 Mabberley & Moore (1999).

23 Mabberley (1985), p. 359.

24 Mabberley (1985), p. 315.

25 Mabberley (1999).

26 Brown (1844), p. 2.

27 Norst (1989), p. 92. Some of the paintings of fruit and other subjects made at this time are reproduced in C. Riedl-Dorn, *Die Grüne Welt der Habsburger*, Naturhistorisches Museum, Vienna, 1989, pp. 37–39, 42.

28 Lack (1998).

29 Norst (1989), p. 85.

30 Norst (1989), p. 112.

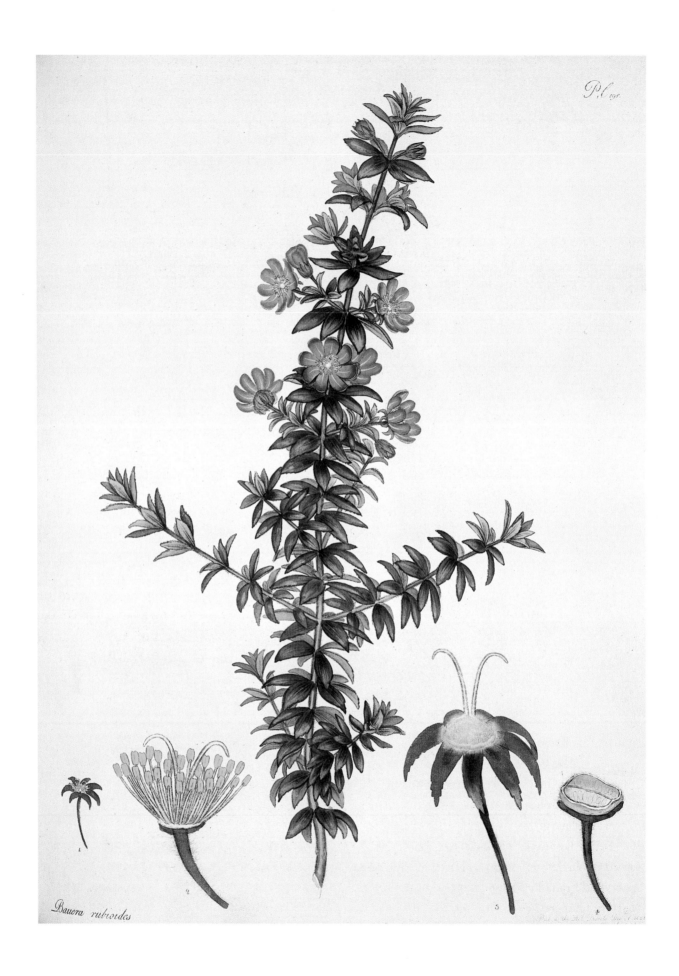

Bauera rubioides

Pl. 198

Vale!

Ferdinand Bauer

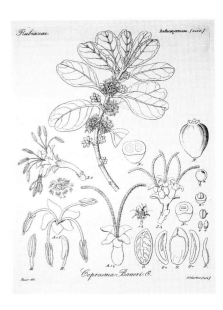

33 *Coprosma baueri* Endl. (Rubiaceae). Lithograph by Gebhart (S. Endlicher, *Iconographia generum plantarum,* t. III, 1841), based on a field drawing by Ferdinand Bauer in 1804–05. The generic name comes from *kopros,* Greek for 'dung', and *osme,* Greek for 'smell'; the plants in this genus are often foetid when bruised. Brought early into cultivation and planted near seaspray zones on Norfolk Island.

PLATE 61 *Bauera rubioides* Banks ex Andrews
(Cunoniaceae)
Hand-coloured etching by Henry Andrews
(H.C. Andrews, *The botanist's repository,* 3: t. 198, 1801),
drawn from a plant grown in the conservatory of the
Lee & Kennedy nursery, Hammersmith, London.
Named by Sir Joseph Banks in honour of both
Ferdinand and Franz Bauer, the genus comprises four
species from temperate Australia, until recently segre-
gated in their own family Baueraceae.

The historian Bernard Smith has referred to Ferdinand Bauer as the "Leonardo of natural history illustration", noting that Bauer's work avoids "both the dryness of science and the sweetness of sentiment".[1] There is something magical in the way the animals, but particularly the plants, have a three-dimensional quality that the observer can almost embrace. In his essay of 1817 on drawing, no less an authority than Johann Wolfgang Goethe, himself a good naturalist, wrote two pages on Bauer's work for Lambert's *Pinus,* which he saw in the Ducal Library in Weimar: "we are enchanted at the sight of these leaves: nature is revealed, art concealed, great in its precision, gentle in its execution, decisive and satisfying in its appearance".[2]

Yet the great output of Ferdinand Bauer was effec-tively kept from sight. His early work in Valtice is only now being published, that done in Vienna was published in expensive books now extremely rare today. His botan-ical work for Sibthorp became the most expensive botan-ical book ever and his zoological drawings are now only being published for the first time, having slumbered in Oxford for two hundred years. None of the finished *Investigator* drawings was published until 1960. A few illus-trations reached a broader audience in learned societies but only with modern colour reproduction has it been possible for the general public to encounter his work.

Major exhibitions have been held in Australia and some of the drawings have been reproduced both there and in England. The Australian drawings have indeed received most attention, being covered in a book and cat-alogues of the British holdings.[3] Perversely, the publi-cations which had a greater effect during his life, notably those on economically significant groups of plants — quinine trees and pines for Lambert and foxgloves for Lindley — have perhaps been less appreciated recently, despite the fact that they are supreme examples of botan-ical art.

Much has been made of the fact that Bauer wrote so little. There is no point, perhaps, in going beyond his unbalanced education to explain his reluctance to write. Much has also been made of his amiable disposition but there is little proof that it was so. We know that he fell out with Sibthorp, and that he irritated Banks with his

wayward habits. He seems to have had disagreements with Brown in New South Wales. As the oldest of the 'Gentlemen' on the *Investigator* voyage, deferential allowances may have been made for him, but even Flinders thought that despite Bauer's politeness and gentle nature, he must qualify his judgement, "I fear there is a dreadful disposition at the bottom".[4]

Much of this behaviour may of course have been due to his devoting himself unstintingly to his art and wishing to have no one peering at his work and perhaps overseeing him. On the other hand, the disagreements with Sibthorp seem to have stemmed from financial matters and perhaps this more worldly side should be considered by the more hagiographical of his biographers: after all, he died in comfortable circumstances, whereas his brother Franz, apparently cocooned at Kew, was to die a bankrupt in 1841.

For the biographer, the lack of records of Ferdinand Bauer's life can lead only to a frustratingly nebulous assessment of his character. The image, shadowy as it is, that comes through, though, is of a man so entrained in his profession, that, rather than move on in his art, he dug further and further into the style inculcated in him as a boy. But he so developed the technique that his work rose above its mechanical methodology to become supreme in its genre.

Combined with this talent we have other traits of a plain-speaking man, who was perhaps angular and gauche in his dealings with the rich or more intellectual people who were his employers. And there is an earthy robustness with a canny financial flair too: Bauer may have been gifted, brilliant and obsessed with his work, but he was not a saint.

NOTES

1 Quoted in Watts *et al.* (1997), p. 28.
2 Norst (1989), p. 94.
3 Norst (1989), Wheeler & Moore (1994), Watts et al. (1997), Mabberley & Moore (1999).
4 Norst (1989), p. 91.

PLATE 62 Woolly banksia *Banksia baueri* R. Br. (Proteaceae)
Lithograph by Anton Hartinger (1806–1890) from his *Paradisus vindobonensis*, t. 45 (1846, "and has for some years been an inmate of our conservatories. Its flowerheads are often compared by the people to the cap of the British grenadier, to which they bear indeed some resemblance"), drawn from a greenhouse plant in the garden of Carl von Hügel, Vienna. Named for Bauer by Robert Brown, though neither of them saw it growing wild in Australia. A bushy shrub of south-west Western Australia grown for its spectacular large woolly heads of flowers taking five to six months to develop.*

BANKSIA BAUERI. *R. Br.*
NAT. ORD. PROTEACEAE
Vaterl. Neu Holland
Aus d. Gart. d. H.n Frreh. Carl v. Hügel

Appendix

Bauer's work and the sprinkling of his letters surviving in London and elsewhere are not all by which we remember him. He was commemorated in a number of animal and plant names, particularly in plant-names coined by Robert Brown, dealing with Australian plants, and by Stephan Endlicher, describing those from Norfolk Island. It is likely that, until recently, many people have unwittingly known more of Bauer in this way than through his art.

Those names in small capitals are those commemorating him and still in use today.

Animals

Fish

Aleuterius baueri Richardson (1846), a name based entirely on Bauer's drawing, = *Brachaleuteres jacksonianus* (Quoy & Gaimard) (Pygmy leatherjacket, Australia).

Birds

Limosa baueri Naumann (1836) = LIMOSA LAPPONICA BAUERI (Naumann) (Bar-tailed godwit, Pacific subspecies).

Psittacus baueri Temminck (1820), *Platycercus baueri* (Temminck) (1825) = *Platycercus zonarius zonarius* (Shaw) (Australian ringneck).

Plants

Ferns

CEPHALOMENES BAUERIANUM (Endl.) P.S. Green (*Trichomanes baueriana* Endl.), Hymenophyllaceae – Norfolk Island and Lord Howe Island.

Pteris baueriana Diesing ex Endl. = *Pteris tremula* R. Br. (Pteridaceae).

Flowering plants

ACACIA BAUERI Benth. (*Racosperrma baueri* (Benth.) Pedley), Leguminosae – Queensland and New South Wales.

Acronychia baueri Schott (*Baurella baueri* (Schott) T.G. Hartley, *Jambolifera baueri* (Schott) Kuntze) = *Sarcomelicope simplicifolia* (Endl.) T.G. Hartley (Rutaceae).

Allium bauerianum Bak. = *Allium nigrum* L. (Alliaceae).

Alternanthera baueri Moq. = *Gomphrena lanata* R. Br. (Amaranthaceae).

Anamirta baueri Endl. = *Anamirta cocculus* (L.) Wight & Arn. (Menispermaceae).

Aristolochia baueri Duch. =? *Aristolochia thozetii* F. Muell. (Aristolochiaceae)

BANKSIA BAUERI R. Br. (*Sirmuellera baueri* (R. Br.) Kuntze), Proteaceae – south-west Western Australia.

BAUERA Banks ex Andr., Cunoniaceae – also commemorating Franz Bauer.

Baueraceae Lindl. = Cunoniaceae R. Br.

Bauerella Borzi = *Sarcomelicope* Engl. (Rutaceae).

Bauerella Schindler (*Baueropsis* Hutch.) = *Cullen* Medikus (Leguminosae).

Calycothrix baueri Schauer (*Calytrix baueri* (Schauer) Benth.) = *Calycothrix exstipulata* DC. (Myrtaceae).

Canavalia baueriana Endl. = *Canavalia rosea* (Sw.) DC. (Leguminosae).

Clianthus baueri A. Cunn. ex Maiden = *Streblorrhiza speciosa* Endl. (Leguminosae).

COPROSMA BAUERI Endl. (*Coprosma baueriana* Hook.f.), Rubiaceae – Norfolk Island.

Cordyline baueri Hook.f. = *Cordyline obtecta* (Graham) Bak. (Laxmanniaceae).

Diplachne baueri R. Br. ex Desf. = *Verticordia plumosa* (Desf.) Druce (Myrtaceae).

Dodonaea baueri Endl. = *Dodonaea ceratocarpa* Endl. (Sapindaceae).

Enchysia baueri Presl (*Isotoma baueri* Presl, *Laurentia baueri* (Presl) A. DC., *L. ferdinandi* F. Wimmer) = *Laurentia fluviatilis* (R. Br.) F. Wimmer (Campanulaceae).

Epilobium baueri Endl. = *Epilobium billardierianum* DC. subsp. *cinereum* (A. Rich.) Raven & Engelhorn (Onagraceae).

EUCALYPTUS BAUERIANA Schauer, Myrtaceae – eastern Australia.

EUPHORBIA BAUERI Engelm. ex Boiss., Euphorbiaceae – Australia.

FREYCINETIA BAUERIANA Endl., Pandanaceae – Norfolk Island and New Zealand.

GENOPLESIUM BAUERI R. Br. (*Prasophyllum baueri* (R. Br.) Poiret, Orchidaceae) – New South Wales.

GREVILLEA BAUERI R. Br., Proteaceae – New South Wales.

Harmogia baueriana Schauer = *Babingtonia densifolia* (Sm.) F. Muell. (Myrtaceae).

LASIOPETALUM BAUERI Steetz, Malvaceae – south-eastern Australia.

Litsea baueri Endl. = *Neolitsea dealbata* (R. Br.) Merr. (Lauraceae).

MELODINUS BAUERI Endl., Apocynaceae – Norfolk Island.

MIRBELIA BAUERI (Benth.) J. Thompson (*Chorizema baueri* Benth.), Leguminosae – New South Wales.

Murucuia baueri Lindl. (*Disemma baueri* (Lindl.) G. Don f., *D. baueriana* Endl., *Distemma bauerianum* (Endl.) Lem., *Passiflora baueriana* (Endl.) Masters) = *Passiflora aurantia* Forst. f. (Passifloraceae).

Peperomia baueriana Miq. = *Peperomia urvilleana* A. Rich. (Piperaceae).

Phyllota baueri Benth. = *Phyllota phylicoides* (DC.) Benth. (var. *baueri* (Benth.) Domin) (Leguminosae).

POUTERIA BAUERI (Montr.) Baehni (*Beccariella baueri* (Montr.) Aubrév., *Planchonella baueri* (Montr.) Dubard, *Sapota baueri* Montr.), Sapotaceae – New Caledonia.

RHOPALOSTYLIS BAUERI H. Wendl. & Drude (*Areca baueri* Hook.f., *Eora baueri* (H.Wendl. & Drude) O.F. Cook, *Kentia baueri* (Hook.f.) Seem.), Palmae – Norfolk Is., New Zealand.

SOLANUM BAUERIANUM Endl., Solanaceae – extinct endemic of Norfolk Island and Lord Howe Island.

TEPHROSIA BAUERI Benth., Leguminosae – Australia.

THYSANOTUS BAUERI R. Br. (*Chlamysporium baueri* (R. Br.) Kuntze), Laxmanniaceae – southern Australia.

Utricularia baueri R. Br. = *Utricularia biloba* R. Br. (Lentibulariaceae).

ZEHNERIA BAUERIANA Endl. (Cucurbitaceae) – Norfolk Island and New Caledonia.

Bibliography

ANDERSSON, L., 'A revision of the genus *Cinchona* (Rubiaceae-Cinchoneae)', *Memoirs of the New York Botanical Garden* 80 (complete) 1998

BONNEMAINS, J., FORSYTH, E., and SMITH, B., eds, *Baudin in Australian waters: the artwork of the French voyage of discovery to the southern lands (1800–1804)*, Melbourne (Oxford University Press) 1988

BROWN, R., *On the female flower and fruit of Rafflesia arnoldi and on Hydnora africana*, London (Taylor) 1844

BURBIDGE, A.A., ATKINSON, K.A., BROWN, A.P., and COATES, D.J., 'Conservation of a megadiverse flora: problems and processes in south-western Australia', in Touchell, D.H. and Dixon, K.W., eds, *Conservation into the 21st Century*, West Perth (Kings Park and Botanic Garden) 1997, pp. 101–09

DESMOND, R., *Kew. The history of the Royal Botanic Gardens*, London (Harvill) 1995

EDWARDS, P.I., 'The journal of Peter Good, gardener on Matthew Flinders['s] voyage to Terra Australis 1801–03', *Bulletin of The British Museum (Natural History), Historical Series* 9 (complete) 1981

GRANDISON, R., 'Retracing the route taken by Robert Brown and company in a portion of the Flinders Ranges', in Short, P.S., ed., *History of systematic botany in Australasia*, South Yarra, Victoria (Australian Systematic Botany Society Inc.) 1990, pp. 105–07

GREEN, P.S., *Oceanic Islands I. Flora of Australia*, 49, Canberra 1994

HENREY, B., *British botanical and horticultural literature before 1800*, 3 vols., Oxford (Oxford University Press) 1975

HENSLOW, J.S., *On the examination of a hybrid Digitalis*, facsimile edition with a preface by S.M. Walters and introduction by V.H. Heywood, Cambridge (University Botanic Garden) 1981

JACKSON, B.D., *George Bentham*, London (Dent) 1906

LACK, H.W., 'Die Frontispize von John Sibthorps "Flora Graeca"', *Annalen des Naturhistorischen Museums Wien*. 99B, 1997, pp. 615–54

LACK, H.W., 'Jacquin's "Selectarum stirpium americanorum historia", the extravagant second edition and its title pages', *Curtis's Botanical Magazine*, ser. 6, 15, 1998, pp. 194–214

LACK, H.W., 'Recording form in early nineteenth century botanical drawing. Ferdinand Bauer's "cameras"', *Curtis's Botanical Magazine*, ser. 6, 15, 1998, pp. 254–74

LACK, H.W., 'The Berlin passionflowers – Ferdinand Bauer's swan-song', *Curtis's Botanical Magazine*, ser. 6, 16, 1999, in press

LACK, H.W., with MABBERLEY, D.J., *The Flora Graeca story. Sibthorp, Bauer, and Hawkins in the Levant*, Oxford (Oxford University Press) 1998

LHOTZKY, J., 'Biographical sketch of Ferdinand Bauer, natural history painter to the expedition of Captain Flinders, R.N., to Terra Australis', *Hooker's London Journal of Botany*, 2, 1843, pp. 106–13

MABBERLEY, D.J., 'Dr. Smith's *Anemia*, or, the prevention of later homonyms', *Taxon*, 32, 1983, pp. 79–87

MABBERLEY, D.J., *Jupiter botanicus. Robert Brown of the British Museum*, Braunschweig (Cramer) and London (British Museum (Natural History)) 1985

MABBERLEY, D.J., 'Robert Brown on *Pterocymbium* (Sterculiaceae)', *Archives of Natural History*, 13, 1986, pp. 307–12

MABBERLEY, D.J., *The plant-book. A portable dictionary of the vascular plants*, 2nd edn, reprinted with corrections, Cambridge (Cambridge University Press) 1998

MABBERLEY, D.J., 'Robert Brown on *Rafflesia*', *Blumea*, 44, 1999, pp. 343–50

MABBERLEY, D.J., and MOORE, D.T., 'Catalogue of the holdings in The Natural History Museum (London) of the Australian botanical drawings of Ferdinand Bauer (1760–1826) and cognate materials relating to the Investigator voyage of 1801–1805', *Bulletin of the Natural History Museum, Botany Series*, 29, 1999, pp. 81–226

MASLIN, B.R., and COWAN, R.S., 'Robert Brown, the typification of his new Acacia names in edition 2 of Aiton's "Hortus Kewensis"', *Nuytsia*, 10, 1995, pp. 107–18

MEIKLE, R.D., *Flora of Cyprus*, vol. 1, Kew (Bentham Moxon Trust) 1977

MILLER, H.S., 'The herbarium of Aylmer Bourke Lambert. Notes on its acquisition, disposal, and present whereabouts', *Taxon*, 19, 1970, pp. 489–553

MOORE, D.T., 'The pencil landscape drawings made by Ferdinand Bauer in Norfolk Island, from August 1804 to February 1805, in the Natural History Museum, London', *Archives of Natural History*, 24, 1998, pp. 213–20

NORST, M.J., *Ferdinand Bauer. The Australian natural history drawings*, London (British Museum of Natural History) 1989

PAVORD, A., *The tulip*, London (Bloomsbury) 1999

PETTER, H.M., *The Oxford Almanacks*, Oxford (Clarendon Press) 1974

RENKEMA, H.W., and ARDAGH, J., 'Aylmer Bourke Lambert and his "Description of the genus *Pinus*"', *Journal of the Linnean Society of London. Botany*, 48, 1930, pp. 439–66

ROACH, F.A., *Cultivated fruits of Britain. Their origin and history*, Oxford (Blackwell) 1985

ROURKE, J.P., 'Robert Brown at the Cape of Good Hope', *Journal of South African Botany*, 40, 1974, pp. 47–60

SCLATER, P.L., 'On the birds of Sibthorp's "Fauna Graeca"', *Ibis*, ser. 8, 4, 1904, pp. 222–27

SCRASE, D., *Flowers of three centuries. One hundred drawings and watercolors from the Broughton Collection*, Washington, D.C. (International Exhibitions Foundation) 1983

SCRASE, D., *Flower drawings*, Cambridge (Cambridge University Press) 1997

SEEMANN, B., 'The late Dr. John Lindley, F.R.S., F.L.S.', *Journal of Botany*, 3, 1865, pp. 384–88

SITWELL, S., and BLUNT, W., *Great flower books, 1700–1900*, London (Witherby) 1990

STAFLEU, F.A., and COWAN, F., *Taxonomic literature*, vol. 2., Utrecht (Bohn et al.) 1979

STEARN, W.T., 'Mikan's *Delectus florae et faunae brasiliensis*', *Journal of the Society for the Bibliography of Natural History*, 3, 1956, pp. 135–36

SWANN, T., *Botanical books. A bookseller's perspective*. London (The Natural History Museum) 1997

SYMES, M., 'A.B. Lambert and the conifers at Painshill', *Garden History*, 16, no. 1, 1988, pp. 24–40

VALLANCE, T.G., 'Jupiter Botanicus in the bush: Robert Brown's Australian field-work, 1801–5', *Proceedings of the Linnean Society of New South Wales*, 112, 1990, pp. 49–86

WATTS, P., POMFRETT, J.A., and MABBERLEY, D.[J.], *An exquisite eye. The Australian flora and fauna drawings 1801–1820 of Ferdinand Bauer*. Glebe, NSW (Historic Houses Trust) 1997

WHEELER, A., and MOORE, D.T., 'The animal drawings of Ferdinand Bauer in The Natural History Museum, London', *Archives of Natural History*, 21, 1994, pp. 309–44

Notes to the Plates and Figures

Index